American Castles

A PICTORIAL HISTORY OF MAGNIFICENT MANSIONS

Publications International, Ltd.

CONTRIBUTING WRITER: Sheryl DeVore

Images from FLICKR (details below), Shutterstock.com and Commons.Wikimedia.org.

Edward Stojakovic (8-9), Ben Ledbetter (20-21), mbtrama (20), Steven dosRemedios (23), Mark B. Schlemmer (32), Francisco Anzola (42), Claudia Brooke (42), Ken Lund (42), Steve (43), Miguel Discart (43), Preservation Maryland (44), Openroads.com (48), Joel Solomon (76), Nicolas Henderson (102), David (115), Reading Tom (119)

Louis Weber, CEO
Publications International, Ltd.
8140 Lehigh Avenue
Morton Grove, IL 60053

Permission is never granted for commercial purposes.

ISBN: 978-1-64030-892-3

Manufactured in China.

8 7 6 5 4 3 2 1

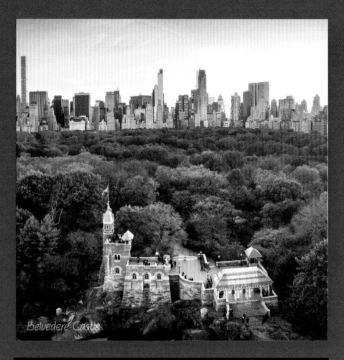
Belvedere Castle

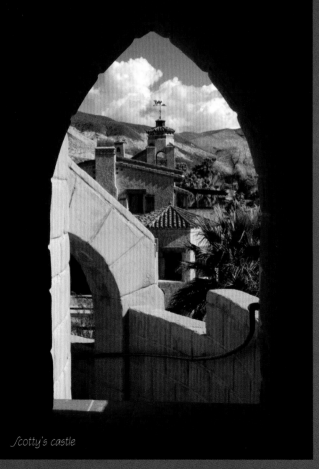
Scotty's castle

Let's get social!
@Publications_International
@PublicationsInternational
www.pilbooks.com

TABLE OF CONTENTS

WRIGLEY MANSION4

ENNIS HOUSE6

FILOLI HISTORIC HOUSE & GARDEN8

HEARST CASTLE10

SCOTTY'S CASTLE14

STAHL HOUSE18

SUNNYLANDS20

THE MANOR22

WINCHESTER MYSTERY HOUSE24

BISHOP CASTLE26

DEATON SCULPTURED HOUSE28

GILLETTE CASTLE30

THE GLASS HOUSE32

ERNEST HEMINGWAY HOUSE34

VIZCAYA36

THE MERCER-WILLIAMS HOUSE38

IOLANI PALACE40

OAK ALLEY PLANTATION..................42

SOTTERLEY PLANTATION44

CASTLE HILL46

HOUSE OF THE SEVEN GABLES48

NAUMKEAG50

THE MOUNT52

ALDEN B. DOW HOME & STUDIO54

GLENSHEEN MANSION56

THE JAMES J. HILL HOUSE58

VAILE MANSION........................60

MOSS MANSION62

JOSLYN CASTLE64

CASTLE IN THE CLOUDS..................66

DRUMTHWACKET70

EARTHSHIP........................72

TAOS PUEBLO........................76

BANNERMAN CASTLE..................80

BELVEDERE CASTLE84

BOLDT CASTLE86

LYNDHURST MANSION88

DARWIN D. MARTIN HOUSE90

OHEKA CASTLE92

OLANA STATE HISTORIC SITE..............94

BILTMORE MANSION96

LOVELAND CASTLE......................98

MARLAND MANSION....................100

QUANAH PARKER STAR HOUSE102

PITTOCK MANSION104

CAIRNWOOD ESTATE108

FALLINGWATER........................110

FONTHILL CASTLE112

BELCOURT OF NEWPORT................114

ROSECLIFF........................116

THE BREAKERS118

DRAYTON HALL120

GRACELAND122

BISHOP'S PALACE........................124

BEEHIVE HOUSE........................126

HILDENE, THE LINCOLN FAMILY HOME ..130

MONTICELLO132

MOUNT VERNON134

THE WHITE HOUSE138

THE PABST MANSION140

WINGSPREAD........................142

WRIGLEY MANSION

1929–1931

LOCATION: Phoenix, AZ

ARCHITECT: Earl Heitschmidt

STYLE: Spanish Colonial Revival

Chewing gum entrepreneur William Wrigley gave a special 50th wedding anniversary present to his wife, Aida. He commissioned an architect to build a mansion in Phoenix where they could spend several weeks in winter.

Wrigley died shortly after the home was complete and was not able to spend much time there. But countless others today continue to revel in this 16,000 square-foot home overlooking the scenic valley below and Camelback Mountain.

The Wrigley Mansion now houses a lounge, wine bar, and restaurant with food created by award-winning chefs. Home tours are also offered.

Architect Earl Heitschmidt used a combination of styles—including Spanish colonial—to design the red tile-roofed mansion that includes 24 rooms and 12 bathrooms.

The tile used for many of the floors and fireplaces was hauled by a donkey from a Wrigley-owned factory. Visitors can still see the original decorative tile today.

In 1989, the mansion was listed on the National Register of Historic Places, and today, it's owned by another well-known business family, the Hormels, makers of Hormel chili and Spam. Geordie Hormel and his wife, Jamie, purchased the mansion in 1992 before it was set to be torn down and replaced with condominiums. Using old photos, the Hormels spent

$2 million to have the mansion restored to its original 1930s splendor.

Those who tour the home can visit some unusual rooms, including the telephone switchboard room where the wallpaper consists of silver chewing gum wrapping. Another room features a Steinway player piano, a highlight for many.

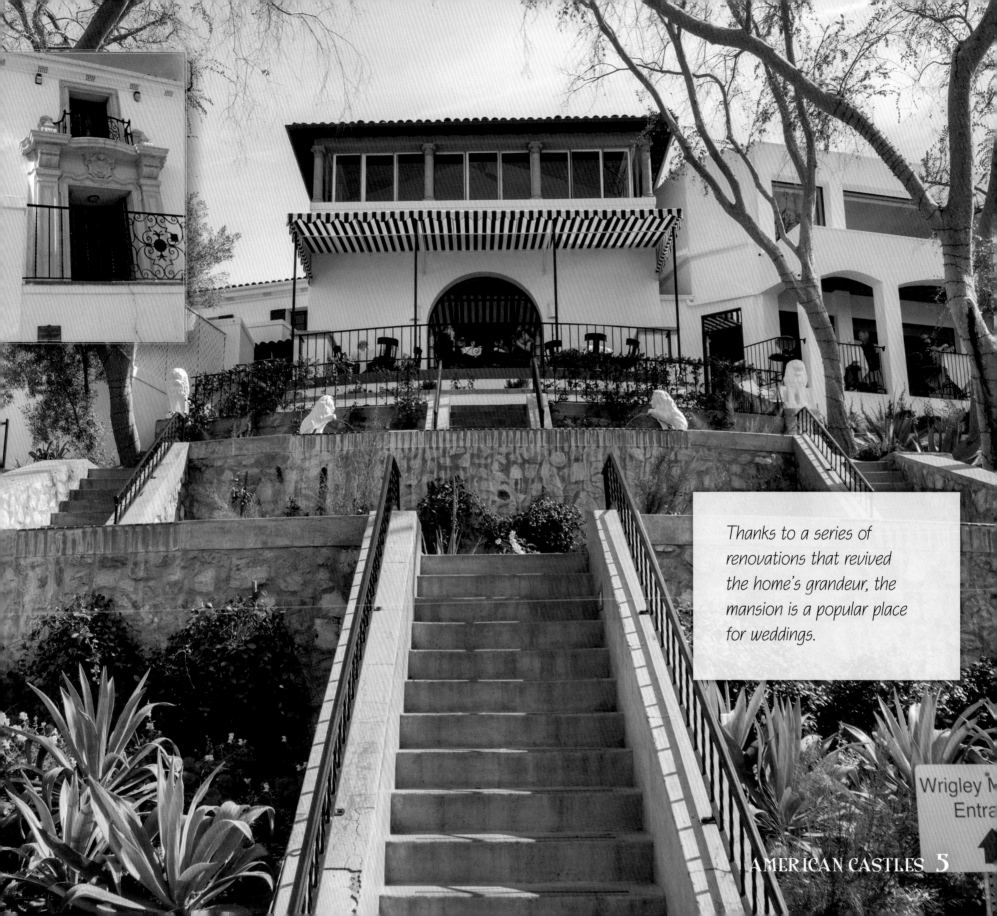

Thanks to a series of renovations that revived the home's grandeur, the mansion is a popular place for weddings.

Wrigley M
Entra

ENNIS HOUSE

1923-1924

LOCATION: Los Angeles, CA

ARCHITECT: Frank Lloyd Wright

STYLE: Mayan Revival

Frank Lloyd Wright

A city, state, and national landmark, Ennis House represents one of Frank Lloyd Wright's Mayan revival style designs. It has attracted Hollywood producers to stage movies there. Among the most famous, even if only for a short scene, is 1982's *Blade Runner*.

Charles and Mabel Ennis commissioned Wright to design the home, and Wright's son, Lloyd Wright Jr., completed the building in 1924. Wright Sr. designed this and three other homes in northern Los Angeles in a Mayan revival style, using inspiration from ancient temples erected by people who once lived in the Yucatan.

The homes are built with concrete blocks that fit together like a puzzle. For the Ennis home, a concrete mix of gravel, granite, sand, and water was poured into a mold to create

patterned blocks measuring 16 inches wide, 16 inches tall, and 2.5 inches deep. Some 27,000 blocks were pieced together to create the 6,000-square-foot home. The interior features marble and hardwood floors and rooms incorporating the same blocks used for the exterior.

Over the years, the Ennis House suffered damage from an earthquake and horrendous rains. In 2005, the National Trust for Historic Preservation designated it as one of the nation's most endangered landmarks. Businessman and trustee of the Frank Lloyd Wright Conservancy, Ron Burkle, purchased the home in 2011 and reportedly spent nearly $17 million to restore it. The home was once open for tours, but now visitors can only admire it from the outside. Ennis House was listed for sale in December 2018 for $23 million.

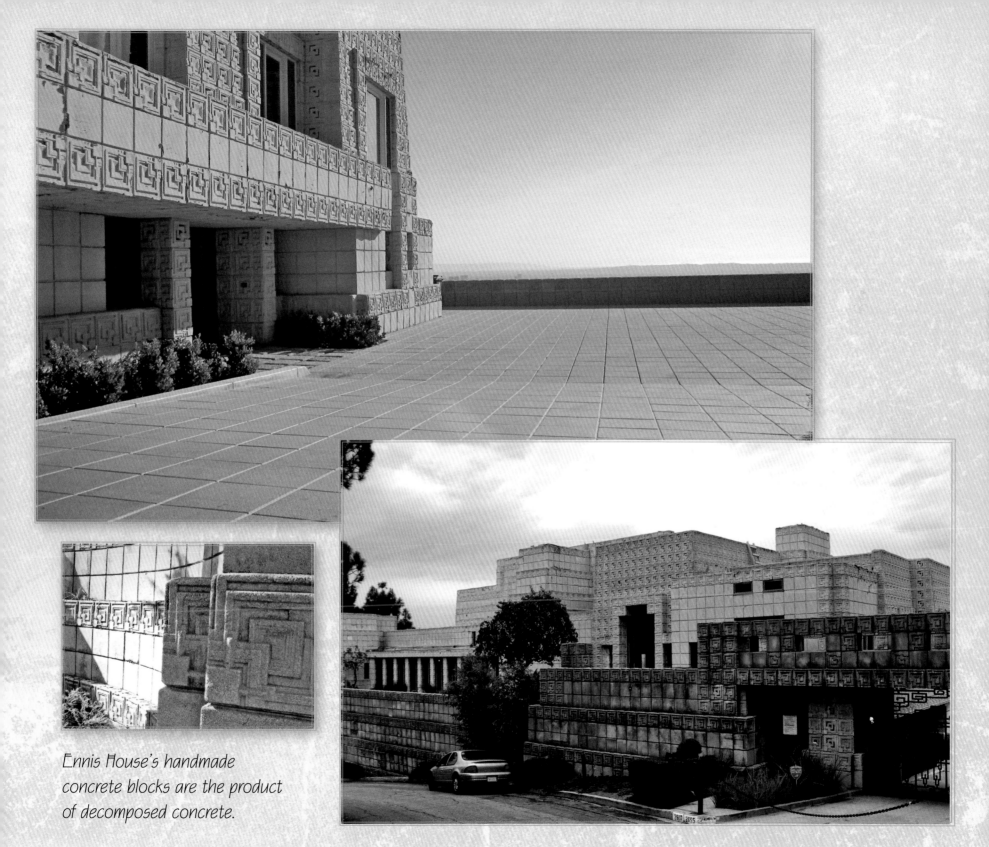

Ennis House's handmade concrete blocks are the product of decomposed concrete.

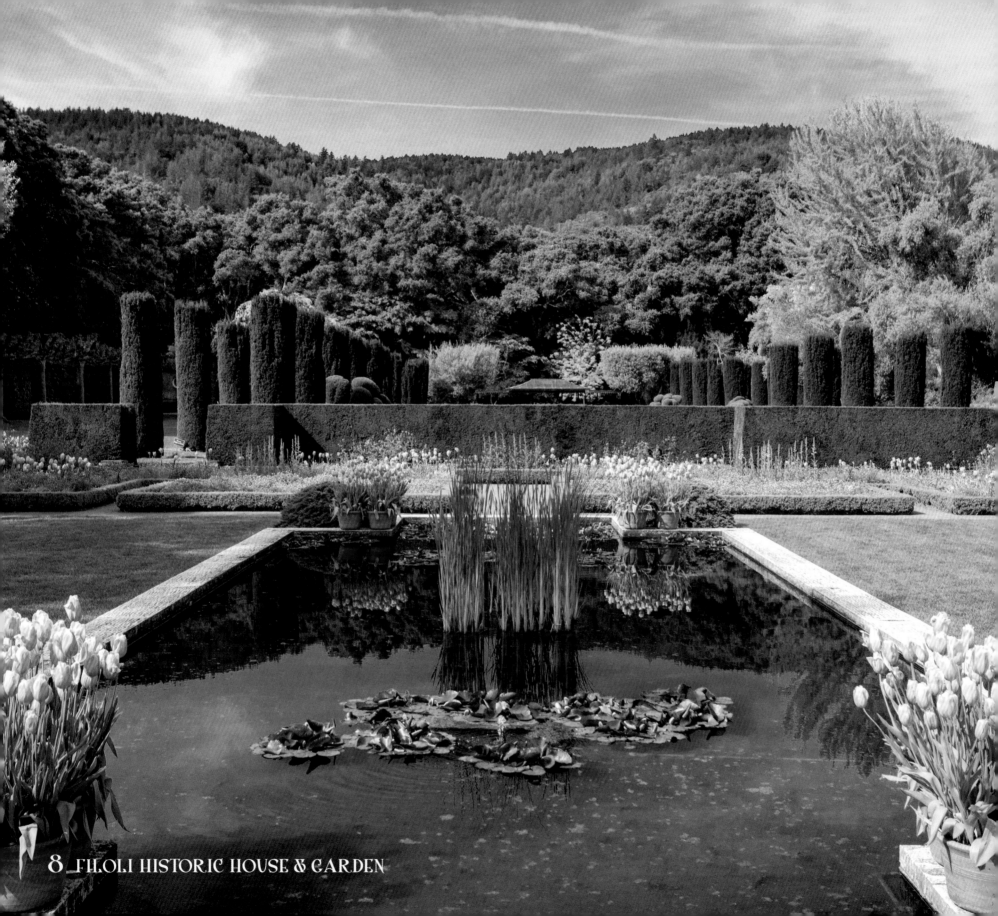

FILOLI HISTORIC HOUSE & GARDEN

1915–1917

LOCATION: Woodside, CA

ARCHITECT: Willis Polk

STYLE: Georgian Revival

One of only 27 properties owned by the National Trust for Historical Preservation, the 36,000-square-foot Filoli Mansion in southern California and its formal gardens shine as a living museum.

William Bowers Bourn II and his wife, Agnes Moody, commissioned Willis Polk, an architect known for combining different styles into one structure, to build a house in 1915. Bourn worked with Polk and other architects to ensure his vision for the home was fulfilled. They made sure the native oak trees were not harmed during the home's construction, and the oaks grew to overlook a formal garden, designed and built between 1917 and 1929.

The mansion's grounds encompass nearly 600 acres.

Featuring formally trimmed evergreens, boxwoods, and other plants; brick walls; reflecting pools; fountains; and statues, the Filoli garden is considered today to be one of the best remaining examples of an English Renaissance style landscape.

The home was built with Flemish brickwork and features Spanish mission roof tiles, French-style windows, and Italian monolithic columns.

After Bourn's death, the Roth family purchased the estate in 1937 and kept the gardens and interior well-maintained, eventually donating the home to the national trust. The rest was later given to the Filoli Center, a nonprofit that manages the home and grounds.

Since 1976, the public has been able to tour the home and walk along some of the formal gardens, shady walkways, and nature trails—as well as have afternoon tea or wine in a café. The Filoli Center also offers a wide variety of art shows, educational programs, and other activities. The Filoli Mansion is listed on the National Register of Historic Places.

HEARST CASTLE
1919-1947

LOCATION: San Simeon, CA
ARCHITECT: Julia Morgan
STYLE: Spanish Revival

The first woman admitted to the architecture program at L'École nationale supérieure des Beaux-Arts in Paris, Morgan was also the first female architect licensed in California. She designed more than 700 buildings, including many for women and girls.

Newspaper magnate William Randolph Hearst reportedly told Julia Morgan, the architect of the Hearst Castle in California, he wanted a bungalow built. That way he didn't have to sleep in a tent atop a hill on thousands of acres he inherited and explored as a child.

Soon Hearst had a more grandiose plan.

The "bungalow" became a 68,500-square-foot estate, with three separate guest houses. Hearst called it "la cuesta encantada," or "enchanted hill."

A National Historic Landmark, Hearst Castle remains open to the public today as a historic museum and state park. The estate sits atop a hill within the Santa Lucia mountains, overlooking the Pacific Ocean five miles away.

Construction began in 1919 and continued for nearly three decades. Hearst asked the architect to incorporate various architectural styles he admired while traveling. For example, the castle's twin towers resemble those atop a church in Spain that Hearst loved.

The estate contains more than 130 rooms, with 123 acres of gardens, terraces, and pools. It also houses a movie theatre, now the Hearst Castle Visitor Center.

One of the highlights—and there are many—includes the 345,000-gallon outdoor Neptune Pool, which was renovated in 2018.

Hearst died in 1951, and the Hearst Corporation donated the estate to California in 1958. At the estate, the public can view some of Hearst's rare art collections and explore the gardens with native and rare plants.

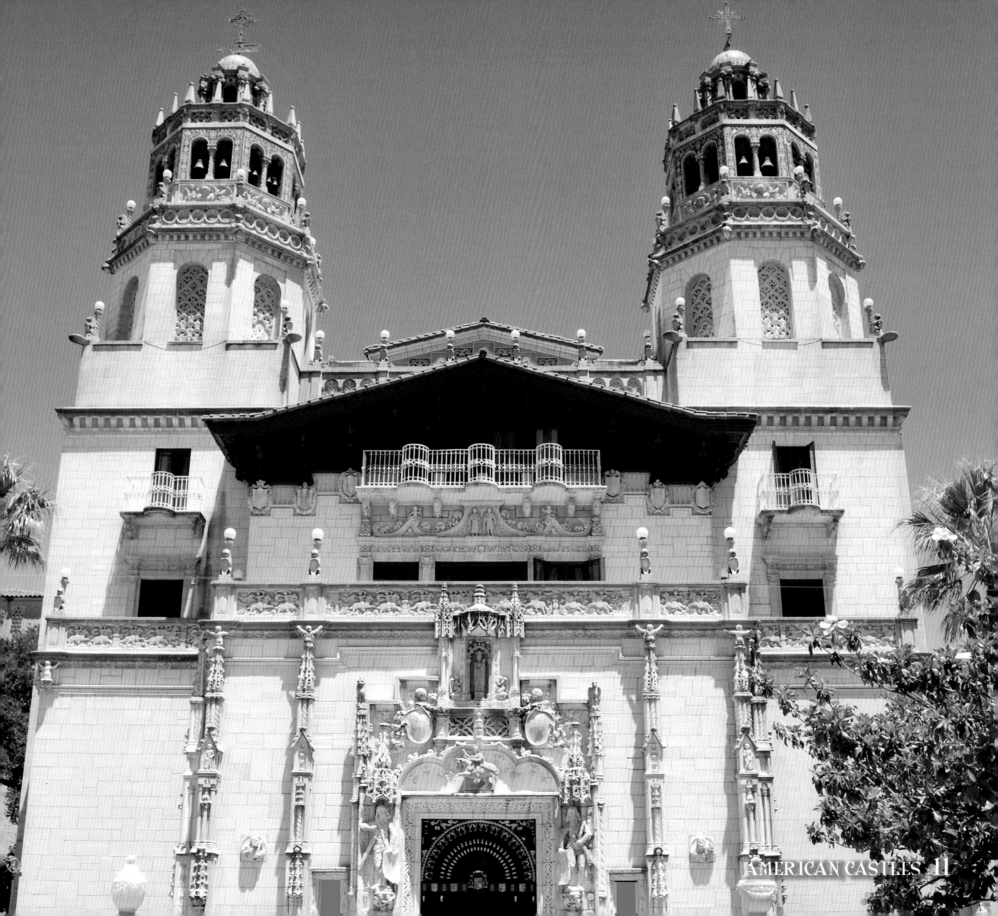

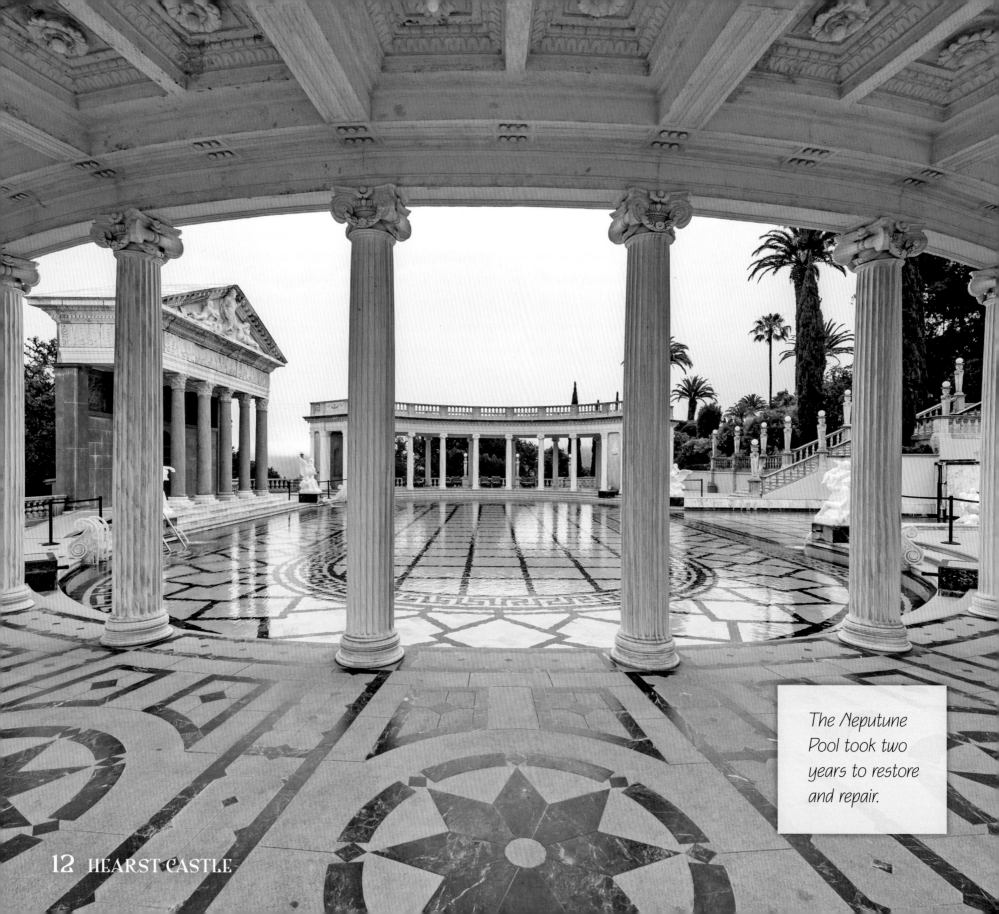

The Neputune Pool took two years to restore and repair.

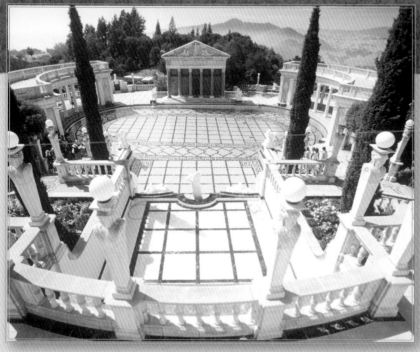

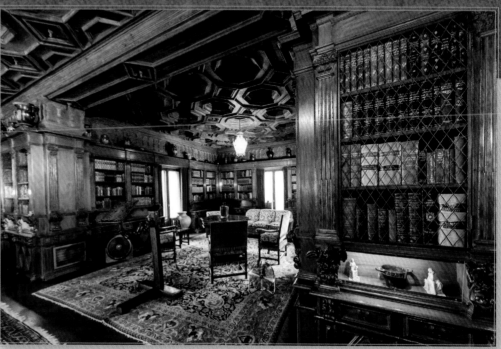

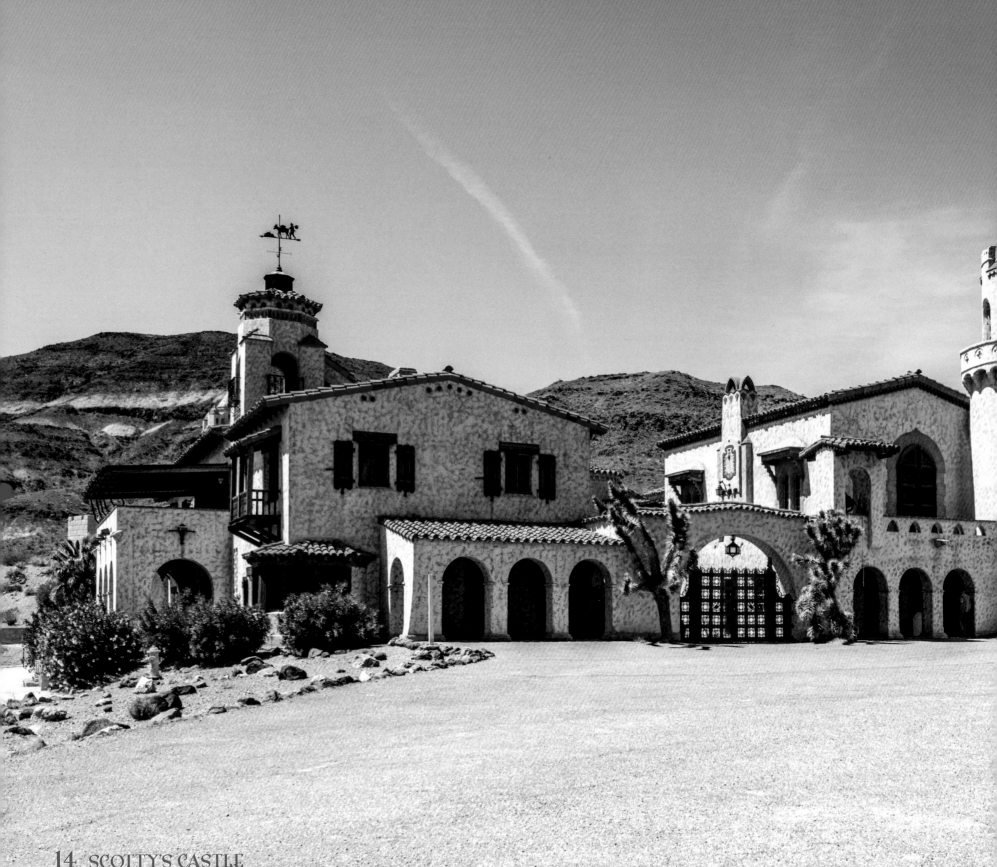

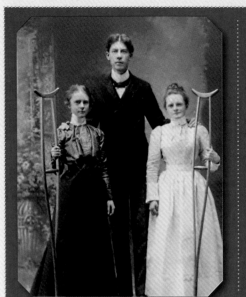

SCOTTY'S CASTLE
1922–1931

LOCATION: Death Valley, CA
ARCHITECT: Martin de Dubovay
STYLE: Spanish Revival

Albert Johnson by his wife Bessie (left) and a nurse, who hold his crutches

Walter Scott never lived in a castle, even though a mansion in the midst of Death Valley was named after him. And the stories behind the man people called Scotty are as fascinating as the mansion itself.

Scott, known as Death Valley Scotty, was a gold prospector from Kentucky who reportedly conned businessmen to invest in a nonexistent gold mine in California. One of them was Albert Mussey Johnson, who first grew angry when he learned about Scotty's lies, but later took a liking to this wannabe cowboy. They become friends, and Johnson and his wife, Bessie, commissioned architect Martin de Dubovay to design a home on property they bought in the region for about $1.5 million in the early 1920s.

Built above an underground spring in Spanish-hacienda style, the home was decorated with custom furniture, hand-made fixtures, and antiques from Europe. A 500-pound wrought iron chandelier hangs in the great room.

Scotty spread the rumor the money to build it came from riches he earned from his mines, and the Johnsons went along, often inviting him and his guests to their home.

After the Johnsons died, the National Park Service purchased the villa and began leading tours wearing 1930s style clothing and telling stories of the Johnsons and Scotty.

A major rainstorm deluged Death Valley in 2015. Flooding destroyed the road to Scotty's Castle as well as some portions of the estate. The park service is restoring the grounds, hoping to reopen the villa in 2020. Meanwhile, staff members are giving public tours of the grounds to talk about the renovation and tell stories about Scotty's Castle.

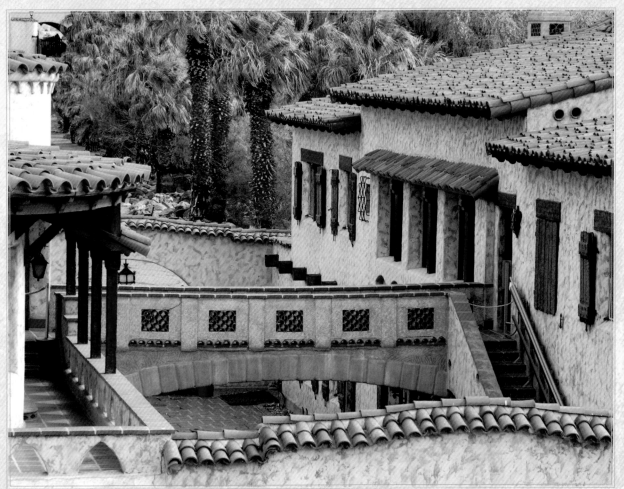

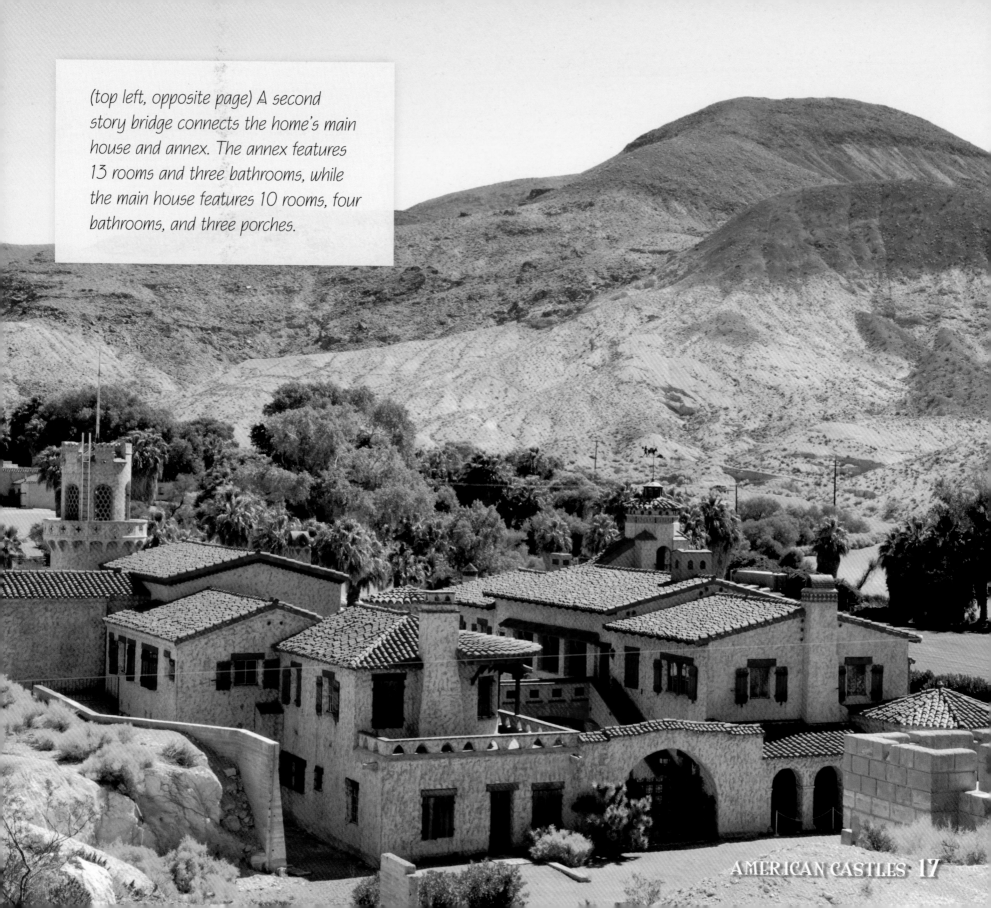

(top left, opposite page) A second story bridge connects the home's main house and annex. The annex features 13 rooms and three bathrooms, while the main house features 10 rooms, four bathrooms, and three porches.

STAHL HOUSE
1959-1960

LOCATION: Los Angeles, CA
ARCHITECT: Pierre Koenig
STYLE: Mid-Century Modernism

One of the most photographed homes in the world and most famous in Los Angeles likely could not be built today because it wouldn't pass structural codes.

But it stands as a monument to mid-twentieth century modern architecture, and it is listed on the National Register of Historic Places. Known as the Stahl house, it represents the ultimate in minimalism and openness enjoyed by the wealthy in the middle of the twentieth century.

The Stahls purchased land in 1954 and began mapping out their dream home. They found an architect, Pierre Koenig, who designed a 2,300-square-foot home with a 4,000-square-foot roof deck. Exposed steel and uninterrupted glass walls are the main features. The open living area faces a steel-framed fireplace, behind which are freestanding appliances. The Stahl children were said to have enjoyed jumping from the roof into the pool and roller skating on the floors. Buck and Carlotta Stahl's children continue to offer tours of the estate.

The Stahl House is one of 27 homes designated by the now-defunct *Arts & Architecture* magazine as a case study house. It's often referred to as Case Study House No. 22.

Julius Shulman photographed the house at night with two women sitting in the living room that overlooked the lights of Los Angeles. That photo brought the home and its architecture into the limelight, and it's been used in fashion shoots, films, television shows, and advertisements.

Today, visitors who tour the home can imagine what it would be like living in a glass house seemingly on the edge of the world.

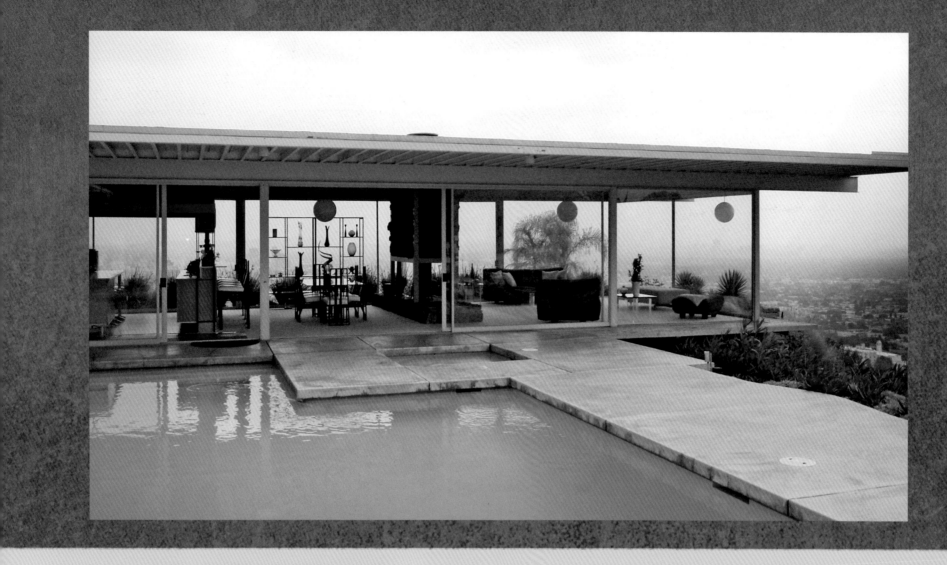

SUNNYLANDS
1963–1966

LOCATION: Rancho Mirage, CA
ARCHITECT: A. Quincy Jones
STYLE: Mid-Century Modernism

Capitalizing on Frank Lloyd Wright's style of melding architecture with the outdoor landscape, A. Quincy Jones designed a 25,000-square-foot estate in California where world leaders—including eight U.S. presidents—have visited. Dwight D. Eisenhower, Ronald Reagan, and Barack Obama are among those who spent time at Sunnylands, which has become known as the Camp David of the West Coast.

The estate, noted for its pyramidal pink roof, was commissioned by philanthropists Walter and Lee Annenberg; both served as ambassadors for the U.S., and Walter was a publisher and power broker. Jones integrated the desert and mountainous landscape with the mansion, including pink stucco walls outside and Mexican lava stone walls inside. He also used partition-style walls that don't reach the ceiling. Copious use of floor-to-ceiling glass ties the outdoors to the indoors.

The Annenbergs decorated their home with paintings and sculptures of nineteenth and twentieth century artists like Rodin, Monet, and van Gogh. The library contains thousands of books about art, nature, music, history, and government.

The couple also hosted New Year's Eve parties with guests Ronald and Nancy Reagan, Bob Hope, Colin Powell, and many other political figures and Hollywood stars.

They established the Annenberg Foundation Trust in 2001 to preserve the estate as a place where world leaders could hold important discussions—and where the public would be free to roam the gardens and part of the interior.

Visitors will also notice the foundation's dedication to protecting the environment, which includes various water use reduction techniques and replacement of turf grass with native, meadow grasses. The estate also includes 11 artificial lakes, three Jones-designed cottages, and a 17,000-square-foot visitor center commissioned by Lee Annenberg.

The house's structures—trellises, coffered ceilings, and steel beams—are exposed rather than hidden. The exposed structure is in lockstep with mid-century modernism.

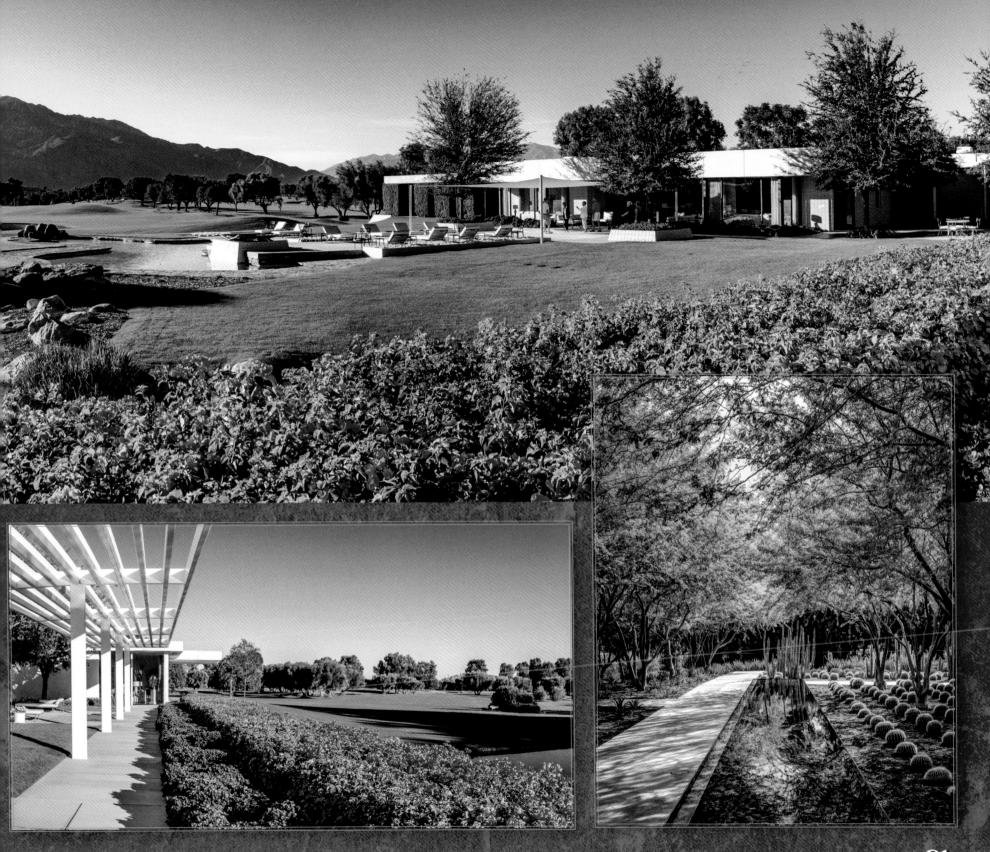

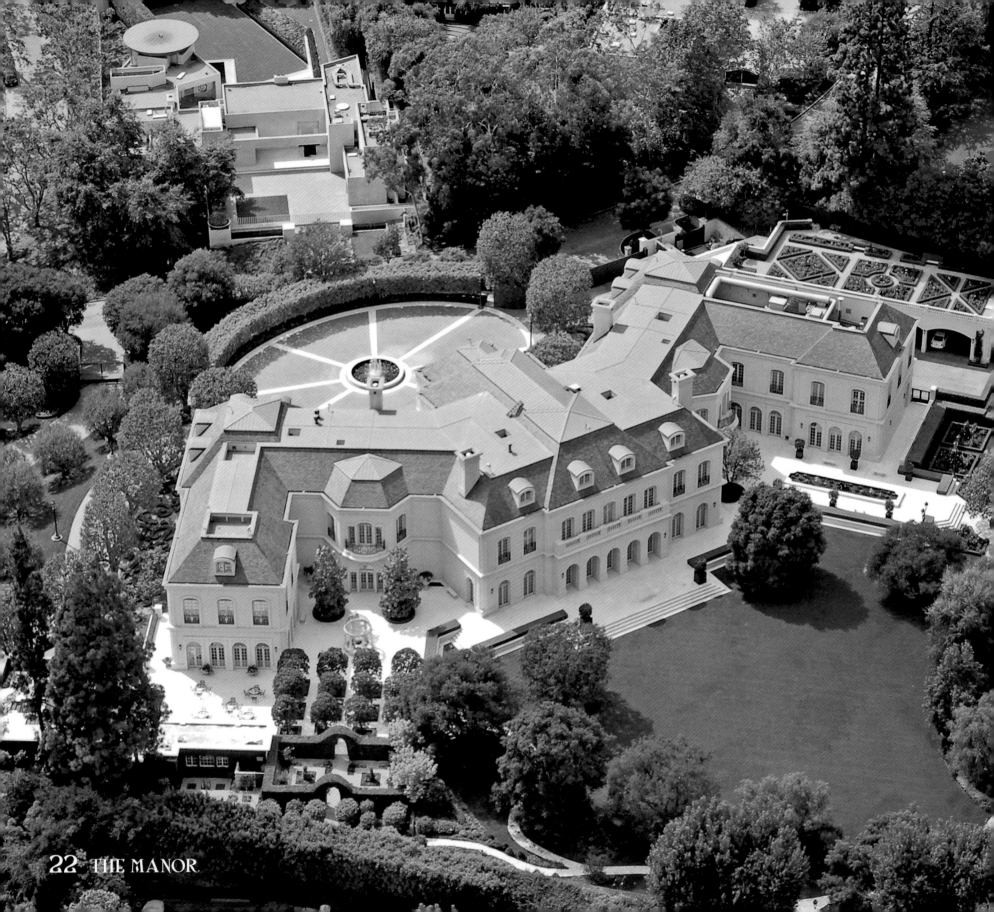

THE MANOR
1988–1990

LOCATION: Los Angeles, CA
ARCHITECT: James Langenheim & Associates
STYLE: French Chateau Revival

The 56,000-square-foot mansion built for television producer Aaron Spelling makes the surrounding huge estates in the Holmby Hills area of Los Angeles County look like bungalows.

In fact, during construction of the estate, an editor of the *Los Angeles Times* questioned the need for such an ostentatious residence. Spelling purchased the property and had a mansion once owned by Bing Crosby razed to make way for his much larger estate.

The two-story home, located on five acres, cost Spelling $12 million to build. It included a screening room, an arcade, a bowling alley, a gym, tennis court, two pools, a rooftop rose-garden, and at least one special room just for wrapping presents. Spelling's wife, Candy, once said she sometimes wrapped at least 900 presents for all of the actors and behind-the-scenes workers on her husband's various television shows.

All in all, the house has at least 123 rooms.

In 2011, five years after her husband's death, Candy Spelling sold the private residence to Petra Stunt, the daughter of business tycoon Bernie Ecclestone. Stunt was 22 years old when she bought the home for $85 million; several years after renovating the home's interior, she put it on the market. As of this writing, it was reportedly for sale for $175 million, reduced from $200 million.

Although some might consider the mansion overindulgent, it should be noted that Candy Spelling is a philanthropist offering her time and funds to programs that benefit children and animals, among other causes.

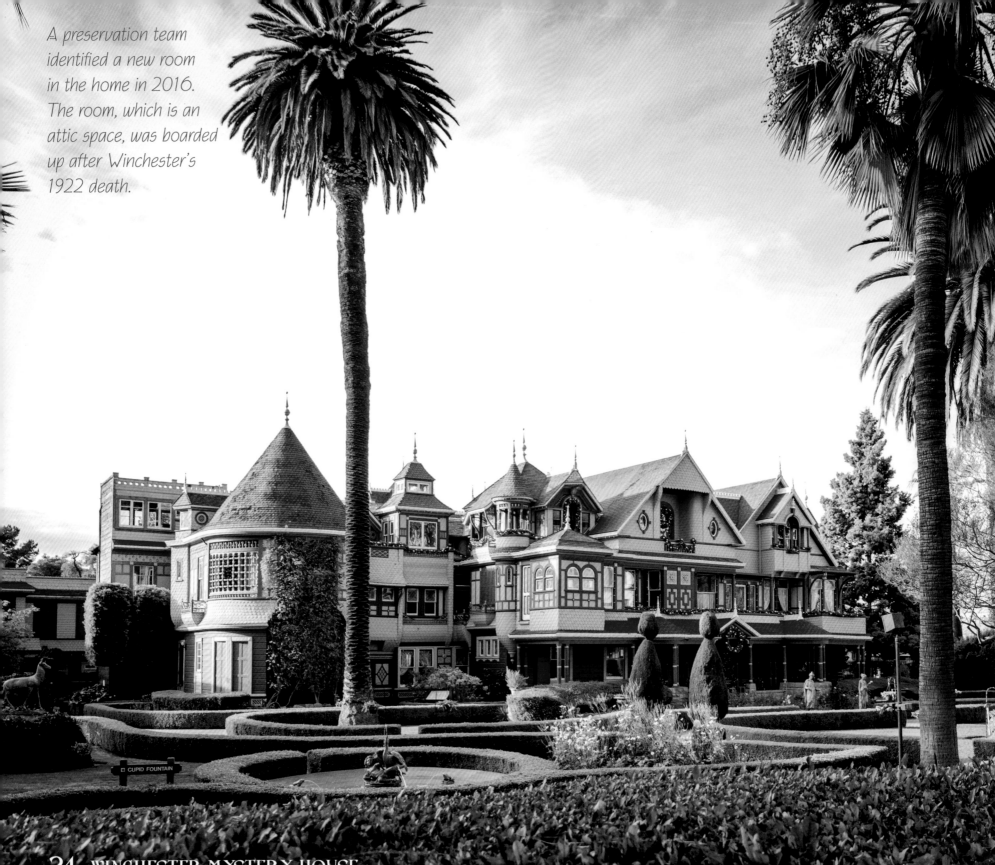

A preservation team identified a new room in the home in 2016. The room, which is an attic space, was boarded up after Winchester's 1922 death.

☐ CUPID FOUNTAIN

WINCHESTER MYSTERY HOUSE

1884

LOCATION: San Jose, CA
ARCHITECT: Unknown
STYLE: Queen Anne Style Victorian

At first glance, the Winchester Mystery House in San Jose, California, may appear to be a typical Queen Anne Victorian style home. But inside the 24,000-square-foot mansion, built without an architect and no master plan, is a mysterious interior that some claim is haunted.

Some of the doors and stairs to the 161-room home lead to nowhere. Spider web motifs and the No. 13 were used in various ways throughout the house. These oddities were said to deter spirits of humans who were killed by the Winchester rifles manufactured by William Wirt Winchester. After his death, his wife, Sarah

Winchester, bought an unfinished farmhouse in California in 1884 reportedly to provide a home for the spirits.

This home is a designated California historical landmark, listed on the National Register of Historic Places and open for public tours. Though the house is mostly made of redwood, Winchester supposedly didn't like the way it looked and had the wood covered with more than 20,000 gallons of paint.

The home has 17 chimneys, two ballrooms, two basements, 47 fireplaces, 2,000 doors, 10,000 windows, and other opulent fix-

tures. The home survived collapse during a 1906 earthquake because it was built on a floating foundation.

Construction of the home continued on and off until Winchester's death in 1922. After that, renters opened the house to the public for tours. An investment firm now owns the mansion. The movie *Winchester* starring Helen Mirren as Sarah Winchester was released in 2018 and filmed on site. Some critics called the movie dull, but the story behind the Winchester Mystery House is anything but.

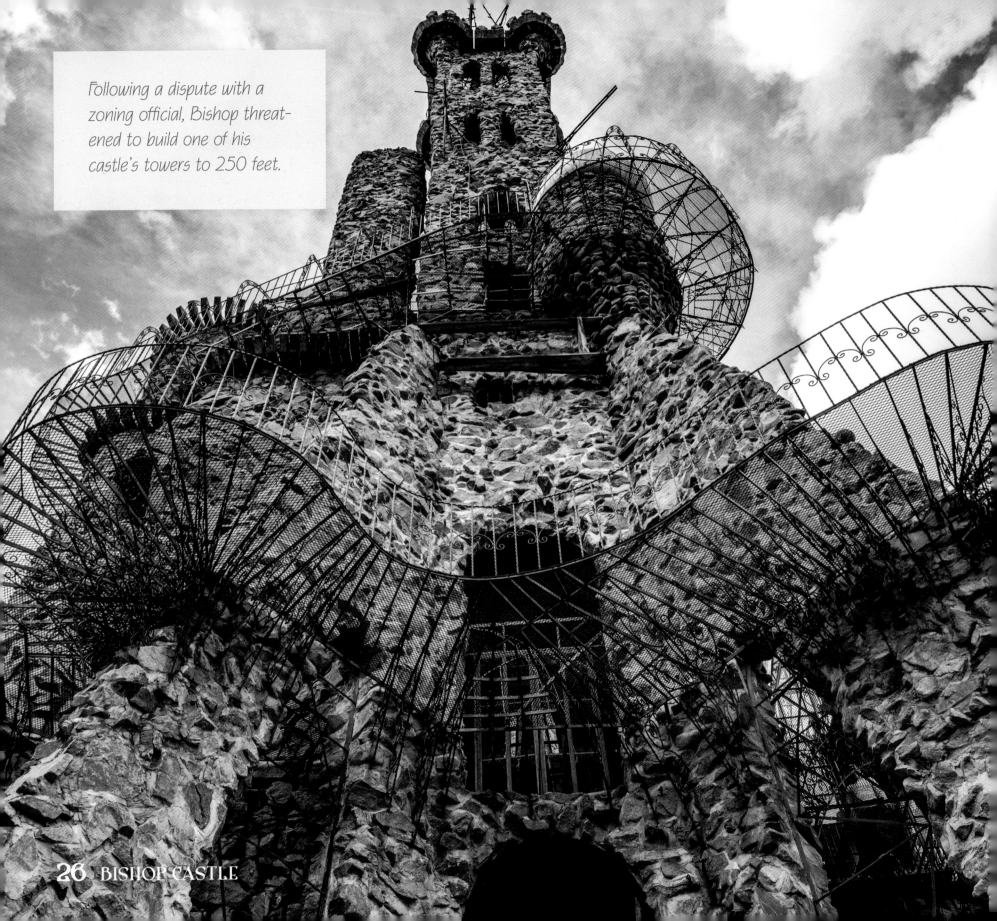

Following a dispute with a zoning official, Bishop threatened to build one of his castle's towers to 250 feet.

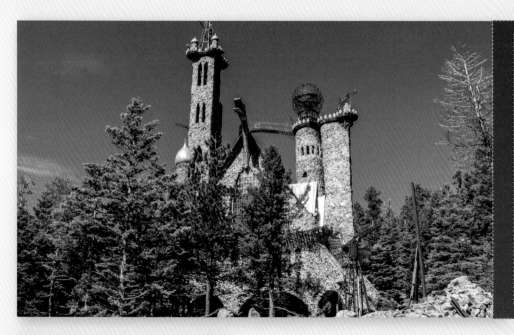

BISHOP CASTLE

1970-

LOCATION: *Wetmore, CO*
ARCHITECT: *Jim Bishop*
STYLE: *Modern Eclectic*

The story of Bishop Castle is one of perseverance and a can-do-attitude. Located at 9,000 feet within the San Isabel National Forest in Colorado, this home was conceived, designed, and built by one person—Jim Bishop, a man with definite stick-to-itiveness.

Beginning in about 1969, Bishop transported 1,000 tons of rock to his property to create what he thought would be a cabin, but it then turned into a stone and iron castle with a glass roof.

Bishop called it a monument to hardworking people.

Visitors are welcome to explore the grounds and castle. What they'll find is a castle reminiscent of Harry Potter's Hogwarts School with towers rising to the sky; winding, outdoor stairways; and a steel dragon sculpture on the roof. The indoors contain three stories of rooms, including the grand ballroom and arched windows from which spectacular views can be had.

Bishop pretty much did it all himself. He worked with his father in an iron shop and knew how to weld, perform millinery work, and fit objects together. His wife, Phoebe, whom he married in 1969, supported his dream.

The only plans or blueprints he used were from drawings contained within a book he wrote entitled *Castle Building from my point of view.*

Bishop even built a dragon sculpture atop the roof from stainless steel warming plates destined for the landfill. He also installed a burner from a hot air balloon to make it appear as if the dragon was breathing fire. As of 2021, Bishop was still working on his castle.

DEATON SCULPTURED HOUSE
1963

LOCATION: Golden, CO
ARCHITECT: Charles Deaton
STYLE: Modernism, Expressionism

Famously featured in Woody Allen's 1973 film *Sleeper*, the Deaton Sculptured House is a futuristic-looking, spaceship-like, clamshell-shaped oddity that happens to be one of Colorado's most famous homes.

Nestled on the side of Genesee Mountain overlooking Interstate 70, the four-bedroom, 7,700-square-foot home is an unusual structure.

Charles Deaton, who was first an aircraft engineer before he became an architect, began construction on the house in 1963. He famously opined that people shouldn't live in boxes, calling his house an "act of freedom." Deaton said he wanted the house to "sing an encumbered song." Unfortunately, Deaton was unable to complete the house due to financial difficulties.

Following its appearance in Allen's film, the home laid empty for years (absent periodic visits from animals and vandals). A second owner purchased the property for $800,000 in 1991 and, like Deaton, never lived in the burdensome home. One possible reason: the house, according to one property appraiser, is the "most unlivable thing you could imagine," thanks to its small round rooms, cupped walls, and curvature. It has more than 150 windows, is notoriously energy inefficient, and is, well, not particularly cozy. However, subsequent owners have made significant energy efficiency upgrades within the home, specifically the windows.

In 1999, technology consultant John Huggins purchased the home for $1.3 million and spent two years restoring it. He attempted to sell the home in 2002 but was unable to sell it until 2006. The house was purchased again in November 2010.

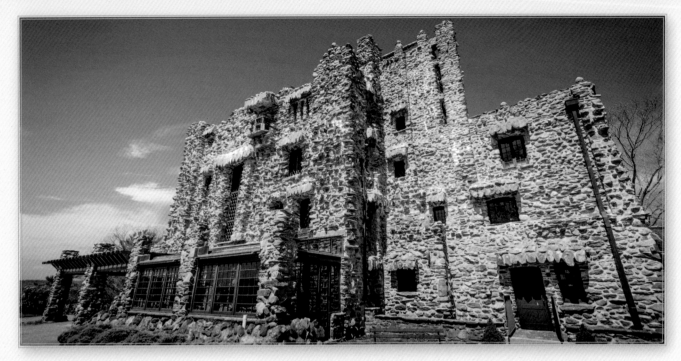

With its whitish-gray fieldstone exterior, the 14,000-square-foot Gillette Castle looks like a medieval mansion straight out of a fairy tale. The man who designed it and lived in it took great pains to give it that look.

That man—William Hooker Gillette— hired 25 men to create a steel framework upon which they'd use local fieldstone. A multitude of mysteries are featured indoors— all designed by Gillette, well-known for his portrayal of Sherlock Holmes.

Gillette admired the Seven Sisters chain of mountains along the Connecticut River, and he decided to build his retirement home there. He designed 47 doors, each with a different look and intricately carved latch.

Myriad oddities can be found inside. For example, Gillette built a secret door from which he would emerge as visitors entered a dark room. A great hall features mirrors placed so Gillette could see, from his bedroom, the guests that were arriving and play harmless pranks on them. Secret doors and passageways are also part of the intrigue. After Gillette's death, the state of Connecticut purchased the home and some 180 acres, including walking paths and stone arch bridges that Gillette had built. More than 300,000 visitors annually come to view the fairy tale-like castle and surroundings now called Gillette Castle State Park. It's open for tours during the warm months and is listed on the U.S. National Register of Historic Places.

Gillette used hand-hewn white oak for the interior woodwork of the 24-room home.

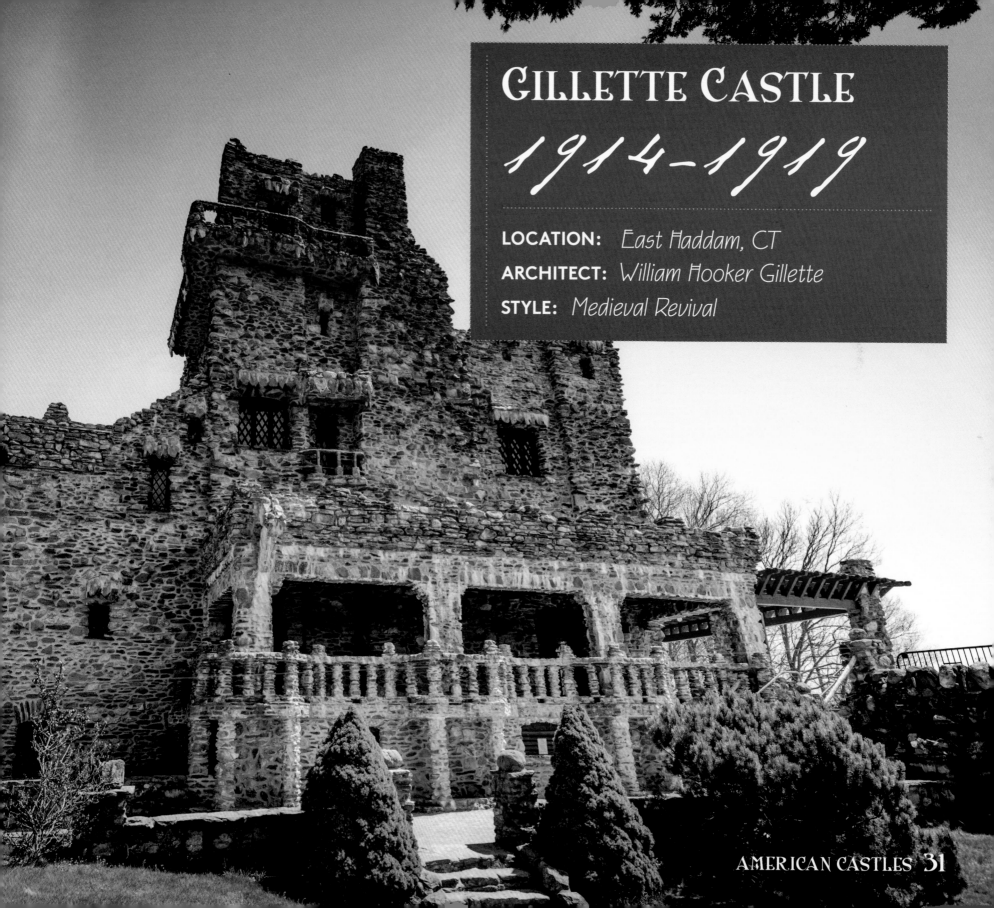

GILLETTE CASTLE
1914–1919

LOCATION: East Haddam, CT
ARCHITECT: William Hooker Gillette
STYLE: Medieval Revival

THE GLASS HOUSE
1948-1949

LOCATION: New Canaan, CT
ARCHITECT: Philip Johnson
STYLE: Modernism

Philip Johnson

Johnson lived in the Glass House from its 1949 completion until his death in 2005.

Behind a stone wall and hidden from the street stands a home on the National Register of Historic Places with walls made entirely of glass.

Many have said its designer and owner, Philip Johnson, patterned his home after famous architect Mies van der Rohe's glass Farnsworth House. Johnson was a curator of a van der Rohe exhibit that featured a Farnsworth House model.

Some critics have said that the Johnson Glass House is not as architecturally brilliant as the Farnsworth House, and van der Rohe reportedly was upset when Johnson finished his house first. Nonetheless, the Johnson House, now owned by the National Trust for Historic Preservation and open for public tours, has long been lauded as a remarkable example of minimalist modern architecture. One architecture critic said the Glass House brought modern architecture into the eyes of the everyday public.

Johnson designed and built the home in 1948. A mere 10.5 feet tall, 56 feet long, and 32 feet wide, the house is basically one glass-enclosed room with kitchen, dining, and sleeping spaces. The glass is held up by black painted steel, and the steel ceiling is also painted black.

Over the years, Johnson built 13 modern structures—including a brick guest house, painting gallery, sculpture gallery, and library—on his 47-acre property. Some of these buildings were not suitable for living; for example, what Johnson called the Ghost House features a chain-link fence around an old barn foundation.

Johnson's longtime companion, David Whitney, helped to design the landscaping and collect art for the various galleries.

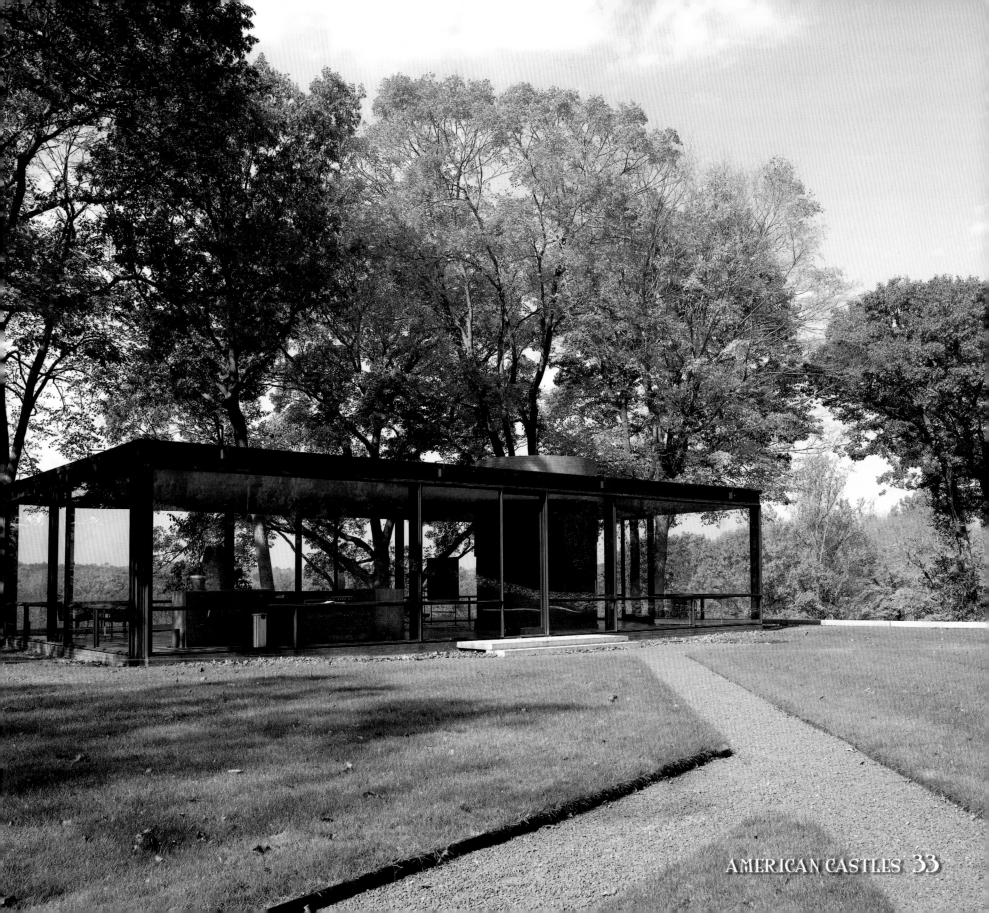

ERNEST HEMINGWAY HOUSE

1851

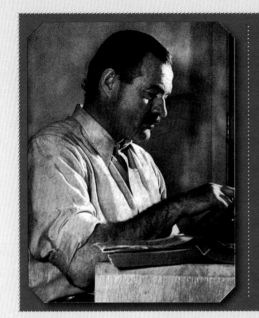

LOCATION: Key West, FL

ARCHITECT: Asa F. Tift

STYLE: Spanish Colonial

Ernest Hemingway

The home and writing space of one of America's most celebrated writers, Key West's Ernest Hemingway House is a Spanish Colonial treasure. Completed in 1851 by Connecticut-born merchant Asa F. Tift, this two-story rectangular home is made of coral rock quarried on site. Its features include a two-story veranda, sweeping French doors, a stucco exterior, a wrought iron balustrade, a spacious living room and master bedroom, a full basement, and plentiful porches.

Tift died in 1889, and the house—one of Key West's oldest buildings—had several owners after his death. Hemingway and his wife Pauline family paid $8,000 for the house in April 1931 and moved in right before Christmas. But when the Hemingways first examined the house, it had a host of problems, including a leaking roof and crumbling plaster. The couple would make a number of renovations to the home, including joining the kitchen with the main house; raising kitchen counters; and adding a catwalk to join the second-floor master bedroom to the carriage house. They also installed a swimming pool on the property, the first such addition to a home in Key West at that time.

Hemingway was extremely prolific at the house, where he wrote about 14 novels and short stories. He lived in the colonial with Pauline until their separation in 1940. In 1961, after Hemingway's death, Jack and Bernice Daniel purchased the home. The house became a museum in February 1964, and it was added to the National Register of Historic Places in 1968. Today, the home regularly sees hundreds of daily visitors, and it is also home to dozens of cats (most of whom are descended from Hemingway's six-toed cat).

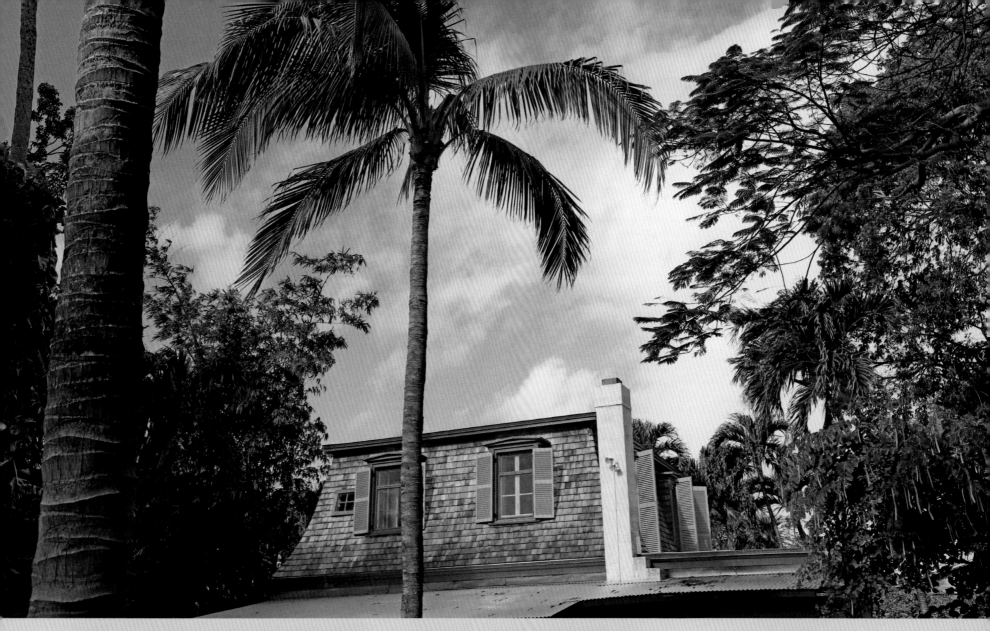

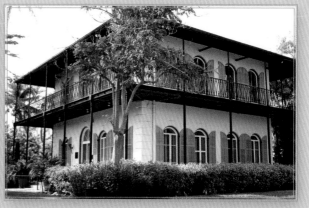

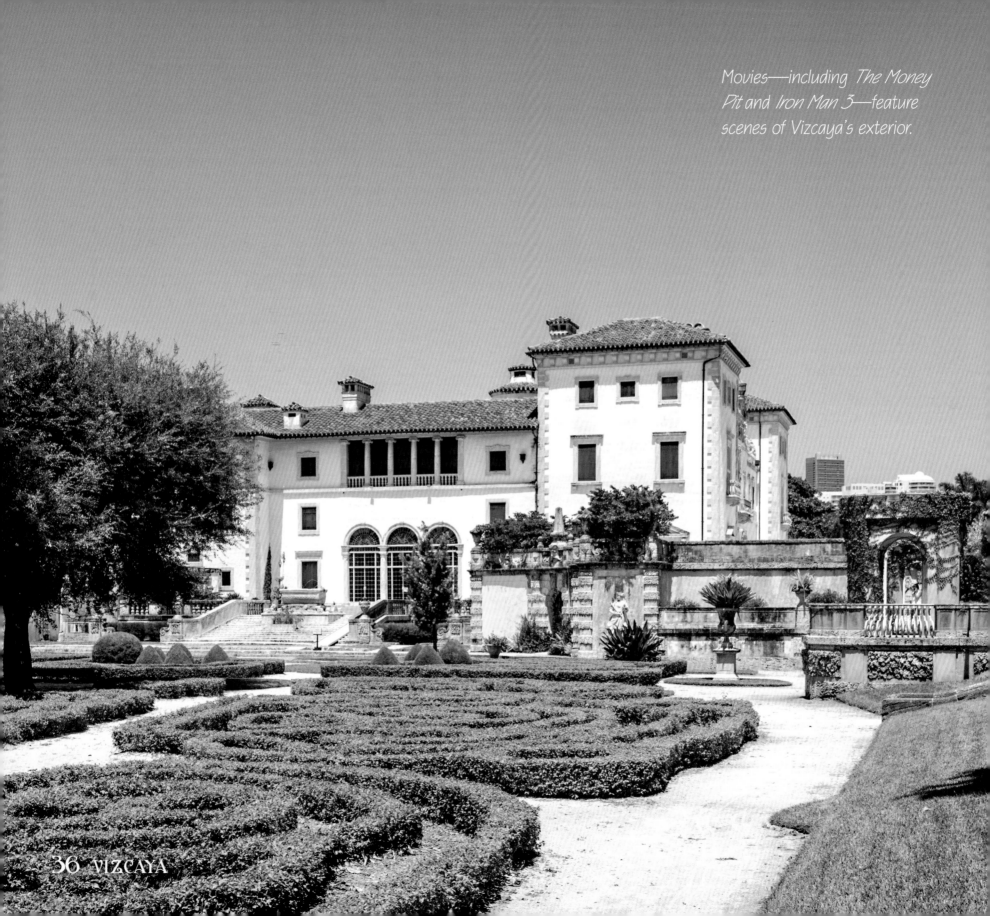

Movies—including *The Money Pit* and *Iron Man 3*—feature scenes of Vizcaya's exterior.

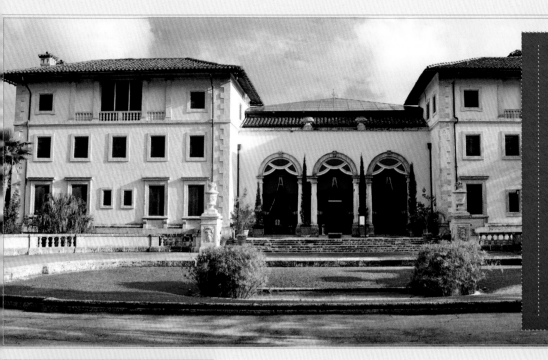

VIZCAYA
1914-1922

LOCATION: Miami, FL

ARCHITECT: F. Burral Hoffman

STYLE: Mediterranean Revival

Business tycoon James Deering purchased more than 100 acres of native mangroves and inland forests in Miami where he built an estate known as Villa Vizcaya. Deering had the villa built along the Biscayne Bay shoreline to protect the native vegetation.

The villa and surrounding formal gardens and lagoons reflect the melding of European architecture with subtropical south Florida. Some examples include French and Italian garden layouts with limestone from Cuba and coral trim.

Deering also selected native Florida plants like palms and philodendrons for his gardens. Vizcaya is the name of a province in northern Spain, but the name also could reflect a legendary Spaniard named Vizcaya who was said to have explored the south Florida region.

Deering spent winters at Vizcaya from 1916 until his death in 1925. The estate passed hands several times until Miami-Dade County purchased it in 1952 and worked on its restoration. Now called the Vizcaya Museum and Gardens, it is open to the public and is designated as a National Historical Landmark.

The home, which is today a museum, contains 70 rooms with varying architectural components. It features many antiques, especially from the fifteenth through nineteenth centuries. In 2008, the National Trust for Historic Preservation named Vizcaya one of America's 11 most endangered historic places.

THE MERCER-WILLIAMS HOUSE
1860–1868

LOCATION: Savannah, GA
ARCHITECT: John S. Norris
STYLE: Italianate

The Mercer-Williams House achieved dubious fame when it was used in much of the filming of the movie *Midnight in the Garden of Good and Evil*, which was based on a 1994 book by John Berendt.

Though tours of the home don't focus on the alleged murder, eventually exonerating the accused, it's easy to get caught up in the intrigue, especially noting its storied history.

Confederate Army General Hugh W. Mercer commissioned John S. Norris to design the 7,000-square-foot red brick home in Savannah before the Civil War. Construction began in 1860 but was interrupted when Mercer enlisted. Confederate soldiers were said to have used materials from the construction site to build shelters nearby during the war.

Reports note that Mercer spent some time in prison after the war. He never returned to his home; instead, he sold it to John Wilder, who had construction of the mansion completed. It features intricately designed iron balconies, tall doorways, and arched windows—a reflection of the Italianate Victorian era and southern U.S. style.

Falling in disrepair, the home was finally purchased by restoration professional and antiques dealer Jim Williams in 1969. Williams restored the home, now open for public tours, and of this writing, the home is owned by his sister. She reportedly doesn't talk much about her brother being accused of shooting Danny Hartsford, his assistant, in 1981. Williams was acquitted after four trials.

The interior is decorated with eighteenth and nineteenth century furnishings, American paintings, Chinese porcelain, and crystal candlesticks supposedly once owned by Martha Washington.

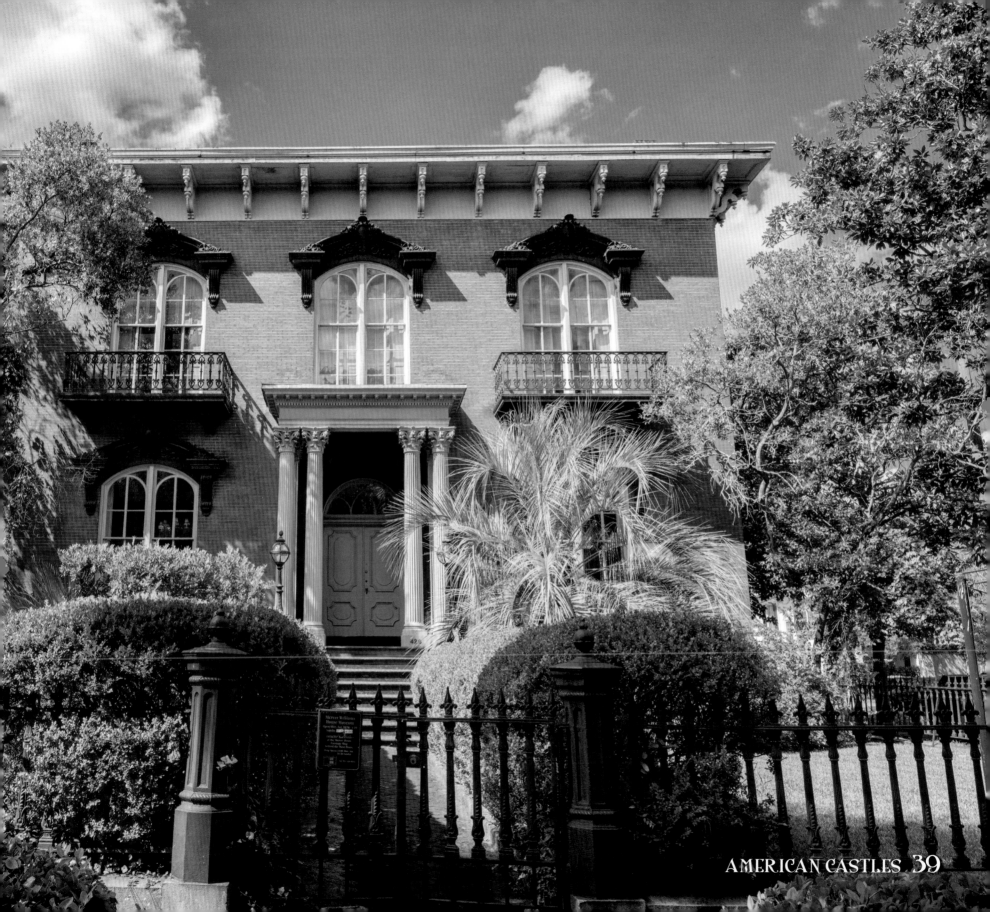

Iolani Palace
1879–1882

LOCATION: Honolulu, HI

ARCHITECT: Thomas J. Baker, Charles J. Wall, Isaac Moore

STYLE: American Florentine

Once the residence of Hawaiian monarchy, Iolani Palace is often seen today as the fictional police headquarters of the original and rebooted *Hawaii Five-O* television series.

But its story starts way before then. In 1845, a wooden house was built for Hawaiian royalty on the site where Iolani Palace is located today—and that was its name even back then. It was torn down when a new king Kalākaua was crowned in 1874. Kalākaua commissioned several architects to design a home based on the palaces he saw while visiting Europe.

The unique design is a cross between Italian Renaissance and Hawaiian architecture. Built of brick and concrete, the mansion features six towers, two of them roofed with verandas. It was equipped with the most modern conveniences of the time, including indoor plumbing, electricity, and a telephone.

Kalākaua and his Queen Kapi'olani moved into the place in 1882. Six years after the king died, the queen was forced to relinquish her throne and later was placed under house arrest with no visitors. A new government took over the palace.

Officials eventually moved into a new building next door as the palace began to deteriorate. In the 1970s, the Friends of Iolani Palace restored the building to its nineteenth century opulence. In 1978, it was opened to the public. Today, visitors can wander the palace grounds where ritualistic worship ceremonies once took place and admire the pavilion where Kalākaua and Kapi'olani were crowned. Indoors, the public can see the room where the queen was held under arrest as well as the grand ballroom where hulas were often performed.

The American Florentine style palace cost about $360,000 to complete.

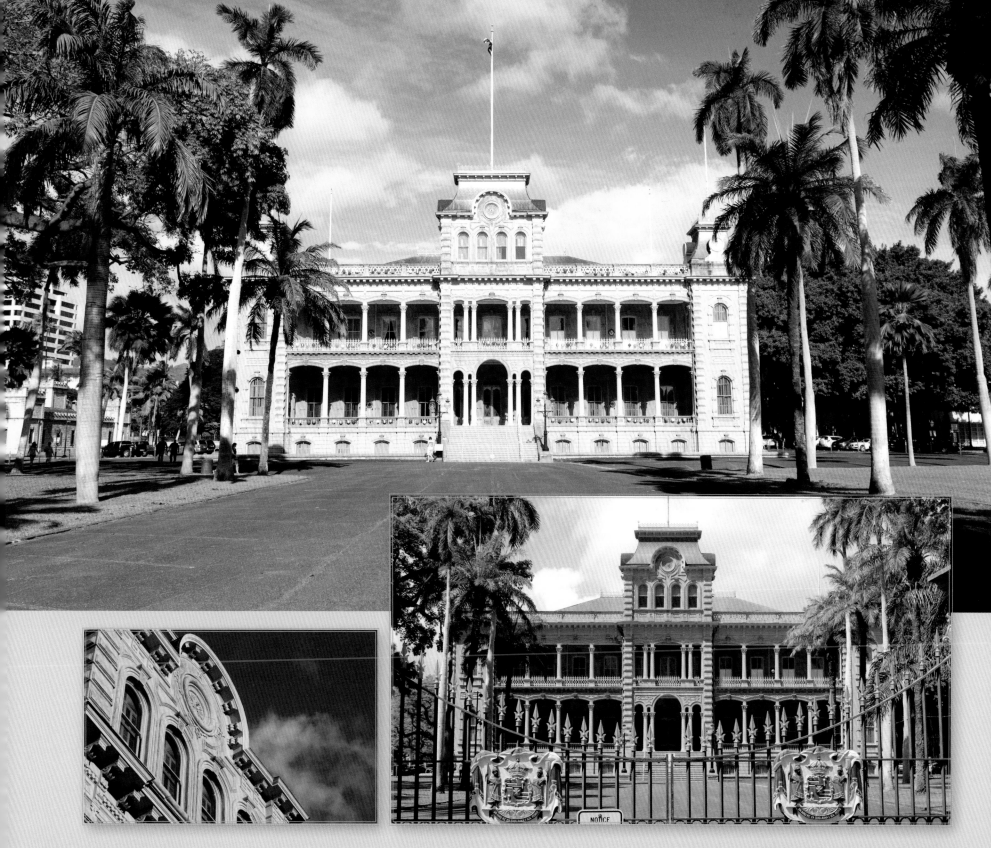

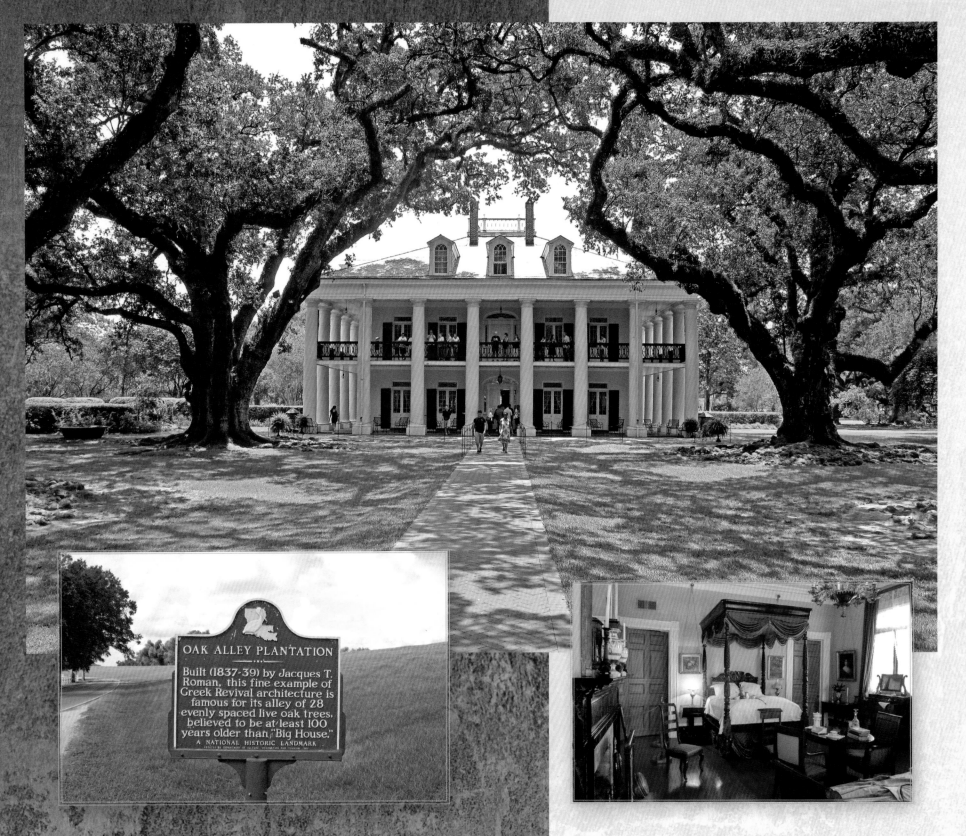

OAK ALLEY PLANTATION

Built (1837-39) by Jacques T.
Roman, this fine example of
Greek Revival architecture is
famous for its alley of 28
evenly spaced live oak trees,
believed to be at least 100
years older than "Big House."

A NATIONAL HISTORIC LANDMARK

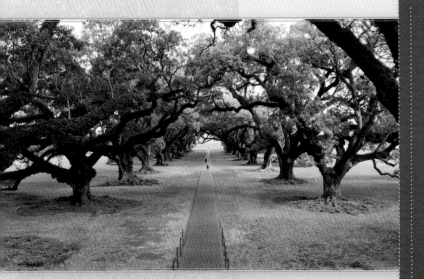

OAK ALLEY PLANTATION
1837–1839

LOCATION: Vacherie, LA
ARCHITECT: Joseph Pilie and Richard Koch
STYLE: Greek Revival

Built entirely by slaves in 1839, the Oak Alley Plantation on the west bank of the Mississippi River in Louisiana stands as a reminder of pre- and post-Civil War history in the south. Landowner Jacques Roman is said to have enlisted his father-in-law and architect Joseph Pilie to design the mansion known as the big house, which was built of bricks made on the site.

The mansion features 28 Greek-style columns on all four sides to represent 28 southern live oak trees on the property. The trees were planted in an avenue between the home and river in the eighteenth century. To simulate marble, the stucco exterior was painted white. Hallmarks of the mansion include huge windows and high ceilings.

Roman and his wife, known as Celina, were said to have had up to 120 slaves, some of whom worked up to 18 hours in the sugarcane fields each day. Other slaves worked in the home caring for children, cooking, and cleaning. If they couldn't fulfill certain indoor duties, they were sent to the fields.

The estate became impossible to maintain after the war and was eventually auctioned off and purchased by Andrew and Josephine Stewart. The Stewarts commissioned architect Richard Koch to restore the home. Today, the home is part of the National Register of Historic Places.

In 1966, Josephine Stewart established the Oak Valley Foundation to offer visitors a chance to learn about life in the south before, during, and immediately after the Civil War.

SOTTERLEY PLANTATION

1703

LOCATION: Hollywood, MD

ARCHITECT: None

STYLE: Colonial

Overlooking the Patuxent River in Maryland is a plantation house built with a wooden shingle roof and clapboard siding. Nearby is a single-room log house, built circa 1830. These two buildings, now registered as a National Historic Landmark, reveal stories of those living on an eighteenth and nineteenth century plantation.

At least four families owned the property known as Sotterley Plantation, starting with the Bowles in 1699. John Bowles built a two-room house and raised crops on his 2,000-acre property. In 1720, he purchased more than 200 slaves and trafficked them to various landowners.

Other owners came along also running a plantation with slaves. The home survived the Civil War, and other structures were added on the property after 1865. It's architecturally significant because the home's oldest sections—an in-ground structure and the original slave cabin—remain intact.

The home's last private owner opened the site to the public working with the Society for the Preservation of Maryland Antiquities. The Sotterley Mansion Foundation owns the 95-acre property, which is managed by the nonprofit Historic Sotterley, Inc. Stories about slaves living and working on the plantation were scarcely mentioned during tours even in the 2000s.

But in 2017, the one-room wooden slave cabin was open to the public. On that day, officials honored a woman who was a descendant of one of the slaves who lived

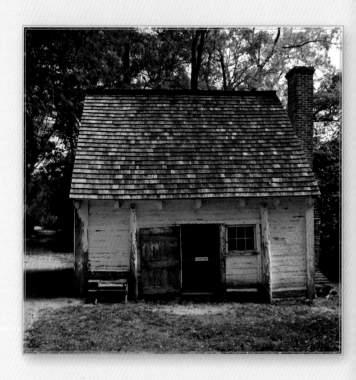

there; she yearned for the cabin to be open to visitors. Today, Sotterley's vision includes exploring "America's complex history and legacy of slavery."

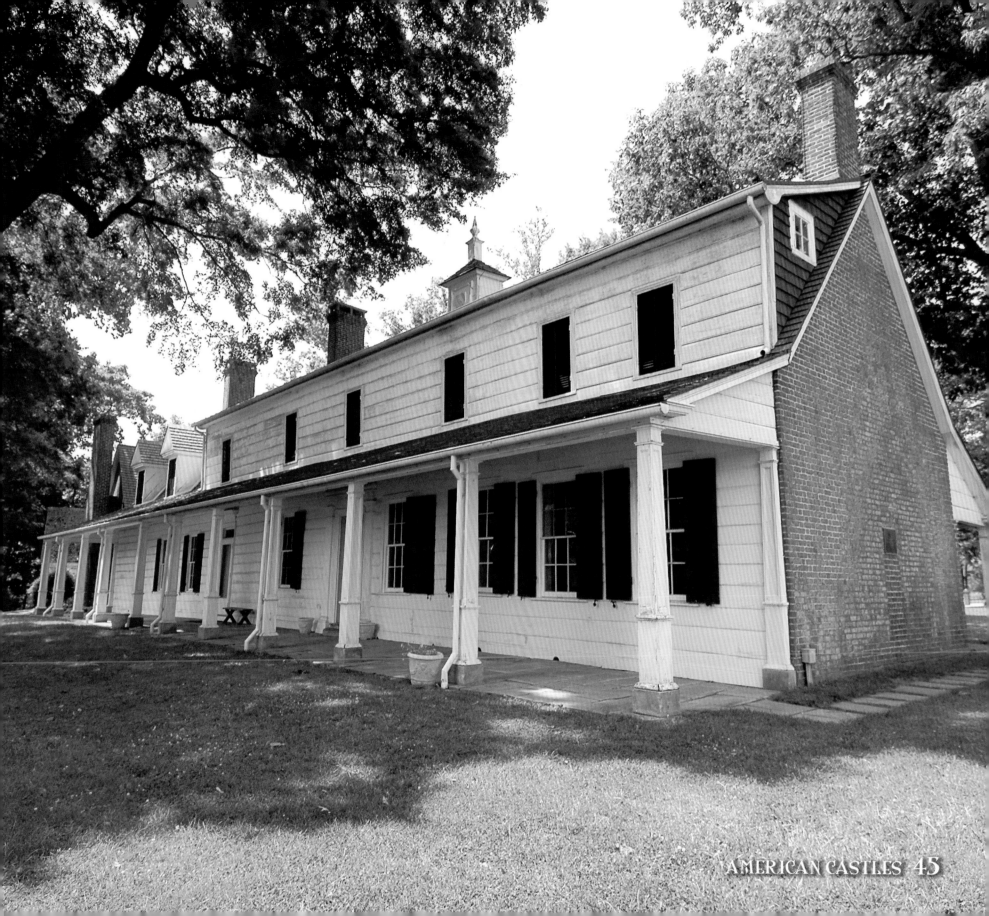

CASTLE HILL
1928

LOCATION: *Ipswich, MA*
ARCHITECT: *David Adler*
STYLE: *Stuart-Style English Manor*

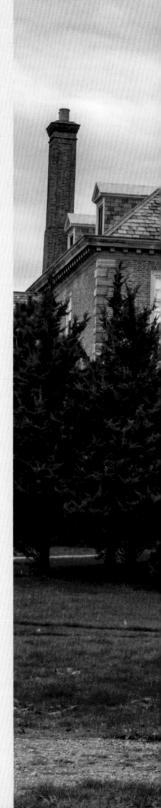

In the early 1900s, wealthy businessman Richard Crane purchased property atop the hill overlooking the Atlantic Ocean in Massachusetts. He hired the well-known Olmsted brothers to design the landscape and the architectural firm of Shepley, Rutan and Coolidge to design an Italian Renaissance-style mansion.

Crane's wife didn't like the house, so 10 years later, Crane had it torn down and commissioned world-renowned architect David Adler to design a new mansion.

Adler created a 59-room manor with the building's façade modeled after seventeenth century Stuart style—a combination of baroque and Palladian architecture—which used classical forms.

Inside, English country house-style carvings are found in the library, while other interior rooms reflect the look of an eighteenth century townhouse. The bathrooms were designed in art deco style. Behind the home is an expansive lawn that overlooks the Atlantic Ocean; beautiful views can be seen in various places inside and around the manor, such as from second-floor porches and bay windows. Much of the Olmstead landscaping, containing terraced gardens and classical statues, was kept intact.

Today, the mansion is called the Great House, and along with the 165-acre estate known as Castle Hill, it's listed as a National Historic Landmark. The manor is also known as one of Adler's most shining projects.

The Cranes donated the beach and private dunes on their property to The Trustees of Reservations, and later, they also donated the mansion. The public can attend seasonal tours and concerts where jazz legends like Louis Armstrong and Ella Fitzgerald once performed. *The Witches of Eastwick*, starring Jack Nicholson and released in 1987, was filmed mostly on location at Castle Hill, which is also a favorite wedding destination.

HOUSE OF THE SEVEN GABLES

1667–1668

LOCATION: Salem, MA
ARCHITECT: Various
STYLE: Colonial and Georgian Revival

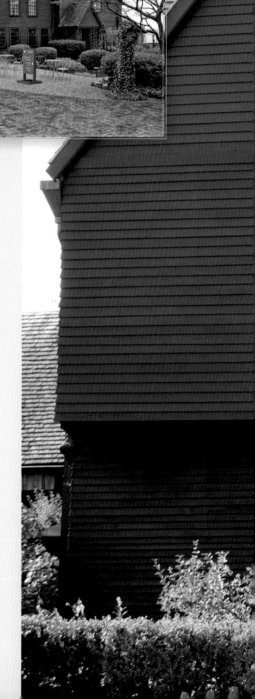

Made famous by author Nathaniel Hawthorne, the House of the Seven Gables stands next to a bay leading into the Atlantic Ocean, a testament to the families who earned sizeable sums from fishing and other businesses. Containing 17 rooms and more than 8,000 square feet, it's known as one of the oldest remaining wooden-framed mansions still resting on its original foundation in North America.

In 1667, Capt. John Turner had a two-story home with a front porch and huge chimney built on family property. Turner and his descendants continued to add onto the home, with John Turner II remodeling the home in the early eighteenth century to reflect a Georgian revival style that featured wooden panels and sash windows. Future owners further remodeled the home, removing the gables and adding more Georgian-style architecture.

Hawthorne wrote about the house with seven gables when only three remained, but he learned of its history and became inspired to write his novel of the same name in 1851. He considered the home to have a meditative spirit.

The founder of the House of the Seven Gables Settlement Association, Caroline Emmerton, bought the home in 1908 and hired an architect to restore it; refurbishment included the addition of gables to model the home to its original appearance.

The House of the Seven Gables turned 350 years old in 2018, and visitors can learn more about three centuries of its history and the people who lived there during public tours.

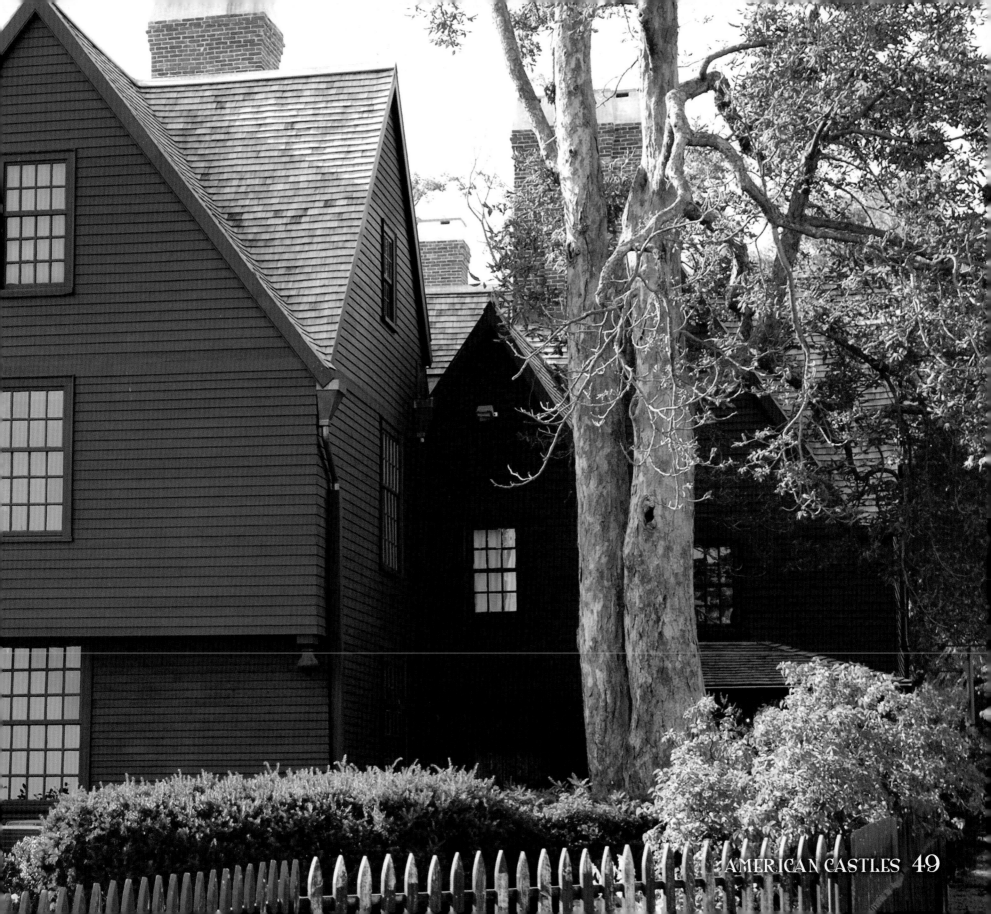

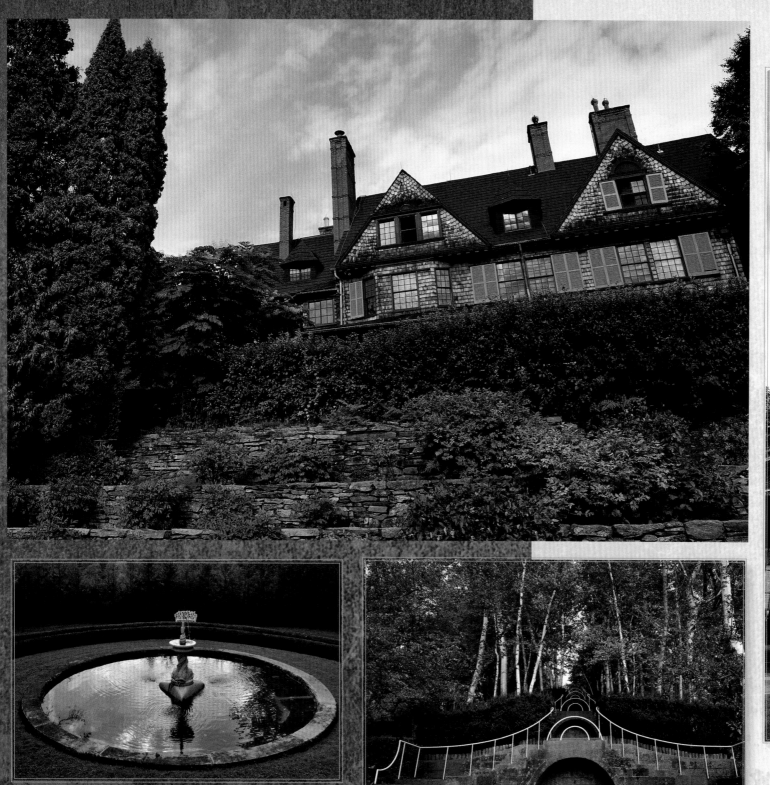

NAUMKEAG
1885–1886

LOCATION: Stockbridge, MA
ARCHITECT: McKim, Mead & White
STYLE: Shingle Style

Joseph Hodges Choate

Wanting an easier walkway from the lawn down to a flower garden, Mabel Choate, daughter of the first owners of Naumkeag, is responsible for having the famous Blue Steps designed.

But it's more than the Blue Steps, one of the most photographed gardens in the U.S., that beckon visitors to this 44-room shingle-style home. The mansion is a representation of the Gilded Age, which featured substantial homes built by well-to-do New Englanders.

New York City attorney Joseph Hodges Choate and his wife had Naumkeag built as a summer retreat. Naumkeag is the Native American name given to the Salem area where Joseph Choate was born.

At the time of its building, the shingle architectural style was new, and the architects combined it with European styles to create a brick and stone exterior with Victorian gardens. Inside, the home has a hand-carved oak staircase; brass and silver fixtures; and cherry, oak, and mahogany woodwork. The home also features 14 fireplaces and nine bathrooms, and it was said to have been visited by President William McKinley.

The Choates' daughter, Mabel, inherited the estate in 1929 and hired well-known landscape architect Fletcher Steel to recreate the gardens, adding new features such as a Chinese garden and the Blue Steps.

The public is welcome to walk the gardens and view the home's interior through scheduled tours.

THE MOUNT
1902

LOCATION: Lenox, MA
ARCHITECT: Edith Wharton, Francis L.V. Hoppin, Ogden Codman Jr., and Beatrix Jones Farrand
STYLE: Georgian Revival

Edith Wharton

The author of dozens of books, Edith Wharton was a prolific American writer. Born into an immensely wealthy family, Wharton mined her aristocratic background as she wrote about the Gilded Age. In 1921, she was the first woman awarded the Pulitzer Prize for Fiction.

Edith Wharton was not only a noteworthy American author in the early twentieth century, but she was also a gifted architect. Her country home, the Mount, was built in 1902 in Massachusetts, and it reflects her skill at design. Wharton worked with architects to create a home inspired by the seventeenth century Belton House in England. Located in the Berkshires, the estate, declared a National Historic Landmark, is open to the public.

The white stucco, green-shuttered, H-shaped home with 35 rooms was built on a hillside. The exterior and interior reflect Wharton's desire to combine the best of classical European architecture. Placed atop the roof are gables and a cupola. The grounds contain a French courtyard and an Italianate garden and terrace. Wharton's niece, Beatrix Jones Farrand (who was the only female of 11 founders of the American Society of Landscape Architects), designed the kitchen garden.

Today, more than 50,000 members of the public explore the property annually, learning about Wharton's legacy and the estate's design.

Interestingly, the Mount was once home to a school for girls who reported paranormal activities at the home. Similarly, Shakespearean actors who lived at the home reported unusual sightings, and professional ghost hunters documented mysterious footsteps and voices inside the home. Wharton, after all, wrote stories about ghosts, and she thought she was haunted by unfriendly spirits as a child.

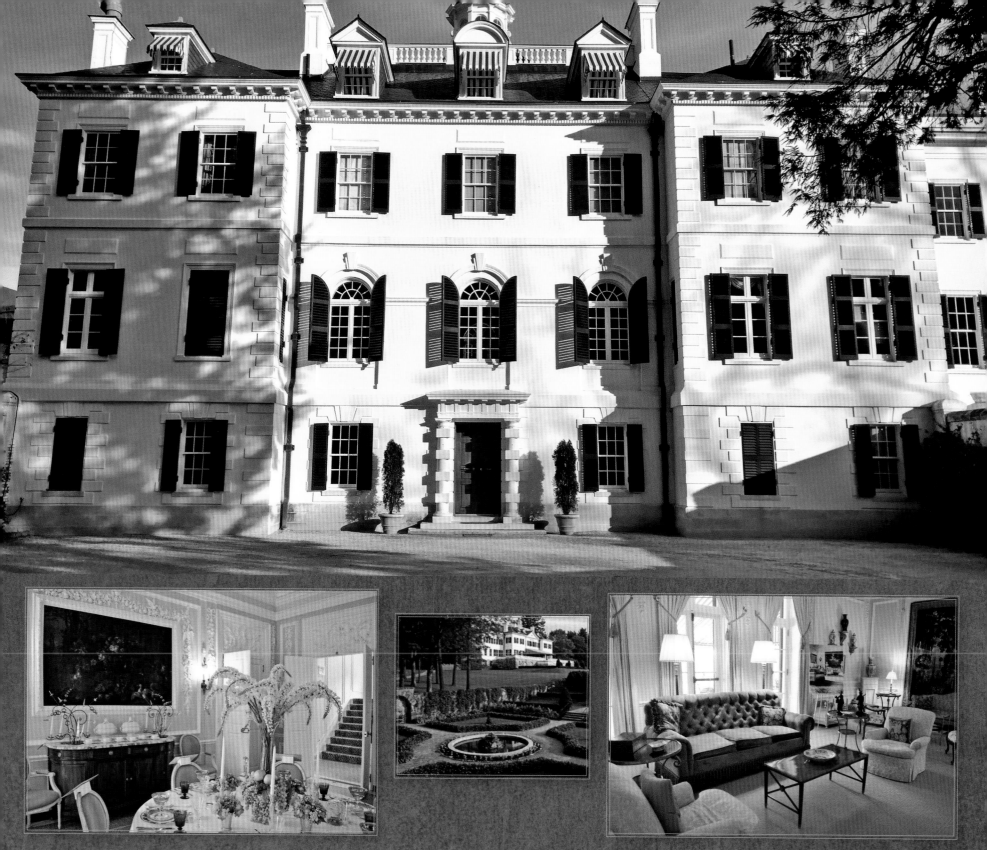

Alden B. Dow Home & Studio

1937-1940

LOCATION: *Midland, MI*

ARCHITECT: *Alden B. Dow*

STYLE: *Modernism*

The son of the founder of Dow Chemical, Alden B. Dow considered joining his father's company; instead, he followed his dream to become an architect.

Dow studied under Frank Lloyd Wright in 1933 and later went on to create his own style—a style that is on display at his 20,000-square-foot Alden B. Dow House. Awarded the Paris Prize for Residential Architecture in 1937, the Michigan house was one of 600-plus architectural projects that Dow worked on during his career.

Named a National Historic Landmark in 1989, the home is created with what is called Dow's unit block building system. Using rhomboid shapes, Dow fashioned cinder blocks of different sizes—which were used to create walls, terraces, and the stepping stones—that lead to the pond on his property.

The home has a green copper roof and geometrical shape that appears to be part of the landscape. Dow was often quoted as saying, "Gardens never end, and buildings never begin."

Dow was a devoted family man to his wife, Vada, and their three children. He also considered himself to be a philosopher.

The home has been said to appear as if it is rising out of the pond (a conference room set below the pond seems to float).

Prior to his death in 1983, Dow was named Michigan's only architect laureate.

Many examples of his architectural work can be found in Midland, Michigan, where the public can tour his home and studio.

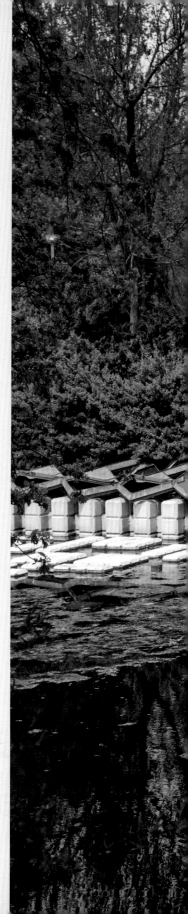

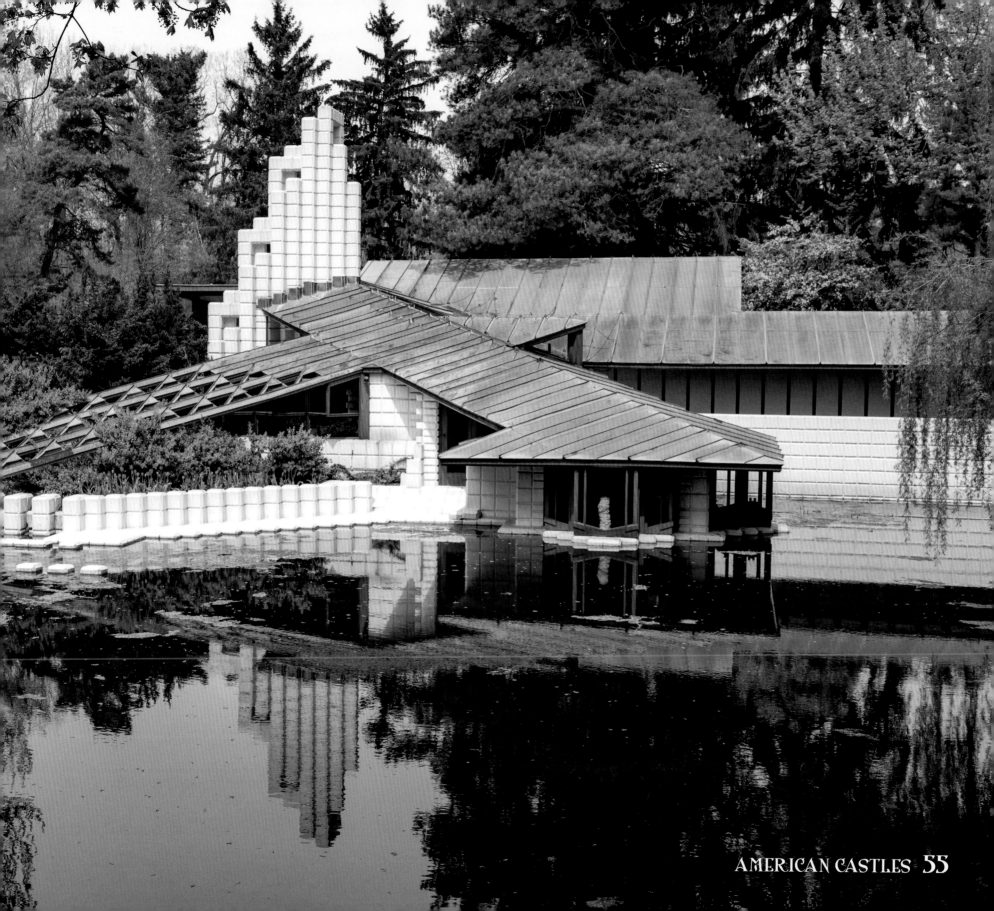

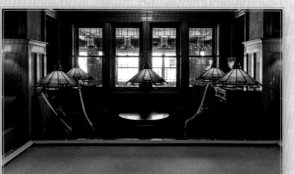

GLENSHEEN MANSION
1905–1908

LOCATION: Duluth, MN

ARCHITECT: Clarence H. Johnston Sr., Charles W. Leavitt Jr.

STYLE: Jacobean Revival

Chester and Clara Congdon were not only known for being one of the wealthiest families in the iron mining region of Duluth, but they also were philanthropists, setting aside land for the public, including what became the North Shore Scenic Highway.

The Congdons had their home built on the Lake Superior shoreline. The 27,000-square-foot mansion known as Glensheen has 39 rooms; it was built in Jacobean style, a style that often features light stone trim, high chimneys, and pillared porches. Glensheen means "shining glen," and it refers to a place in England where Chester's ancestors lived.

The Congdons hired landscape architect Charles Wellford Leavitt Jr. to create an outdoors that kept the natural surroundings intact. He also designed a greenhouse, vegetable garden, and orchard. The estate also included a gardener's cottage and a large boathouse along the lakeshore. The Congdons were known to have held lavish parties on the mansion's lawns.

The Congdons' youngest daughter, Elisabeth Congdon, lived in the home until her death in the late 1970s. Her adopted daughter's husband was convicted of murdering Elisabeth and her nurse in the home. Today, the University of Minnesota operates the home, which is listed on the National Register of Historical Places.

The university prefers not dwelling on the murder; instead, it promotes the legacy of the home and estate. Indeed, original furniture and other pieces remain in the same place in the house as when they were first brought inside more than 100 years ago. Public tours give visitors the chance to see those artifacts as well as Chester Congdon's collection of American artists' works.

THE JAMES J. HILL HOUSE

1891

LOCATION: Saint Paul, MN

ARCHITECT: Peabody, Stearns & Furber

STYLE: Richardsonian-Romanesque

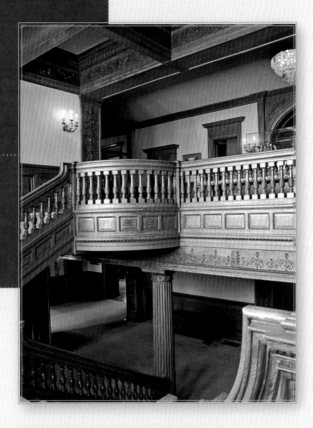

James J. Hill approached his home with the same rigor and grandiose style as he did building railroads like the Great Northern Railway.

Hill hired the firm of Peabody, Stearns & Furber to build a monumental mansion in 1891, which is located near the Cathedral of Saint Paul in Minnesota.

He oversaw the construction and furnishing of the mansion on a bluff overlooking the Mississippi River every step of the way. For example, he told architects not to use Tiffany stained glass windows as they had planned and eventually fired them, having someone else complete the design and building.

The 36,000-square-foot, five-floor home contains 13 bathrooms, 22 fireplaces, and 16 glass chandeliers. Round arches and stone facades on the exterior point to Hill's chosen style of Richardsonian-Romanesque.

Hill also had a three-story pipe organ installed as well as a complicated central system for heating, lighting, water, and security.

Hill and his wife, Mary, were married for 49 years and raised 10 children in the mansion; today, the home is a National Historic Landmark.

The home was used by the Catholic Archdiocese of St. Paul for nearly 50 years as a school, church, and office. In 1978, the Minnesota Historical Society became the owner of the mansion, which is open for public tours and other events. In 2018, the society restored the organ containing 1,006 pipes, and it's considered a prime example of residential organs constructed during the Gilded Age.

The home's fourth floor contains a grand piano, gym equipment, and a stage with room for 200 people.

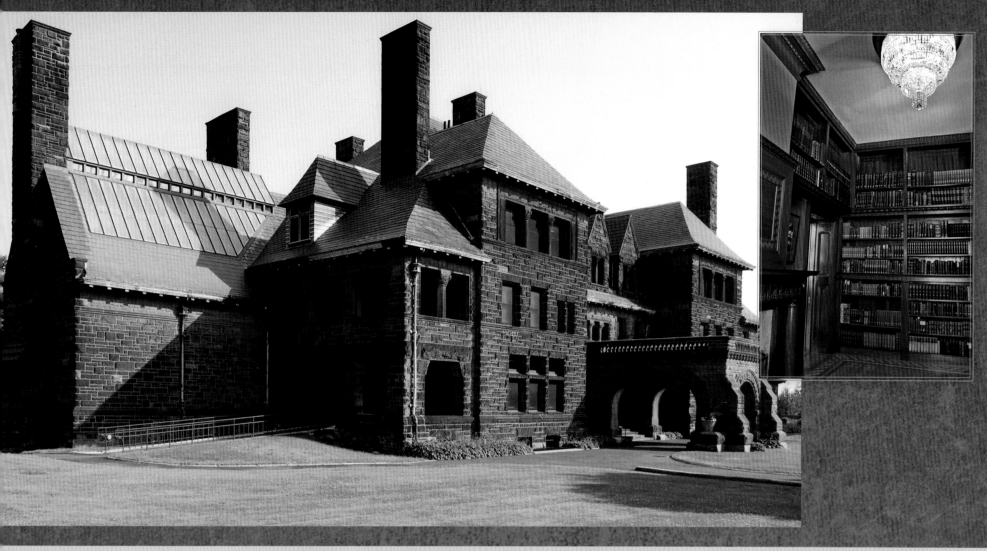

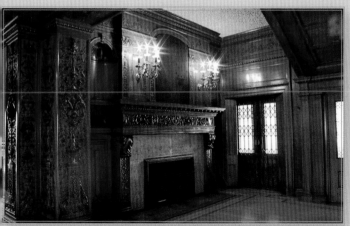

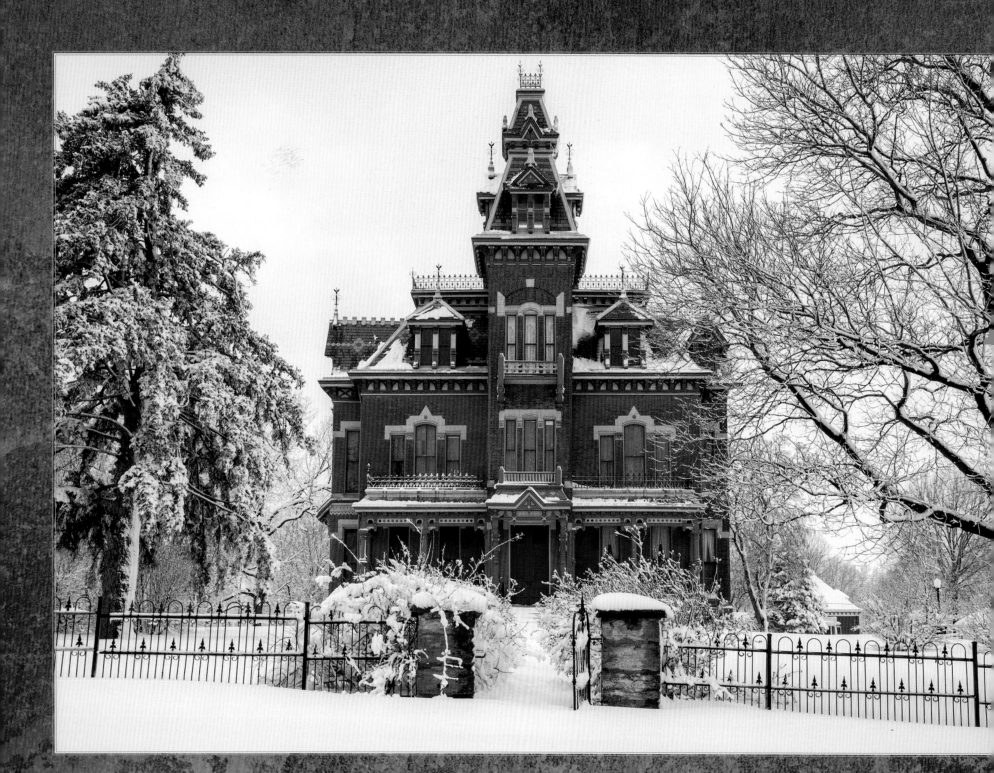

VAILE MANSION

1881

LOCATION: *Independence, MO*

ARCHITECT: *Asa B. Cross*

STYLE: *Second Empire*

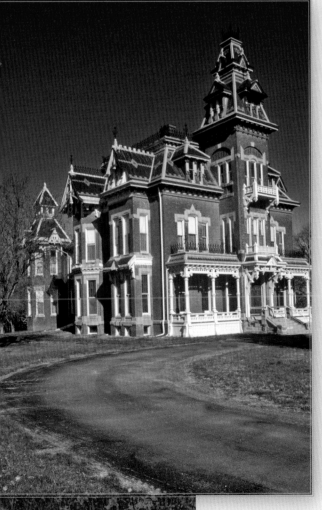

Considered among the best examples of Second Empire style architecture in the U.S., the Vaile Mansion was built in 1881 for Harvey and Sophia Vaile. The style refers to the use of mansard roofs and other architectural designs that were popular during the time of Napoleon III in France.

The Vaile Mansion exterior was made of hand-pressed red brick trimmed with limestone; it also includes narrow 120-foot-tall windows, bracketed cornices, and a one-story porch.

The 31-room interior features a black walnut grand staircase, nine fireplaces with mantles made of hand-carved Italian marble, painted ceilings, and a huge wine cellar. Two chandeliers in the home reportedly were at one time meant to hang in the White House. The kitchen was ultra-modern at the time with indoor running hot and cold water. It was the first home in Jackson County, Missouri, to have flush toilets indoors.

Listed on the National Register of Historic Places in 1969, the mansion was used as a nursing home and later for a bottling company. The nursing home maintained the nine fireplaces and original paint work in the home; eventually, the property was turned over to the City of Independence.

In 1983, the Vaile Victorian Society formed, and members worked to restore the home, bring authentic Victorian era furnishings into the mansion, and arrange tours for the public.

Once situated among 630 acres, Vaile Mansion estate is now on about six acres of property. During the holidays, the mansion is decorated with copious Victorian-style decorations like dozens of tall Christmas trees.

MOSS MANSION
1902–1903

LOCATION: Billings, MT
ARCHITECT: Henry Janeway Hardenbergh
STYLE: English Renaissance

Henry Janeway Hardenbergh

Hardenbergh was born in 1847 in New Brunswick, New Jersey. He attended the Hasbrouck Institute in Jersey City, and he later studied under Beaux-Arts trained architect Detlef Lienau. In 1870, Hardenbergh started an architectural practice in New York City.

At least one member of the Moss family lived in the red stone, three-story, 28-room mansion in Billings, Montana, until 1984. Because of the foresight of some of the Moss children, visitors touring the mansion can see original furniture, fixtures, Persian carpets, paintings, and other artifacts owned by family members. Visitors can also see the original marble fireplaces and hand-painted walls and ceilings along with an attached solarium for growing plants.

An ornate arch, resembling something that would be found at a Spanish castle, beckons the visitor indoors.

Wealthy entrepreneur Preston Moss hired Henry Janeway Hardenbergh to build the home where his wife, six children, and three servants would live. At the time, it cost 20 times more than the average home in Montana to build and furnish. The architect was known for designing other important buildings, such as the original Waldorf-Astoria Hotel that was later razed to make way for the Empire State Building.

Today, the Billings Preservation Society oversees the mansion, which is on the list of National Register of Historic Places.

Tours and special events are held at the mansion, which houses a harp one of the children played and treasures from Africa, South America, and Europe..

Moss Mansion has been featured in *National Geographic Guide to America's Great Houses*. It's also shrouded in some mystery: staff and visitors report paranormal activity like an apparition of a child standing on a staircase and a woman singing in the billiards room.

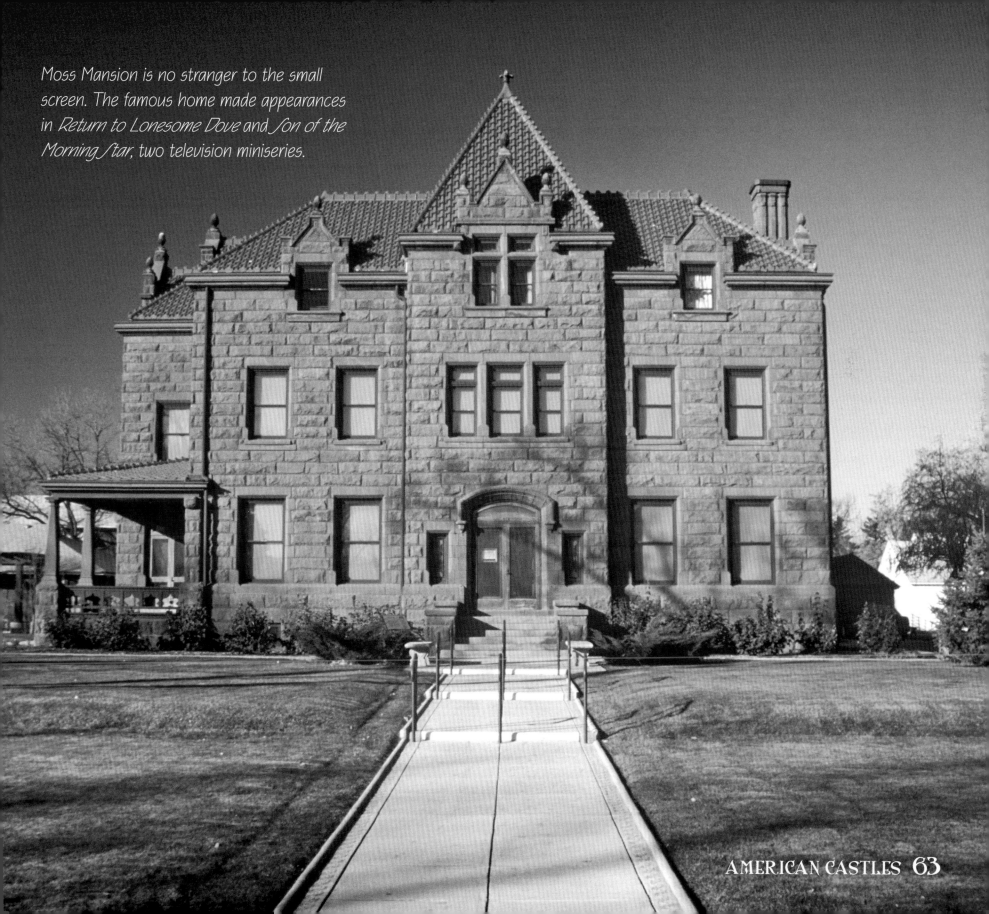

Moss Mansion is no stranger to the small screen. The famous home made appearances in *Return to Lonesome Dove* and *Son of the Morning Star*, two television miniseries.

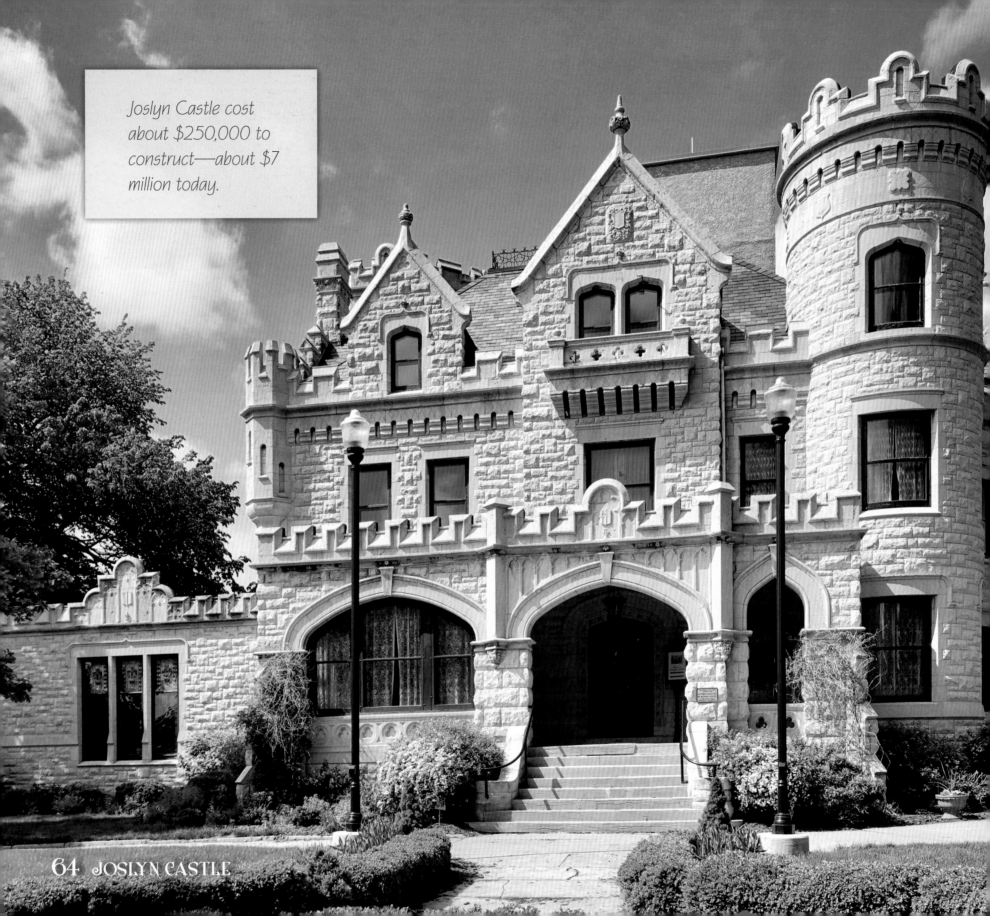

Joslyn Castle cost about $250,000 to construct—about $7 million today.

Joslyn Castle
1903

LOCATION: Omaha, NE
ARCHITECT: John McDonald
STYLE: Scottish Baronial Revival

Wealthy businessman George Joslyn, who owned the Western Newspaper Union and also contributed to philanthropic projects in Nebraska, chose to have a mansion built in what was called Scottish Baronial style. Developed in the sixteenth century, the style is reminiscent of Scottish castles.

Joslyn's four-story mansion, totaling more than 19,000 square feet, was designed with 35 rooms surrounded by five acres of 100 planted mature trees, formal gardens, and greenhouses; there, Joslyn and his wife, Sarah, managed a nationally known collection of orchids. The castle and a carriage house were made of Kansas limestone, and a wrought iron door on the home is said to weigh more than a ton.

Well-known landscape architect Jens Jensen designed the landscaping inside the home's conservatory. The interior features rare woodwork, a large staircase made of Spanish mahogany, stained glass windows, a ballroom, a pipe organ, and indoor plumbing.

A tornado in 1913 that ripped through central and northern Omaha only slightly damaged the home, but some of the furniture and artwork inside were destroyed. A deep freeze after the tornado killed the Joslyns' coveted orchid collection.

George Joslyn died in 1916; Sarah lived at the estate until her death in 1940.

From 1944 to 1989, the Omaha Public School district headquarters were stationed at the castle. Today, it's owned by the Joslyn Castle Trust, established to maintain the historic property and open the grounds for public tours, events, and rentals. The castle has been listed on the National Register of Historic Places.

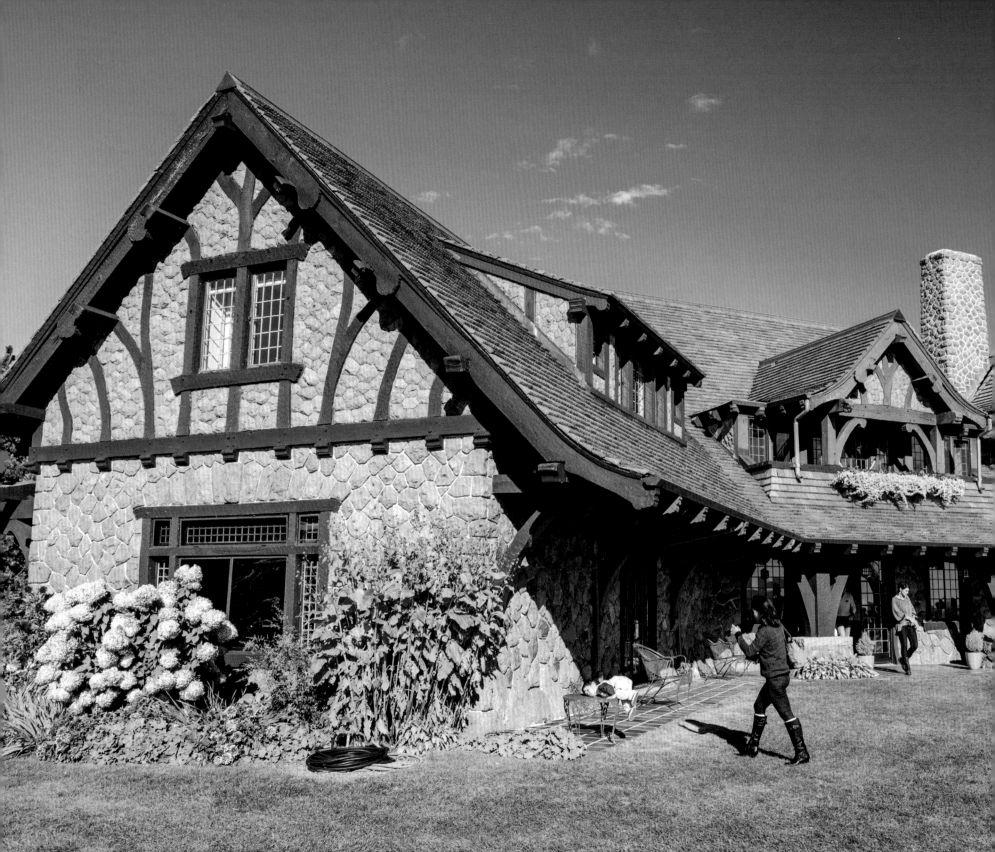

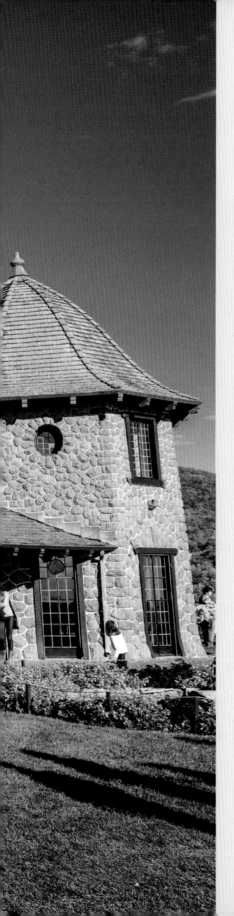

CASTLE IN THE CLOUDS
1913-1914

LOCATION: Moultonborough, NH

ARCHITECT: J. Williams Beal

STYLE: Arts and Crafts

Named to the National Register of Historic Places in 2018, Castle in the Clouds sits within the Ossipee Mountains in New Hampshire and is a fine representative of arts and crafts architecture.

Shoe manufacturer Thomas Plant commissioned the 16-room mansion to be built beginning in 1913. Plant had the home built for his second wife, Olivia, and named it Lucknow, perhaps in reference to a city in India. The estate encompasses more than 5,000 acres, an area where Plant also had other structures built.

The exterior features a clay tile roof and is constructed of hand-hewn white oak made in shipyards in Maine. The workers shaped and pieced together ship timbers with oak dowels. The mansion's front entrance is set off by a gable-roofed porch. The interior features oak-panel walls, carved woodworking, and seven skylights that draw the outdoors inside. Most of the original furniture remains inside the home.

Though Plant eventually lost most of his money and had to foreclose on his house, he was allowed to stay there until his death. The mansion passed through several owners before being purchased by the Castle Preservation Society, which maintains the home and provides tours.

Visitors can also explore 28 miles of hiking trails, maintained by the Lakes Region Conservation Trust. A short hike leads to a 40-foot waterfall, one of many treasures protected on the former Plant estate.

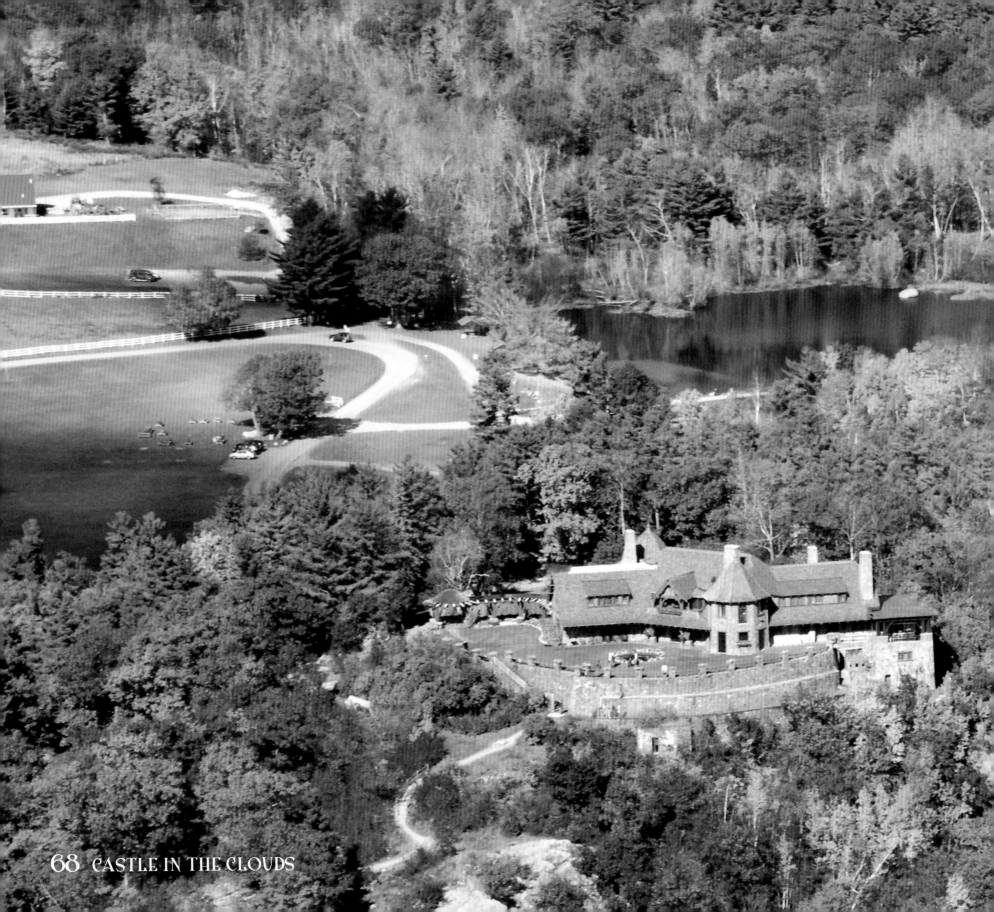

A two-mile driveway, accessible only via trolley, leads visitors past stone posts and gardens and up to the mansion.

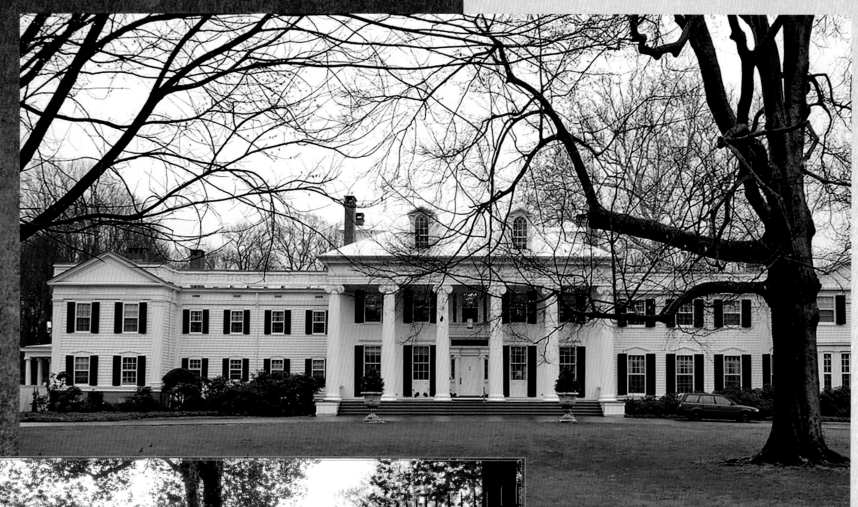

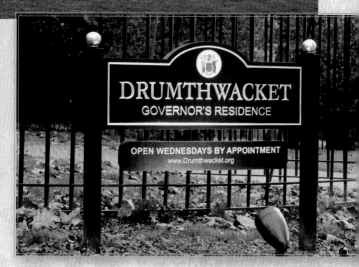

DRUMTHWACKET

CA. 1835

Charles Smith Olden

LOCATION: Princeton, NJ

ARCHITECT: Raleigh C. Gildersleeve

STYLE: Greek Revival, Colonial Revival

Around 1835, Charles Smith Olden (New Jersey's governor during the Civil War) had a home built on land once owned by Pennsylvania Quaker colony founder William Penn. Olden named the home Drumthwacket, a Scottish phrase meaning "wooded hill." The original two-story building contained six Ionic columns that reflect the Greek revival style; the columns remain standing today along with the original hall and two rooms.

Moses Taylor Pyne purchased the home and grounds in 1893 and hired an architect to add two new wings on each side of the original structure. Pyne also hired a landscape architect to design and install Italianate gardens featuring terraces, pathways, and steps.

On the National Register of Historic Places, Drumthwacket was designated the official residence of the New Jersey governor in 1982. Over the years, several governors lived in the mansion.

Next to the mansion is the one-story, mid-eighteenth century farm house where Charles Smith Olden was born. Today, it's known as the Olden House.

Visitors to Drumthwacket can view the original colonial kitchen fireplace made with bricks and the original floors and cupboards; they can also stroll the gardens. The grounds and mansion are protected and restored by the Drumthwacket Foundation, which also hosts educational activities and exhibitions there. Public tour times are limited, and discussions of future renovations and new tours are ongoing.

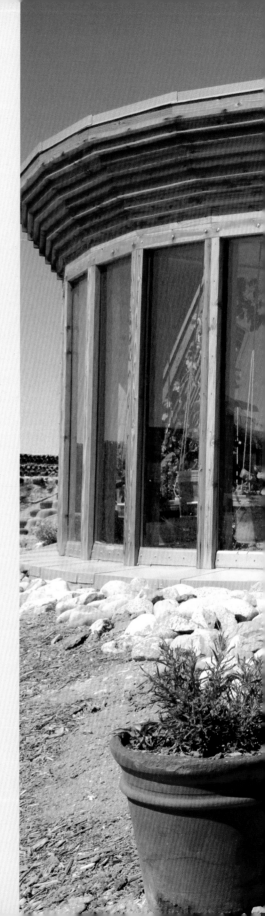

EARTHSHIP
1994

Michael Reynolds

LOCATION: *Taos, NM*

ARCHITECT: *Michael Reynolds*

STYLE: *Biotecture*

Pioneer architect Michael Reynolds began designing and building what he called earthships in the 1980s. They are made of sustainable and recycled materials; they use renewable energy sources like sun and wind. The Earthship Biotecture Campus in Taos, New Mexico, is the only place where visitors can tour earthships as they are built and spend a night in one of the furnished and operational homes.

The exterior walls are made of recycled tires packed with soil. Cans and bottles are used for the interior walls. Energy comes from solar panels and wind. Water—which is ultimately recycled—comes from the roof via rainwater.

A tour at the education center teaches visitors about solar architecture and other energy-saving techniques. Some 75 fully furnished earth homes are located around the campus where families live; five of them are reserved so visitors can rent them for overnight stays and get a taste of green living.

Reynolds's vision was to create a home that would use sustainable architecture and keep homeowners free from relying on outside energy sources. In other words, homeowners would have no utility bills to pay as they use nature's resources to live.

Each home also contains a greenhouse where residents can grow vegetables, herbs, and other foods. Many also have chickens roaming the yards.

The 1,400-square-foot homes are likely to become common dwellings in the future.

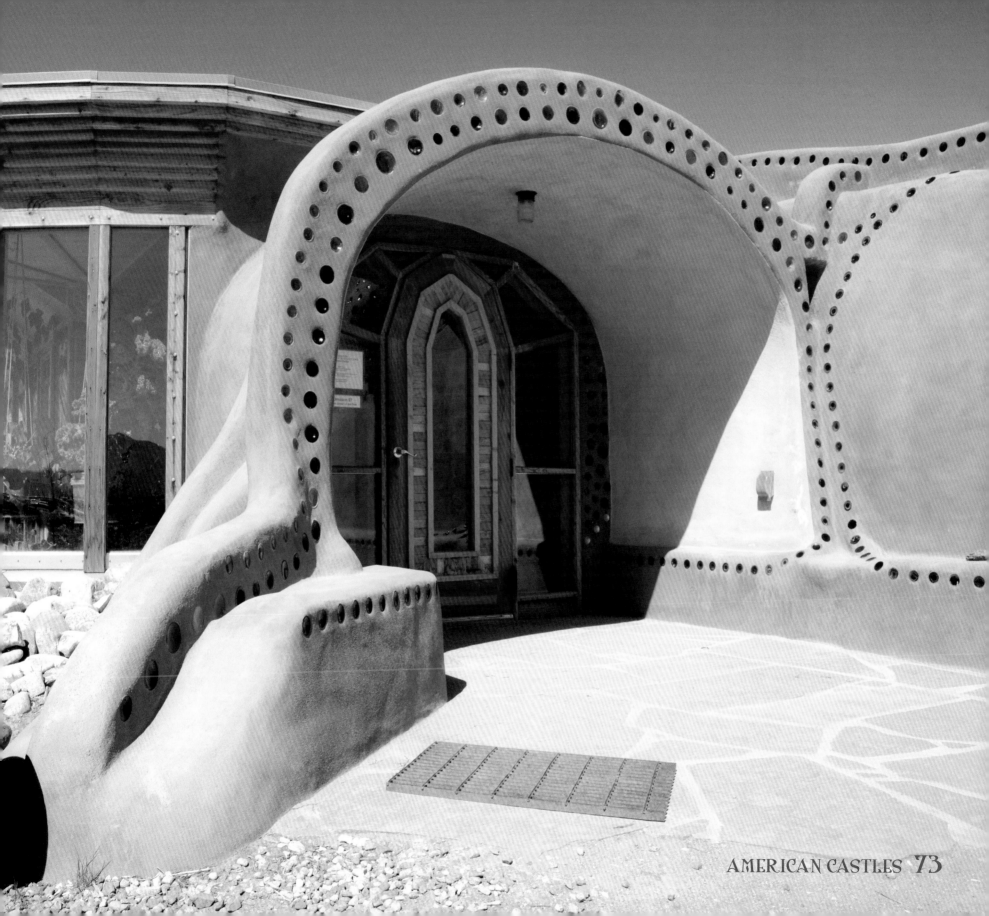

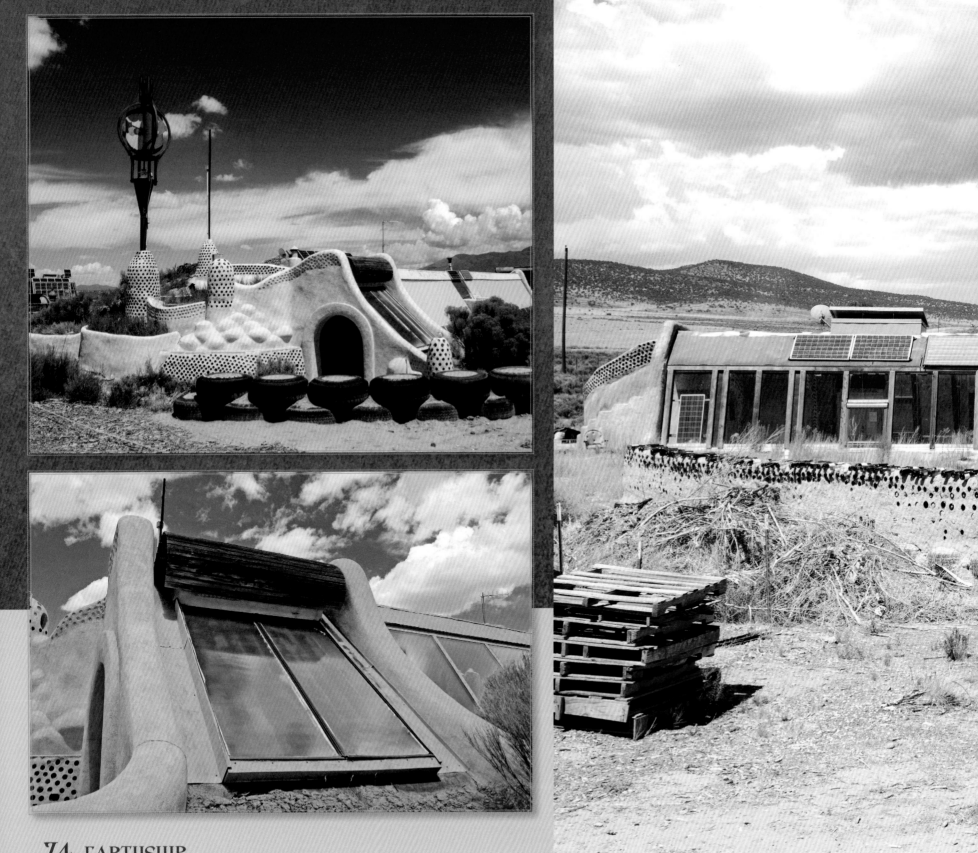

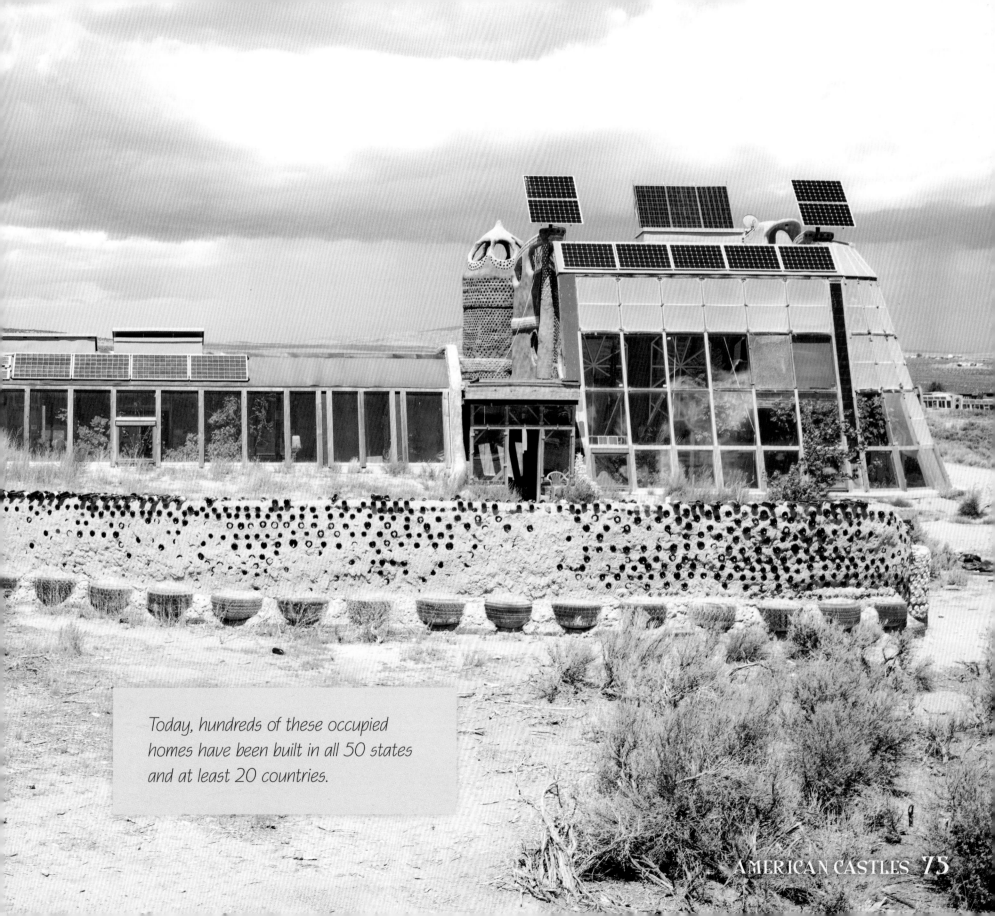

Today, hundreds of these occupied homes have been built in all 50 states and at least 20 countries.

TAOS PUEBLO

1000–1450

LOCATION: *Taos, NM*
ARCHITECT: *Puebloans*
STYLE: *Pueblo*

Designated a UNESCO World Heritage Site, Taos Pueblo is said to be the oldest U.S. community in which people continue to live. Native Americans live at the site next to the Sangro de Cristo Mountains, and their ancestors built the homes at least 1,000 years ago. Built closely together and in five stories, the reddish-brown homes were made of adobe (a mixture of soil, water, and straw).

Large pieces of wood were used to create the roofs, which were then packed with soil. Since there were no doors or windows, people entered their homes from the top via wooden ladders.

Spanish explorers came to the pueblo village around 1540 and introduced new construction ideas like insulation. The explorers saw a glint of gold in the homes, a mineral contained within the adobe; they thought they had found a fabled, ancient city of gold.

Today, about 150 people live in the village, and about 2,000

live in the region. The public is welcome to tour the village at set hours, outside of when private rituals are being performed.

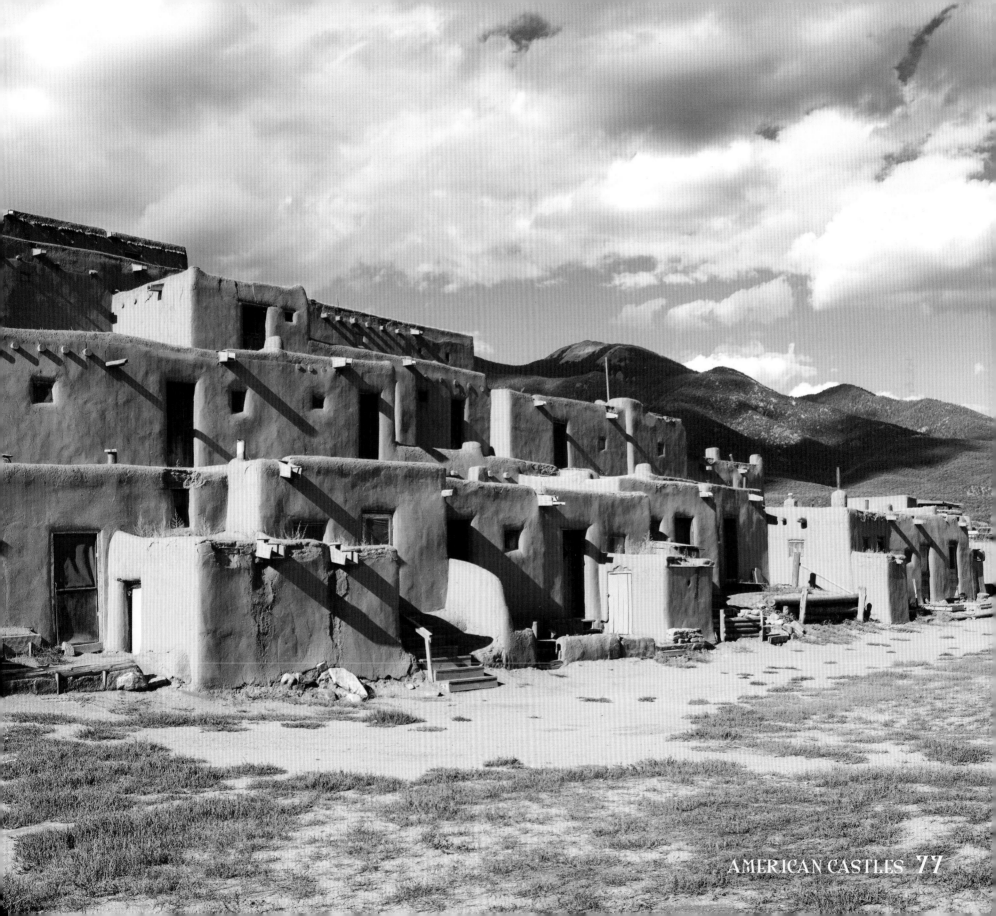

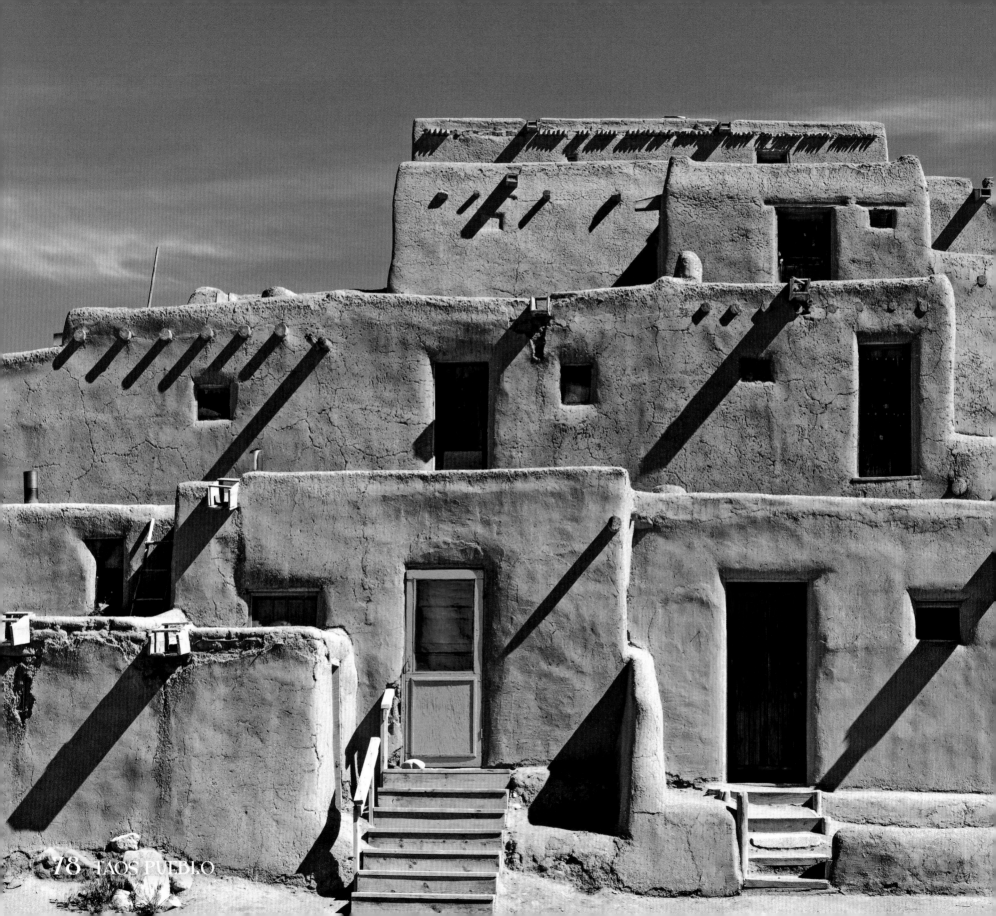

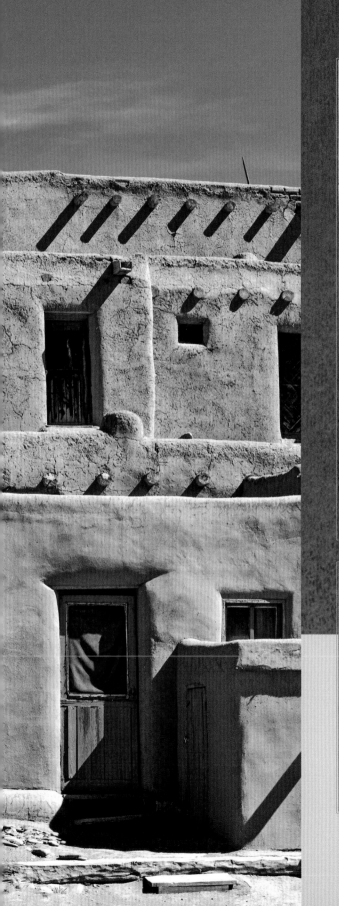

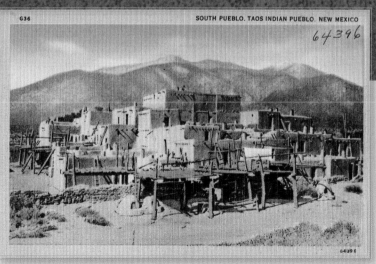

G36 SOUTH PUEBLO. TAOS INDIAN PUEBLO. NEW MEXICO

As a matter of tradition, neither running water nor electricity are allowed inside the homes.

BANNERMAN CASTLE

1901

LOCATION: Fishkill, NY

ARCHITECT: Francis Bannerman

STYLE: Scottish Castle Revival

Located on an island once declared off limits to the public is the remains of Bannerman Castle. A wealthy Scot named Francis Bannerman built the home.

A munitions dealer, Bannerman purchased the land in 1900 from a past owner to store ammunition. Bannerman designed buildings for an arsenal on the island, and he also had a castle built where he and his wife, Helen, could spend the summers. The buildings featured turrets in the style of a Scottish castle, and even a moat was added. The castle and arsenal eventually fell into disrepair, and an explosion of some of the ammunitions destroyed part of the buildings; eventually, the state of New York purchased the buildings and the island.

Bannerman Castle Trust was formed in 1993 to open the island to the public, to find a way to stabilize the castle ruins, and to host musical and theatrical events. Working with the New York State Office of Parks, Recreation and Historic Preservation, the trust was able to arrange kayak tours to the island for the public. In 2004, the public was allowed to tour the island, and in 2011, some of the buildings were partially stabilized. Today, visitors can take a boat to the island for tours and theater and musical performances.

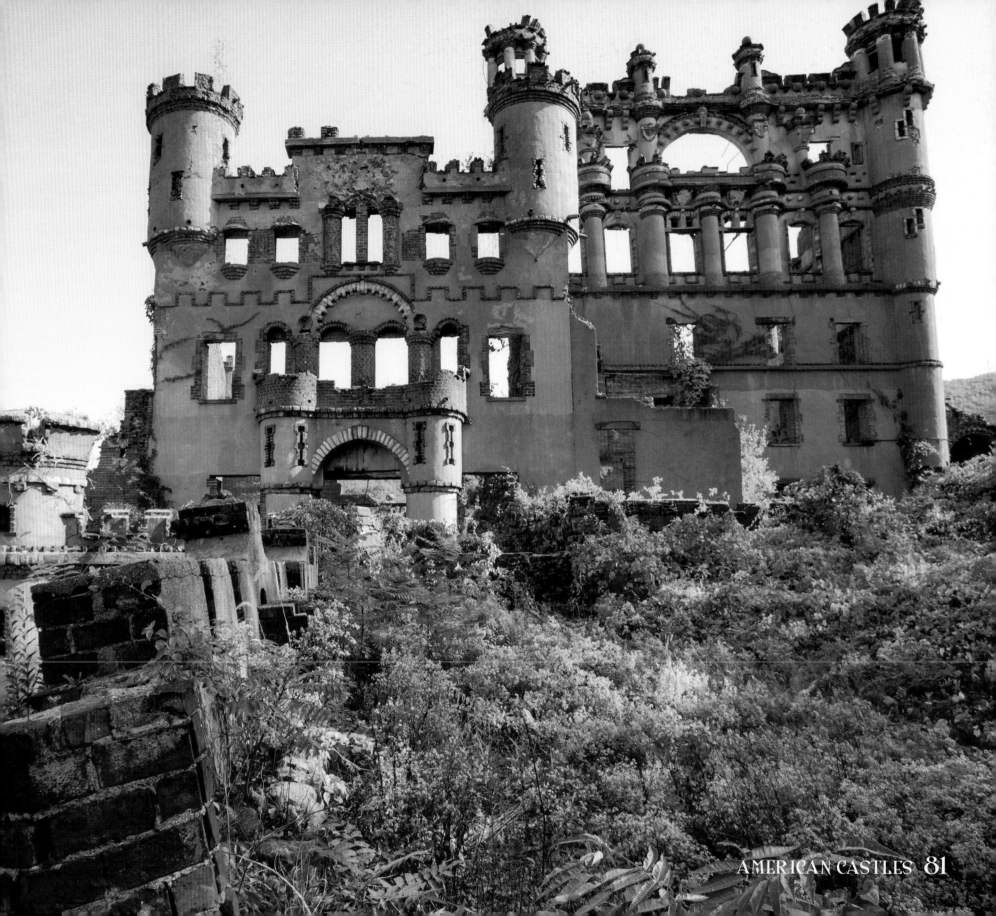

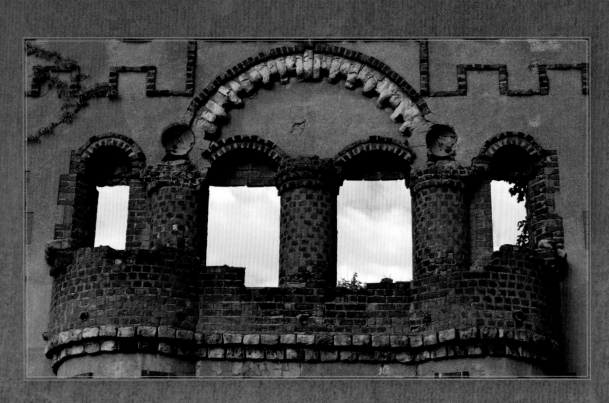

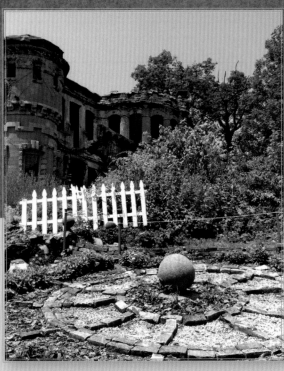

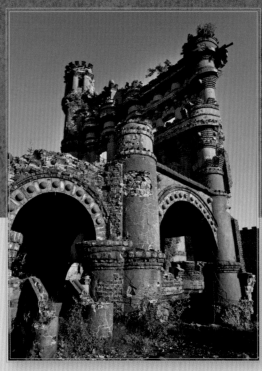

82 BANNERMAN CASTLE

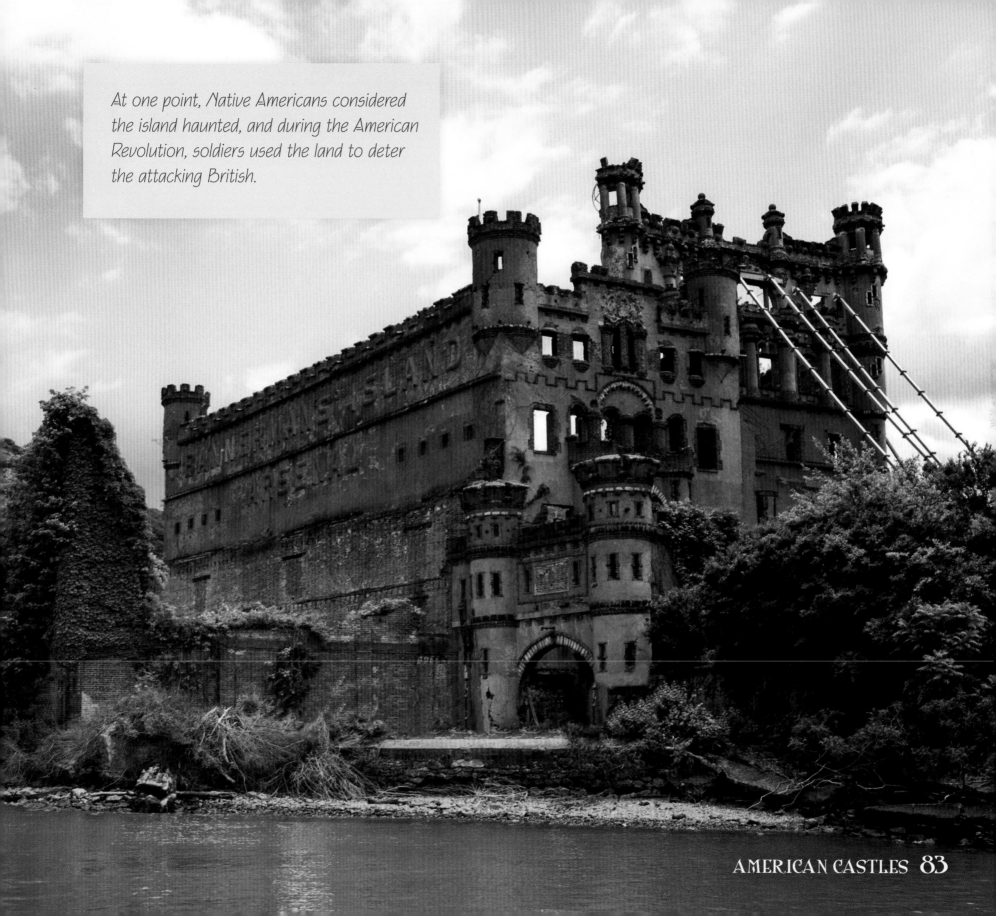

At one point, Native Americans considered the island haunted, and during the American Revolution, soldiers used the land to deter the attacking British.

Belvedere Castle

1865

LOCATION: New York City, NY

ARCHITECT: Calvert Vaux, Frederick Law Olmsted

STYLE: Gothic and Romanesque

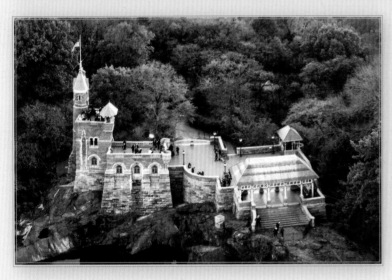

When designing Central Park in New York City with Frederick Law Olmsted in the mid-1850s, Calvert Vaux visualized a fanciful castle overlooking the park.

Belvedere Castle was built in 1865 from schist and granite found naturally in the area. A capped corner tower, among other features, gave the structure a medieval look. It became known as Belvedere Castle, meaning "beautiful view."

In 1919, the castle became the official Central Park weather station; however, when the observatory equipment was automated in the 1960s, the castle was closed and fell into disrepair.

In 1983, the Central Park Conservancy helped to restore and reopen the castle to the public with astronomy, storytelling, and wildlife programs. Visitors enjoy viewing Central Park from the site and exploring natural history artifacts.

In 2018, the Conservancy began another restoration to reintroduce some concepts of the original design, such as replacing current terraced pavement with bluestone pavers designed by the original architects. The Conservancy plans to replace windows and doors with clear insulated glass to emulate Vaux's original open air plan for the castle, where people could view the park in the fresh air.

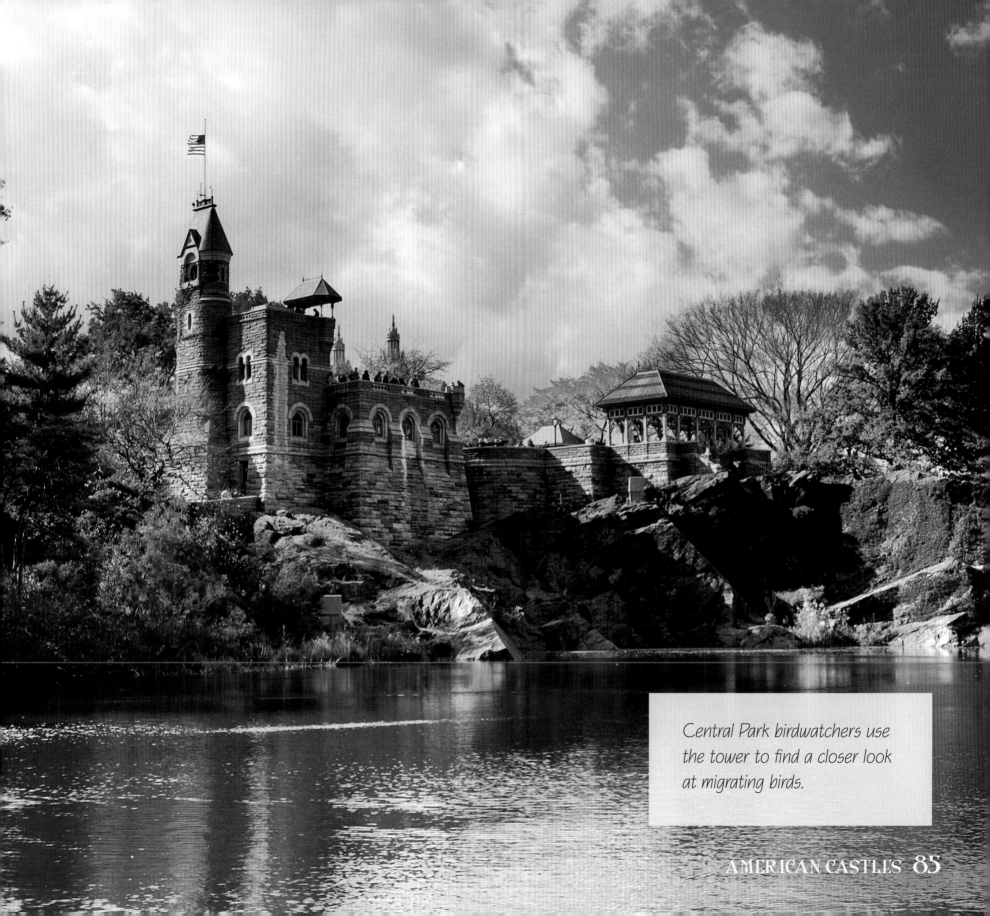

Central Park birdwatchers use the tower to find a closer look at migrating birds.

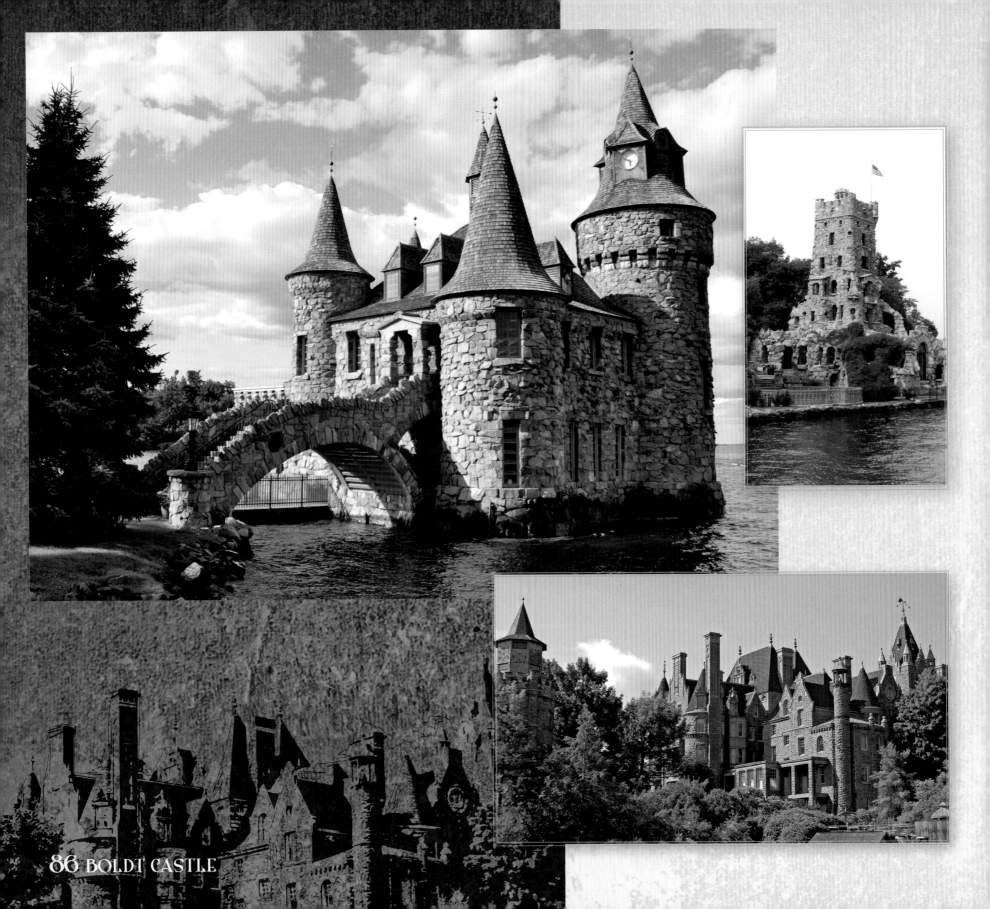

BOLDT CASTLE
1900-1904

George C. Bolt

LOCATION: Alexandria Bay, New York

ARCHITECT: G. W. & W. D. Hewitt

STYLE: Sixteenth Century Castle

In an epic act of love, millionaire hotelier George C. Boldt elected to do what any well-to-do husband of the Gilded Age would: construct a full-size Rhineland castle for his cherished wife. Unfortunately, his love would not live to see the home's completion.

Boldt arrived in America in the 1860s from Prussia. By the end of the century, he was among America's most successful and influential hotel magnates. He was a Cornell University trustee, proprietor of Philadelphia's The Bellevue Hotel and New York City's Waldorf Astoria Hotel, and president of other companies.

One summer, Boldt, his wife Louise, and their two children visited a five-acre island on the St. Lawrence River near the Canadian border. Boldt quickly fell in love with the land (which he later renamed Heart Island), and it was there that Boldt decided to build his extraordinary castle as an ode to his soulmate.

Hundreds of workers—including carpenters, stonemasons, and artists—labored to erect the six-story, 120-room castle. The massive, 365-windowed home would feature tunnels, Italian gardens, a drawbridge, a children's playhouse, and a dovecote. Granite walls, steel and concrete roofs, sharp towers and turrets, and spacious balconies bring a sense of sophistication and majesty to the home.

Boldt, who invested more than $2.5 million of his fortune into the project, intended to present the castle to his wife on Valentine's Day. But in 1904, shortly before the edifice's completion, Louise died. A thoroughly distraught Boldt immediately ceased all work on the castle, and the unfinished summer home stood eerily silent for decades, a plaything for Mother Nature and vandals.

The Thousand Islands Bridge Authority acquired the property in 1977. Since then, millions of dollars—and plenty of labor—have helped to maintain and restore the island's buildings. Today, the island and castle are a popular site for weddings, and annual visits exceed 200,000. Part of the castle is now a museum featuring exhibits that honor the Boldt family and the region.

Inside the grand castle, visitors can marvel at the home's marble staircase, admire the gold-framed wedding portrait of Louise, saunter along the ballroom's wood floors, and examine the castle's numerous fireplaces. Outside, flowers surround a marble fountain, one of several exquisite gardens across the island's five acres. Other sites on the island, including a defense tower and clock tower, provide superb photography opportunities.

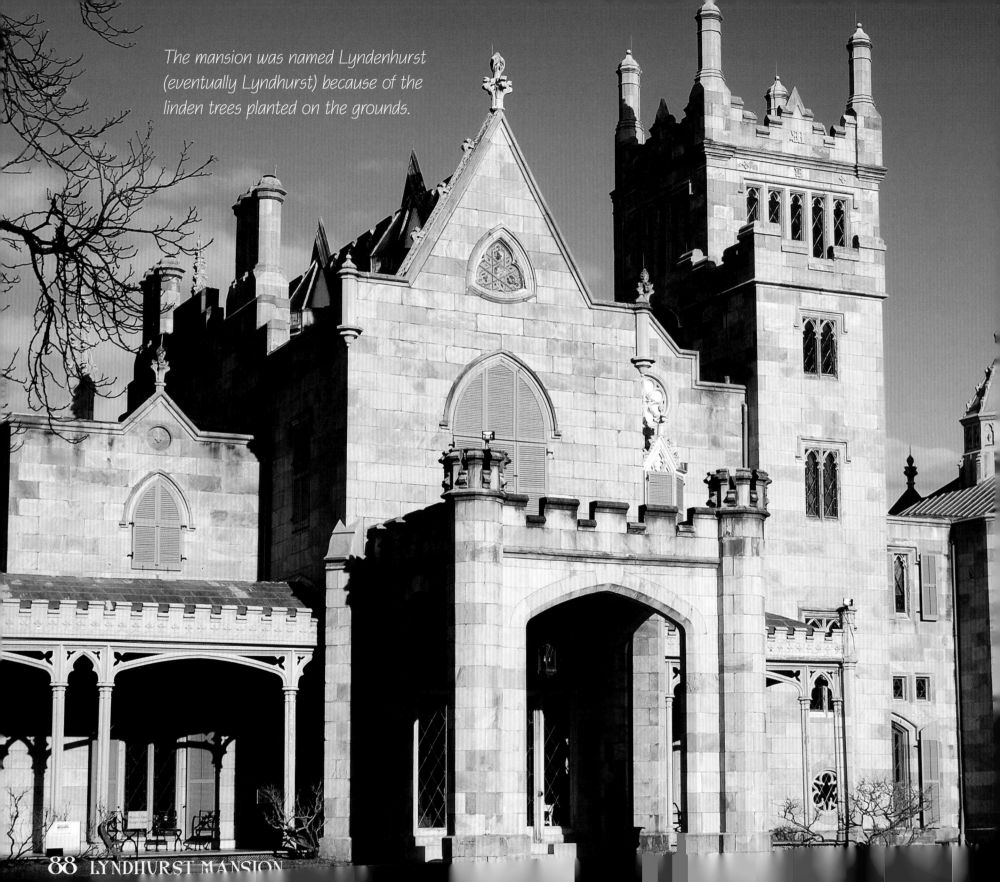

The mansion was named Lyndenhurst (eventually Lyndhurst) because of the linden trees planted on the grounds.

Lyndhurst Mansion

1838

LOCATION: Tarrytown, NY
ARCHITECT: Alexander Jackson Davis
STYLE: Gothic Revival

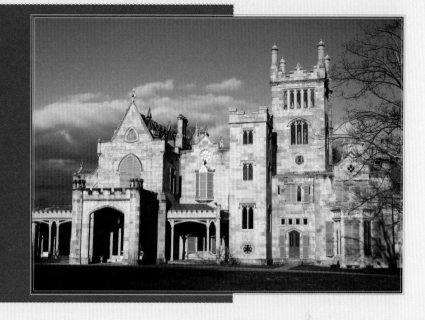

Three families influenced the architectural style of Lyndhurst Mansion, overlooking a park-like setting in the Hudson River Valley of New York. Architect Alexander Jackson Davis created a country villa overlooking the river and called it the Knoll. It stood out among the other area post-colonial style mansions because of its Gothic revival style, which included turrets, arched windows, and a limestone façade.

In 1864, the mansion's size was doubled for its second owner, George Merritt. Davis added a new wing that included a four-story tower.

The third owner was railroad magnate Jay Gould. Upon his death, Gould's daughter took over the estate; she added a sewing school and a recreation center. After his daughter died, her sister maintained Lyndhurst as a country home; she invited soldiers to rest there after World War II and ultimately gifted the 67-acre estate to the National Trust for Historic Preservation.

Today, Lyndhurst features many of the home's original furnishings and Jay Gould's massive art collections. Indoors, visitors will discover painted vaulted ceilings and narrow hallways. The grounds

continue to reflect nineteenth century landscape design.

Lyndhurst is on the National Register of Historic Places, and it was featured as an estate called Collinwood in the 1970 film *House of Dark Shadows*.

Tours, exhibitions, lectures, and plays are held inside the mansion, and a summer concert series is held outdoors.

DARWIN D. MARTIN HOUSE
1903–1905

LOCATION: Buffalo, NY
ARCHITECT: Frank Lloyd Wright
STYLE: Prairie School

The Darwin D. Martin House Complex in New York is ranked as one of Frank Lloyd Wright's most ambitious and important projects created in his Prairie School design.

It wasn't just a home that Wright built for the Martin family, but a series of connecting buildings, including two family residences, a conservatory, and a carriage house. Excluding the gardeners' cottage, which was added in 1907, the complex totals more than 29,000 square feet and is on the National Register of Historic Places.

The complex was built for Darwin D. Martin, who included a second house, the Barton House, where his sister and brother-in-law could live. Wright designed and built the Barton House first as a test project.

The Martin House complex features 394 art glass patterned windows that meld indoors and outdoors into one space. The most famous of these is the Tree of Life window, which is said to contain more than 750 different panes of glass.

Wright designed a pergola beginning at the entrance of the Martin family's residence extending to the conservatory entrance. The pergola and conservatory were demolished in the 1960s and rebuilt during a restoration at the beginning of the twenty-first century. Public and private funds were used to restore the complex to its original 1907 condition. The last phase of the restoration was set to begin in 2018. Plans include reinstalling original furnishings selected by Wright into the Martin House. Public tours, exhibitions, lectures, and other events are held at the complex throughout the year.

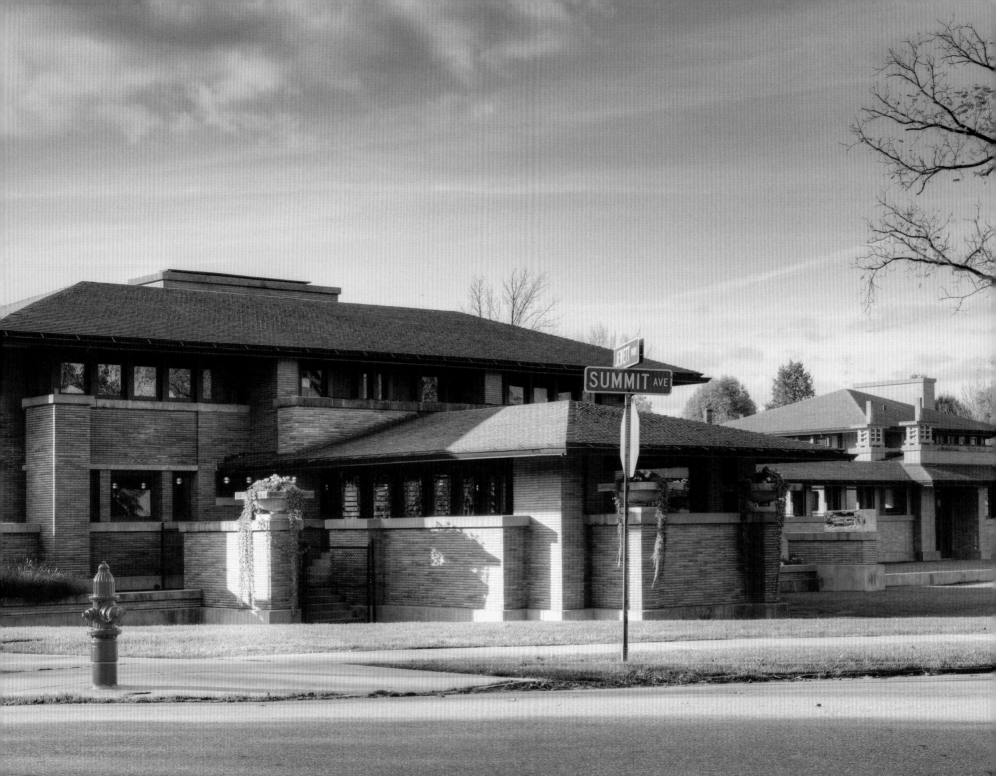

Wright's Prairie Style included horizontal lines that blend into the landscape, low roofs, and horizontal windows.

OHEKA CASTLE
1914–1919

LOCATION: Huntington, NY
ARCHITECT: Delano and Aldrich
STYLE: Beaux-Arts

Investment banker Otto H. Kahn hired premiere architect and landscape designers to create the finest summer home on Long Island in the early 1900s. Known as Oheka Castle, it was the second largest private home in the United States. It cost Kahn an estimated $11 million, which is close to $160 million in today's dollars..

The 109,000-square-foot mansion containing 127 rooms was designed to look like a French chateau. An indoor grand staircase was patterned after one at Chateau de Fontainebleau in Paris.

Because Kahn asked for a fireproof design, his architects used stone and marble for the exterior's construction. Reclaimed cobble-stones were used to create the central court.

Kahn hosted lavish parties at his castle. After his death, the mansion was used as a retreat house and military academy; by 1984, it had been vandalized many times and fell into disrepair.

New York developer Cary Melius purchased the castle in 1984 and began restoring the home and redesigning the gardens to their original plan. He sold the estate and later repurchased it, turning it into what is now named a Historic Hotel of America, a program administered by the National Trust for Historic Preservation. The home is also on the list of National Register of Historic Places.

The public can tour or dine in the mansion, stay overnight in a guest room, and even hold a wedding on the property.

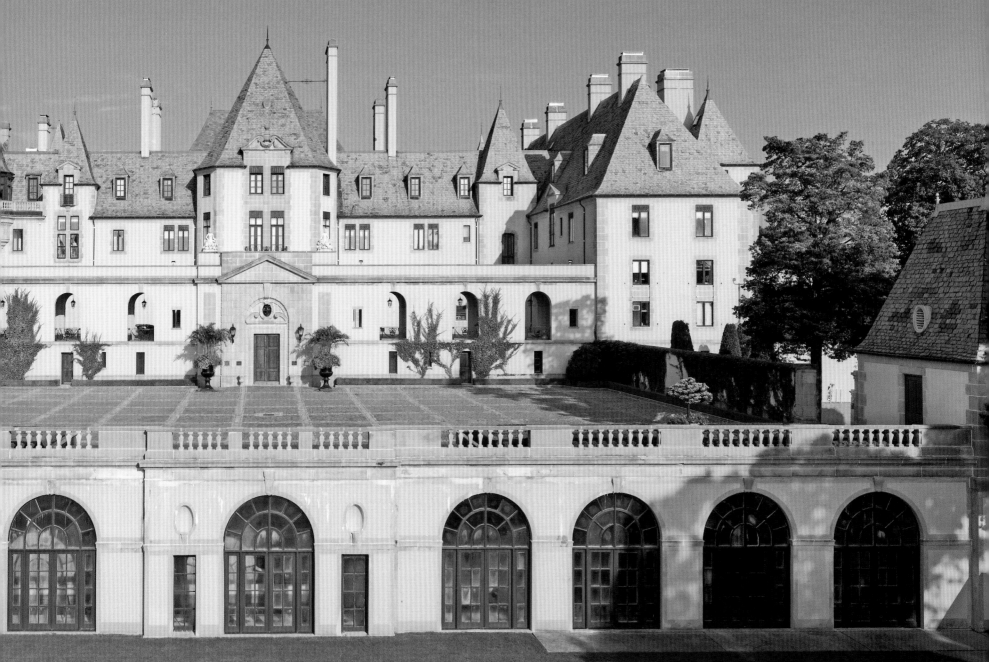

Frederick Law Olmsted's sons designed
the 443 acres of grounds to include a
sunken garden and perfectly trimmed hedges
reminiscent of French gardens.

OLANA STATE HISTORIC SITE
1870-1872

LOCATION: Greenport, NY

ARCHITECT: Calvert Vaux

STYLE: Middle Eastern and Victorian

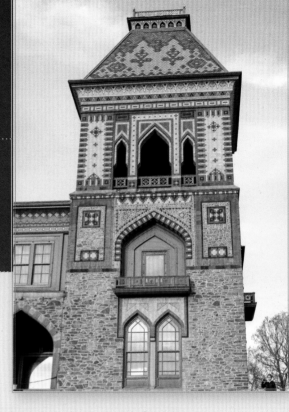

An unusual blend of Victorian and Middle Eastern styles, the Olana home in New York almost met the wrecking ball when one of the original owners' descendants planned to sell it to developers. A story in *Life* magazine about the mansion, along with a keen interest by art historian David Huntington, saved the estate, which is now a National Historic Landmark.

Preserving the estate was important to Huntington because it was owned and commissioned by artist Frederic Edwin Church, who belonged to the famous Hudson River School of landscape painting.

Church worked with architect Calvert Vaux to design a roofed courtyard flanked by stone rooms with glazed windows. Middle Eastern influence is seen in the balcony and tile work and arched windows, while the overall home reflects nineteenth century Victorian styles.

Of particular interest are the stencils created by Church both inside and outside the home. In designing these colorful stencils—some of which are on tile, metal, and stone—he was inspired by Arabian architecture. The stencils, which wore away with age and weather, were restored to their original grandeur in 2004 and 2005. Church also used his artistic skills to create patterns he placed in between amber-colored glass panes.

Church and his wife, Isabel, decorated their home's interior with furnishings they collected from their travels, including in Persia.

In 1966, the state of New York purchased Church's property and opened it to the public. It stands as a place to study and revel in Church's skill as an artist.

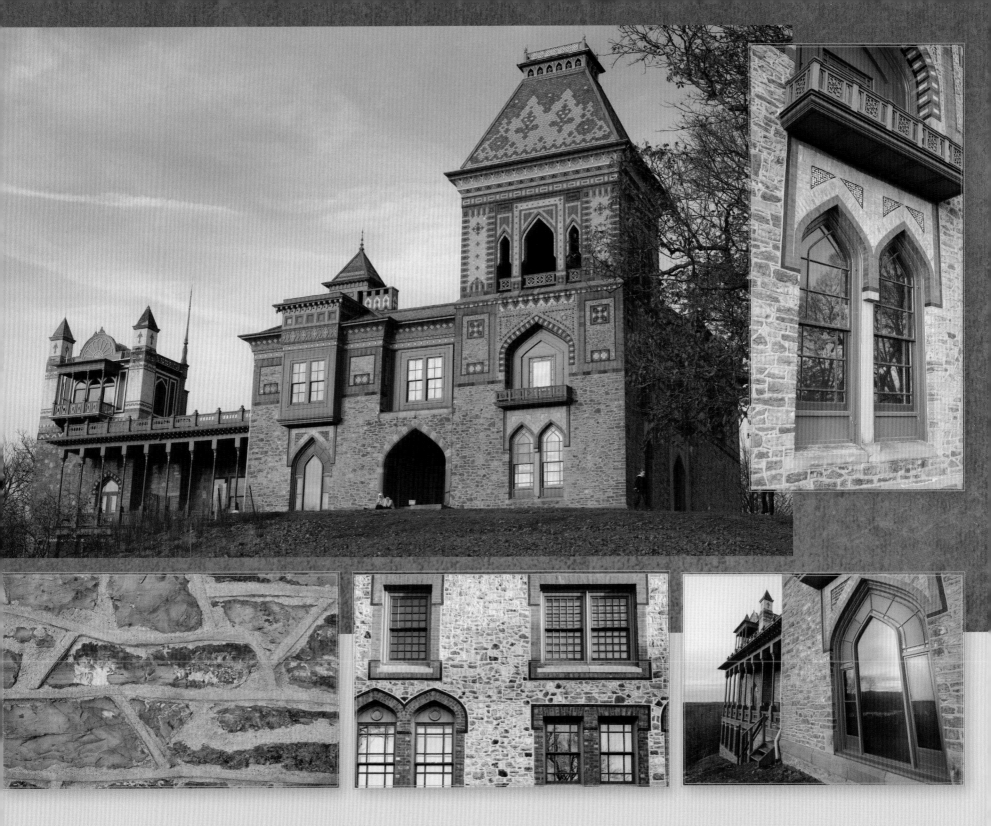

BILTMORE MANSION

1889–1895

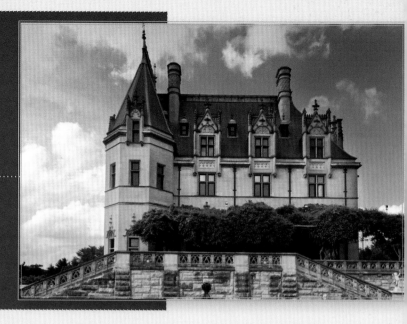

LOCATION: *Asheville, NC*

ARCHITECT: *Richard Morris Hunt*

STYLE: *French Chateau Revival*

Located in the mountains on an 8,000-acre estate, North Carolina's Biltmore Mansion has more than 135,000 square feet of living space. It has remained in the same family since it was built and is the largest privately owned home in the U.S.

George Washington Vanderbilt had his 250-room mansion built as a summer retreat during the Gilded Age. An art collector, he belonged to the wealthy and well-known Vanderbilt family of railroad fame.

Vanderbilt wanted a home resembling a chateau of the French Renaissance. The four-story limestone home was built within the Blue Ridge Mountains and contains 16 chimneys covered in slate tile. It was said to have been modeled after a medieval castle located in France's Loire Valley.

Famous landscape architect Frederick Law Olmsted designed a formal Italian garden, a walled garden, a rose garden, fountains, and a conservatory for orchids and palm trees.

Meanwhile, Vanderbilt toured the world to buy furnishings for the home, including fifteenth century tapestries. Vanderbilt collected original art by impressionistic painter Pierre-Auguste Renoir and English painter John Singer Sargent, which visitors can see today.

To celebrate the opening of his new estate, Vanderbilt invited family and friends to Biltmore Mansion on Christmas Eve in 1895. Four years later, he married Edith Dresser, and they had one child, Cornelia, who was born in the mansion in 1900.

Today, the Biltmore Company oversees the estate and home. A winery, inn, and hotel all operate on the property.

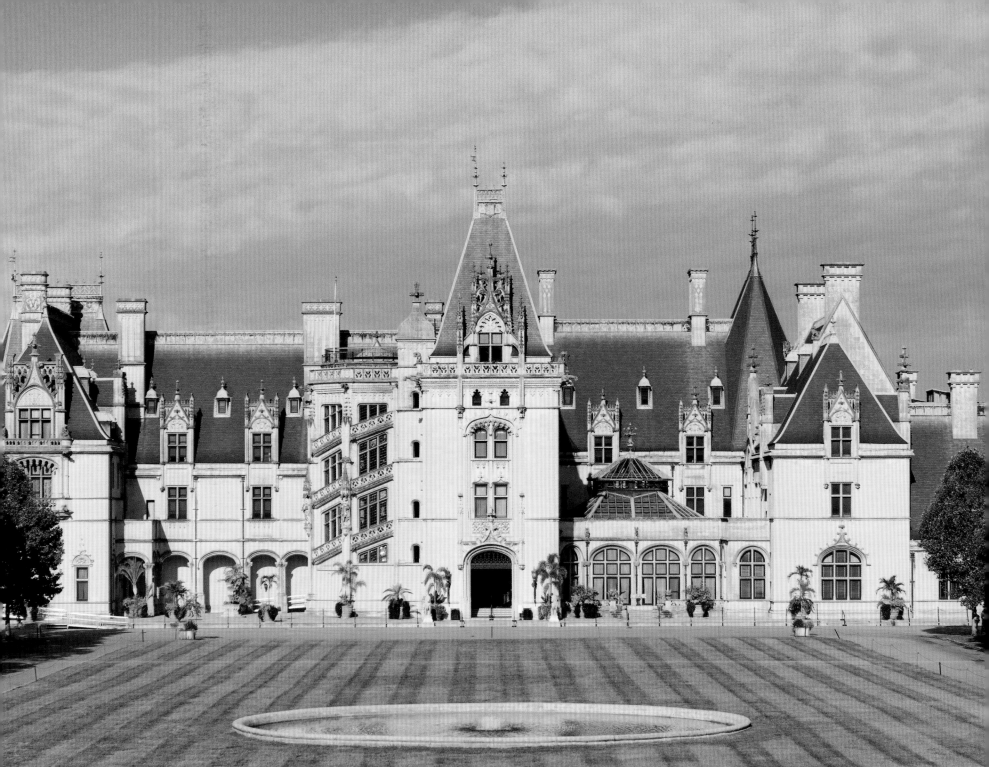

The home has 35 bedrooms, 45 bathrooms, 65 fireplaces, and an indoor pool.

LOVELAND CASTLE
1929-1979

LOCATION: Loveland, OH
ARCHITECT: Harry D. Andrews
STYLE: Medieval Revival

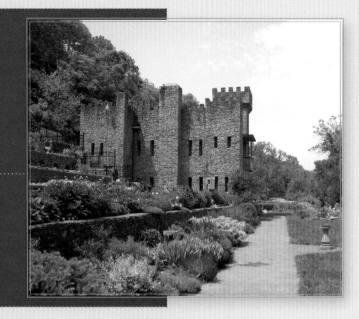

In 1929, Harry Andrews began building his castle with stones he gathered daily along the Little Miami River in Ohio. It took him 50 years to finish, and when he was done, he opened it to the public.

Some scoffed at his idea, but today, the castle remains intact and attracts tourists nationwide. It's run by the Knights of the Golden Trail, a group Andrews started. Their mission is to keep the castle open and run it as a museum with an exhibit featuring Andrews, a World War I veteran. Andrews also had an abiding love for medieval times and noble knights.

Andrews used German, French, and English architectural styles to create four different kinds of towers, a wall that was as big as the castle, and a moat. Inside the castle is a dungeon and prison tower. Visitors can view his collection of weapons popular during the medieval ages, along with a suit of armor and other artifacts.

There is a long story about what drove Andrews to build the castle, but basically, it involves a Boy Scout troop led by Andrews. The troop camped along the river; Andrews would build stone tents for the scouts and, ultimately, the castle.

Andrews, said to have an IQ of 181, died in 1981. He left the castle to the Knights of the Golden Trail.

Today, visitors can explore tenth century herb gardens and organic grounds outdoors, in addition to the castle's interior.

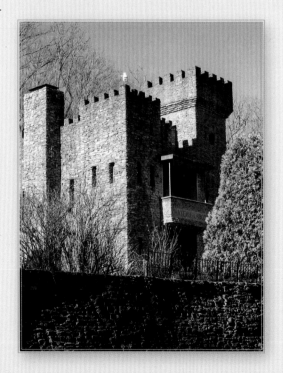

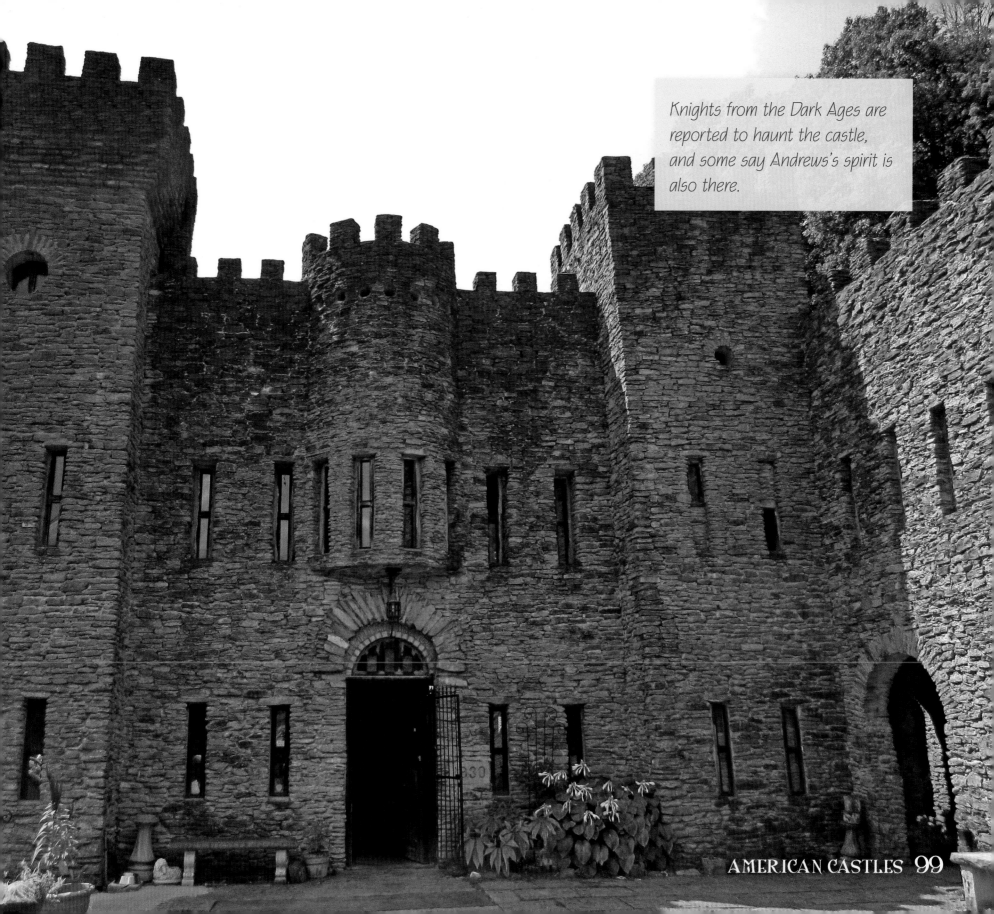

Knights from the Dark Ages are reported to haunt the castle, and some say Andrews's spirit is also there.

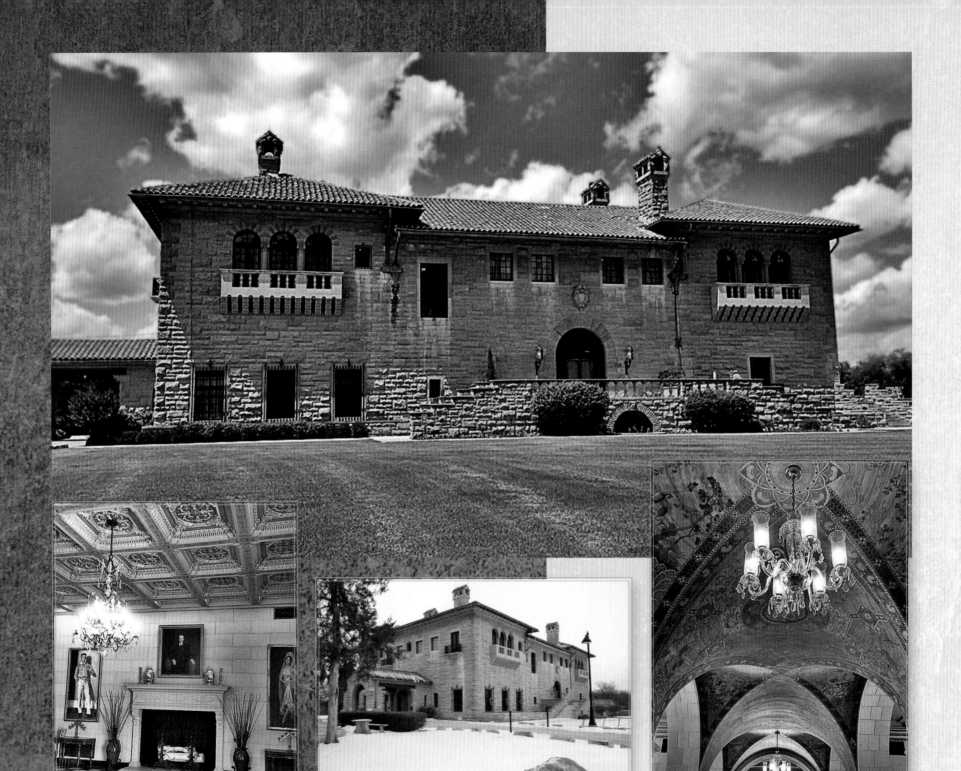

MARLAND MANSION

1925-1928

LOCATION: Ponca City, OK
ARCHITECT: John Duncan Forsyth
STYLE: Mediterranean Revival

John Duncan Forsyth

Born in 1887, Forsyth trained at Edinburgh's Royal Academy of Arts and at the École des Beaux-Arts in Paris. He came to America in 1907; following World War I military service and a job in China, Forsyth returned to America in 1921. He became associated with fellow architect John McDonnell, and he would ultimately design structures in multiple styles, including Colonial, Georgian, Tudor, and Mediterranean.

Oil explorer E. W. Marland went from riches to rags to riches in the early twentieth century. When he discovered oil in Oklahoma, he amassed enough wealth to build two residences on his land. The Grand Home, built in 1914, features 22 rooms and an indoor swimming pool. But the Marland Mansion, which took three years to build, encompasses more than 43,000 square feet and has 55 rooms.

Marland's first wife, Virginia, died before the mansion was completed. Marland then married his adopted daughter, and in 1928, the two moved into the mansion; they called the mansion a palace on the prairie. Today, it's a National Historic Landmark.

Marland wanted his mansion to be built in Italian Renaissance style, based on a villa he saw while in Italy.

The mansion was made from limestone set in concrete atop a steel frame. It features custom-made wooden entrance doors and a clay-tiled roof with carvings of hunting dogs. The mansion contains seven fireplaces, 12 bathrooms, and three kitchens. Intricate decorations adorn the mansion inside and out, such as a vaulted hand-painted ceiling. To recreate the ballroom ceiling would cost more than $2 million today.

Today, the nonprofit Marland Estate Foundation works to restore and preserve the grand home and the mansion. Public tours are held in both homes, while side tours take visitors through the mansion to see the many angels and dragons carved into doors, furniture, stairwells, and ceilings.

QUANAH PARKER STAR HOUSE
CA. 1890

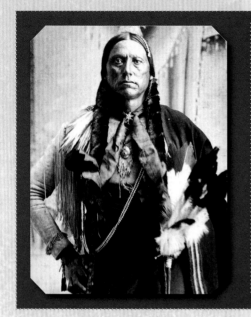

LOCATION: Cache, OK

ARCHITECT: Quanah Parker

STYLE: Comanche

Quanah Parker

Born in 1848, Quanah Parker was a fierce fighter and war chief. He later became an ambassador for the Comanche people and held close relationships with white leaders and businesspeople.

Vacant for more than 60 years, the Quanah Parker Star House is a testament to the grandeur and power of Comanche chief Quanah Parker. Parker, the tribe's last official principal chief, was a powerful and pragmatic leader who maintained productive relationships with white Americans.

Located in Oklahoma's southwest corner, Parker's house was built around 1890. The two-story home includes eight bedrooms (enough for Parker's then-five wives), an attic, kitchen, and dining room. The house's paper walls were later lathed and plastered.

The house earned its name after Parker joked how a brigadier general who wanted to cross the chief's land had many stars on his wagon, flag, and uniform. "Quanah bigger leader—have more warriors," Parker said.

"Maybe tomorrow he will have many white stars painted on roof to show this."

Several prominent military officers and politicians visited the home, including Geronimo. Following Parker's death in 1911, one of his daughters lived in the home until 1957. The house was moved to Cache from Fort Sill in 1958.

Today, the home is in a severely dilapidated condition, thanks in part to decades of deterioration and a significant May 2015 rainstorm. Following the rainstorm, numerous artifacts, including Parker's rugs and furniture, were removed from the house. The house has been on Oklahoma's list of Most Endangered Historic Places since 2007; as of this writing, the home's future is unclear.

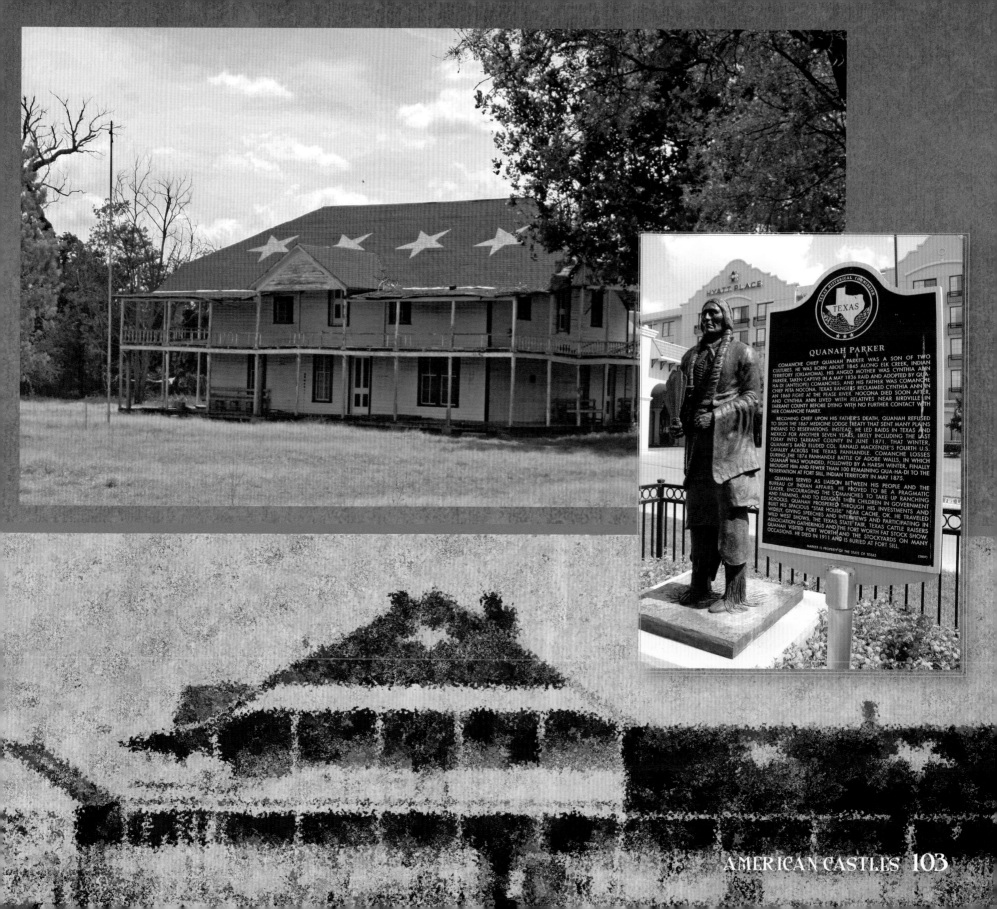

QUANAH PARKER

COMANCHE CHIEF QUANAH PARKER WAS A SON OF TWO CULTURES. HE WAS BORN ABOUT 1845 ALONG ELK CREEK, INDIAN TERRITORY (OKLAHOMA). HIS ANGLO MOTHER WAS CYNTHIA ANN PARKER, TAKEN CAPTIVE IN A MAY 1836 RAID AND ADOPTED BY QUA-HA-DI (ANTELOPE) COMANCHES, AND HIS FATHER WAS COMANCHE CHIEF PETA NOCONA. TEXAS RANGERS RECLAIMED CYNTHIA ANN IN AN 1860 FIGHT AT THE PEASE RIVER. NOCONA DIED SOON AFTER, AND CYNTHIA ANN LIVED WITH RELATIVES NEAR BIRDVILLE IN TARRANT COUNTY BEFORE DYING WITH NO FURTHER CONTACT WITH HER COMANCHE FAMILY.

BECOMING CHIEF UPON HIS FATHER'S DEATH, QUANAH REFUSED TO SIGN THE 1867 MEDICINE LODGE TREATY THAT SENT MANY PLAINS INDIANS TO RESERVATIONS. INSTEAD, HE LED RAIDS IN TEXAS AND MEXICO FOR ANOTHER SEVEN YEARS, LIKELY INCLUDING THE LAST FORAY INTO TARRANT COUNTY IN JUNE 1871. THAT WINTER, QUANAH'S BAND ELUDED COL. RANALD MACKENZIE'S FOURTH U.S. CAVALRY ACROSS THE TEXAS PANHANDLE. COMANCHE LOSSES DURING THE 1874 PANHANDLE BATTLE OF ADOBE WALLS, IN WHICH QUANAH WAS WOUNDED, FOLLOWED BY A HARSH WINTER, FINALLY BROUGHT HIM AND FEWER THAN 100 REMAINING QUA-HA-DI TO THE RESERVATION AT FORT SILL, INDIAN TERRITORY IN MAY 1875.

QUANAH SERVED AS LIAISON BETWEEN HIS PEOPLE AND THE BUREAU OF INDIAN AFFAIRS. HE PROVED TO BE A PRAGMATIC LEADER, ENCOURAGING THE COMANCHES TO TAKE UP RANCHING AND FARMING, AND TO EDUCATE THEIR CHILDREN IN GOVERNMENT SCHOOLS. QUANAH PROSPERED THROUGH HIS INVESTMENTS AND BUILT HIS SPACIOUS "STAR HOUSE" NEAR CACHE, OK. HE TRAVELED WIDELY, GIVING SPEECHES AND INTERVIEWS AND PARTICIPATING IN WILD WEST SHOWS, THE TEXAS STATE FAIR, TEXAS CATTLE RAISERS ASSOCIATION GATHERINGS AND THE FORT WORTH FAT STOCK SHOW. QUANAH VISITED FORT WORTH AND THE STOCKYARDS ON MANY OCCASIONS. HE DIED IN 1911 AND IS BURIED AT FORT SILL.

MARKER IS PROPERTY OF THE STATE OF TEXAS (2007)

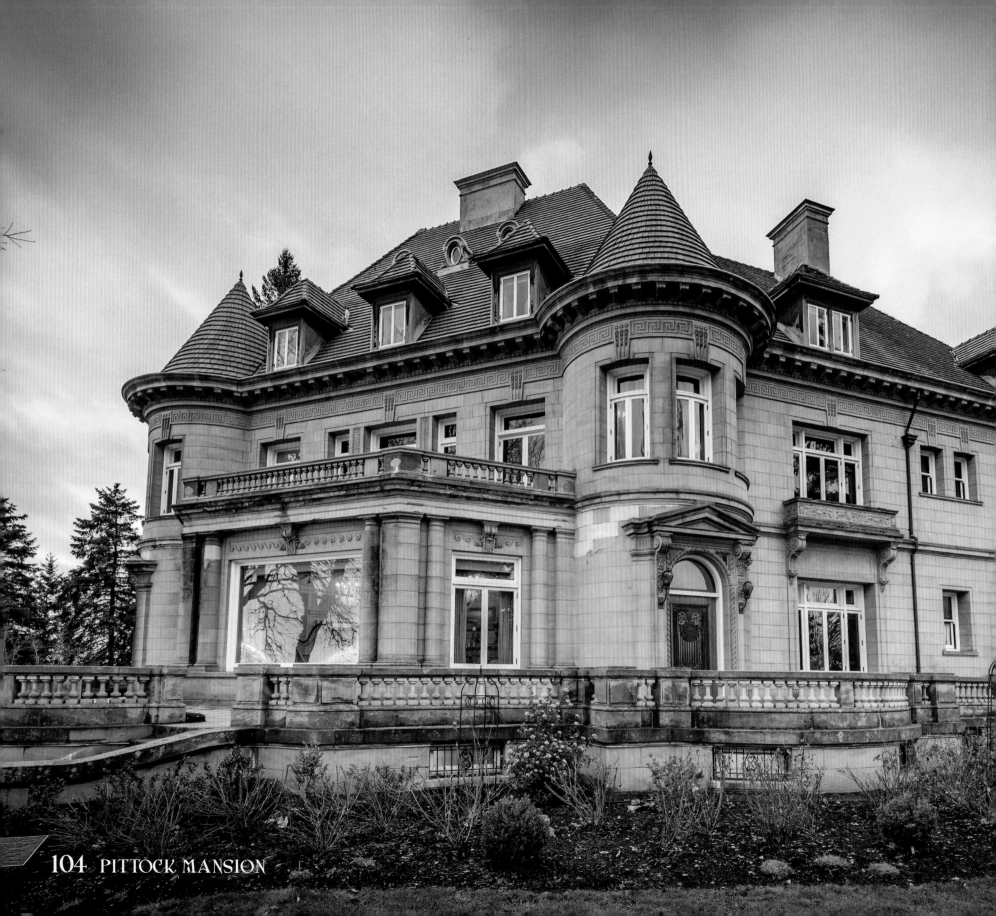

PITTOCK MANSION

1909–1914

LOCATION: Portland, OR
ARCHITECT: Edward T. Foulkes
STYLE: French Renaissance Revival

When newspaper publisher Henry Pittock (the founder of *The Oregonian*, a newspaper still published today) commissioned a French-trained architect, Pittock told him he wanted a Renaissance style mansion with state-of-the-art modern conveniences. The 16,000-square-foot, 23-room home was built on a hill in an oval shape so its inhabitants could get views of both downtown Portland and the Cascade Mountains.

The mansion included a library, smoking room, sewing room, and two porches for sleeping. Modern conveniences included central heating, an elevator, and what was known as a central vacuum system.

The mansion was built by local tradsmen who used local sandstone. The oval- and round-shaped rooms featured curved wooden floors. The interior reflected various styles, including Turkish and French Renaissance.

Pittock and his wife, Georgiana, lived in the home for just a few years before their deaths. A severe storm in 1962 damaged the roof tiles and sent water inside, and the mansion sat unoccupied for nearly four years. It was almost demolished, but the city of Portland purchased it with plans to preserve and restore the home. It ultimately took more than $6 million, with some funding coming from private citizens, to restore the mansion, which is now listed on the National Register of Historic Places.

The nonprofit Pittock Mansion Society runs events, self-guided and behind-the-scenes tours, and educational activities in the mansion. Visitors can also view the gardens, which contain roses in memory of the Portland Rose Society founder Georgiana Pittock.

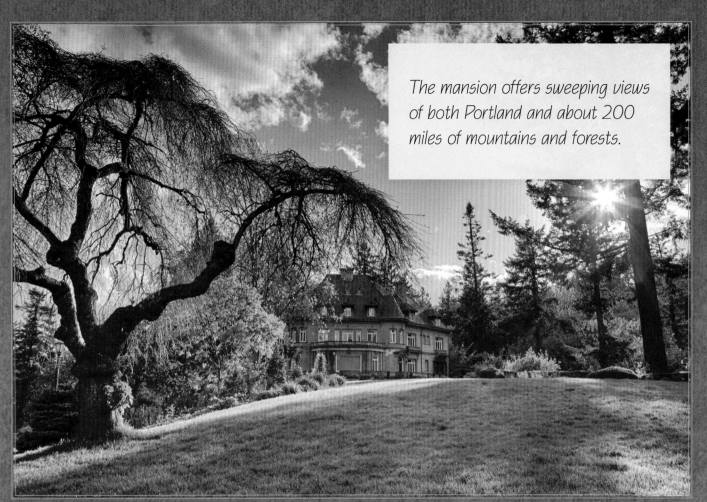

The mansion offers sweeping views of both Portland and about 200 miles of mountains and forests.

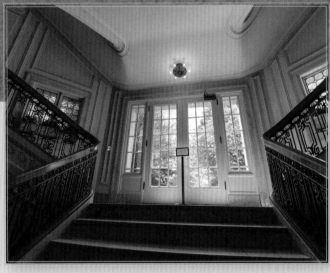

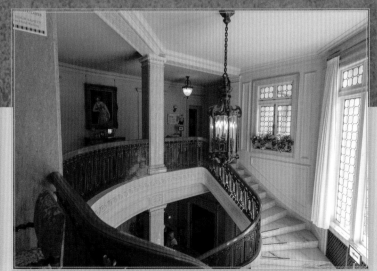

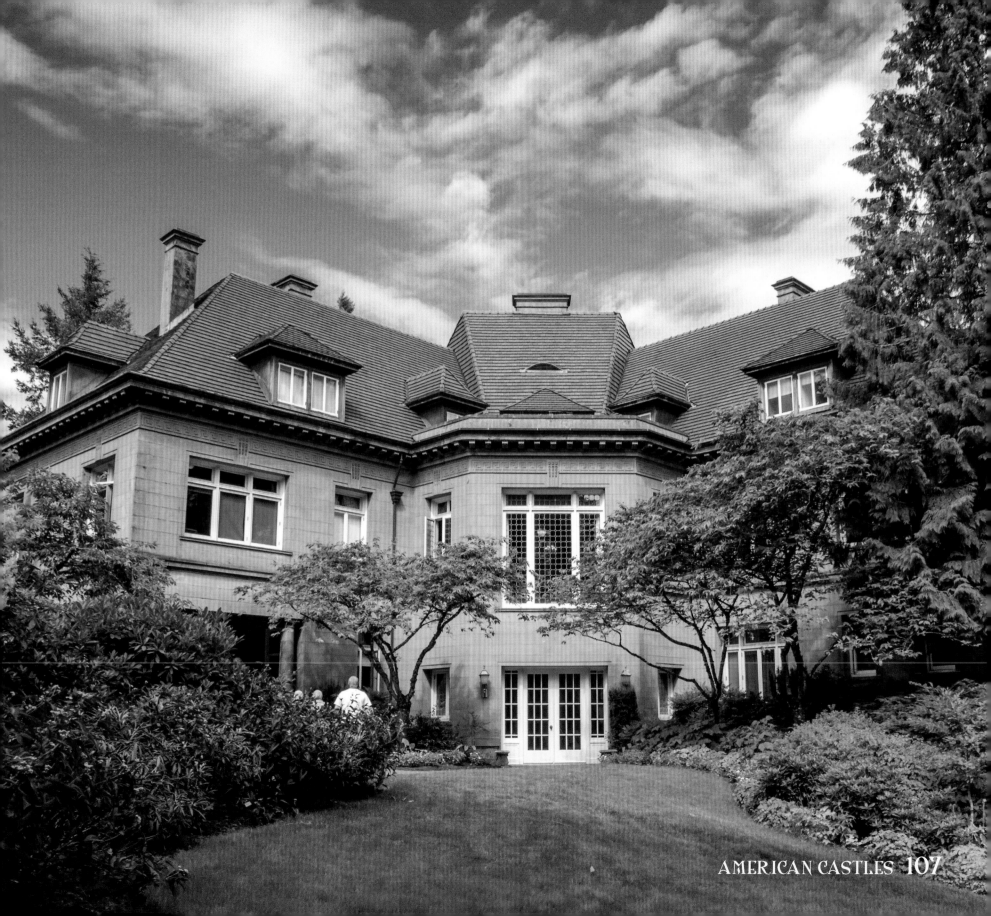

CAIRNWOOD ESTATE
1895

LOCATION: Bryn Athyn, PA
ARCHITECT: John Carrère and Thomas Hastings
STYLE: Beaux-Arts

Thomas Hastings

John Merven Carrère

Architects John Merven Carrère and Thomas Hastings formed the famous Beaux-Arts architecture firm Carrère and Hastings in 1885. Headquartered in New York City, the partnership lasted until 1911, when Carrère died in an automobile accident. Thomas Hastings continued to run the firm until his death in 1929.

What makes Cairnwood special is not only that its designer combined the best of Greek, Roman, and French architecture to create a 26,000-square-foot home, but also that it contains a chapel where the family gathered to worship. The New Church community was founded at the estate. In addition, famed landscape architect Frederick Law Olmsted designed the grounds.

The brick and limestone estate was designed in an L-shape with 28 rooms for wealthy businessman John Pitcairn Jr., a contemporary of Andrew Carnegie and John D. Rockefeller.

Pitcairn had Cairnwood built for his wife, Gertrude, to resemble a French chateau. Inside are stone and marble fireplaces and large upstairs windows and terraces from which the gardens can be seen.

The Pitcairn family donated the estate to the Academy of the New Church; it has subsequently been restored to its 1895 grandeur. The estate is within the Bryn Athyn Historic District, which contains a Gothic cathedral and the Glencairn Museum, the former home of a Pitcairn descendant. It's also listed on the National Register of Historic Places.

Cairnwood Estate is open for tours and special events, and it is often used by the public for weddings and other special occasions. In December, Cairnwood is decorated for the holidays with a historic fashion exhibition and a two-story Christmas tree.

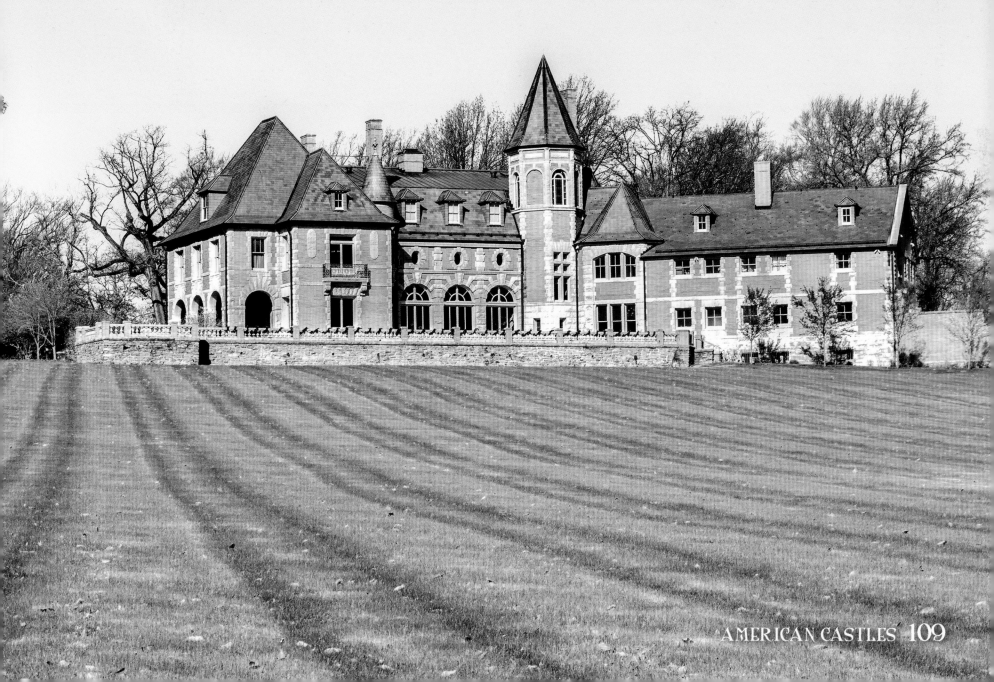

Professional landscape artists take care of the grounds; a favorite spot is an enclosed garden with an antique fountain and a view of the sunset.

FALLINGWATER

1936–1939

LOCATION: Mill Run, PA

ARCHITECT: Frank Lloyd Wright

STYLE: Modern

Frank Lloyd Wright

In his 70-year career, Wright designed more than 1,100 architectural works and produced some of the country's most famous buildings. He is considered by the American Institute of Architects to be the greatest American architect.

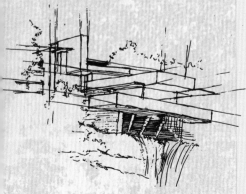

A mere 70 miles southeast of Pittsburgh sits one of America's—and the world's—most famous homes. Positioned partially over a waterfall, Frank Lloyd Wright's brilliant Fallingwater is an ode to man's inextricable connection to nature and the struggle between naturalism and modernity.

The home is the result of a special bond between Wright and a Pennsylvania family. Edgar Kaufmann Jr., the son of a successful department store executive, applied for an architecture apprenticeship established by Wright in the early 1930s. In time, Wright and Kaufmann's parents developed a relationship, and Wright visited the family's Pennsylvania property at Bear Run in December 1934. That's when the architect discovered an appreciation for the scenic spot, including its waterfall's power, the forest's vitality, and the site's dramatic rock ledges and boulders.

The home sits more than 30 feet above the rushing waters by way of cantilevers that are anchored to a four-story sandstone chimney. Stone walls and low ceilings evoke a cave-like atmosphere. The house's stairways even reflect the waterfall's movement. During construction, Wright locally sourced materials for the home, including quarried sandstone on site and Pittsburgh glass and steel.

The junior Kaufmann entrusted Fallingwater and the surrounding 1,500 acres of land to the Western Pennsylvania Conservancy in 1963. In 1976, the house became a National Historic Landmark. And today, annual visitations to Fallingwater exceed 180,000. Diligent preservation and maintenance efforts continue on a daily basis.

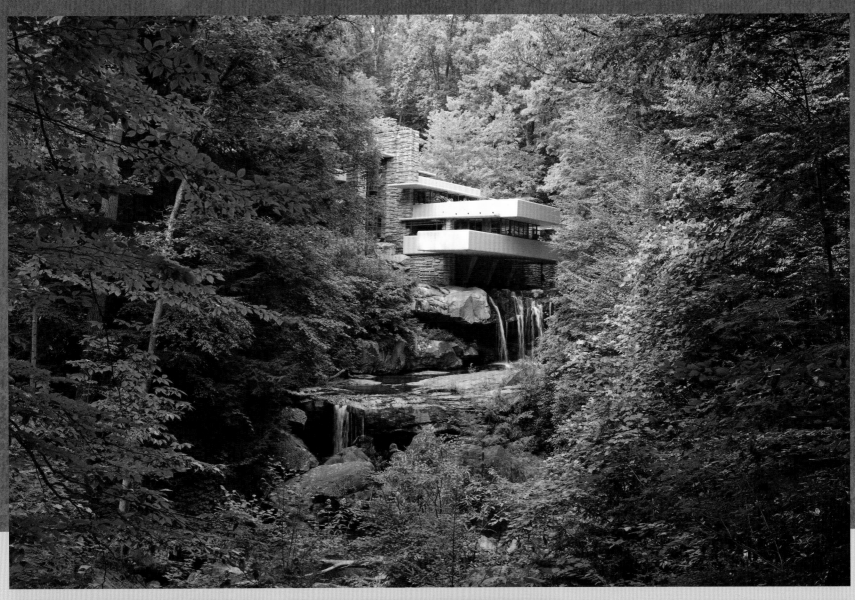

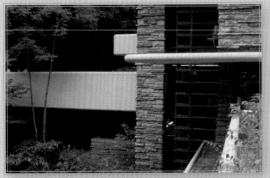

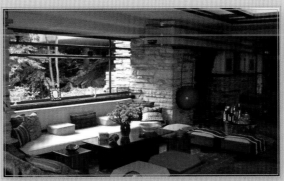

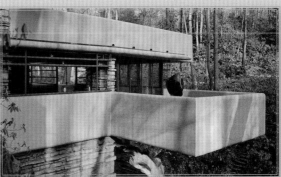

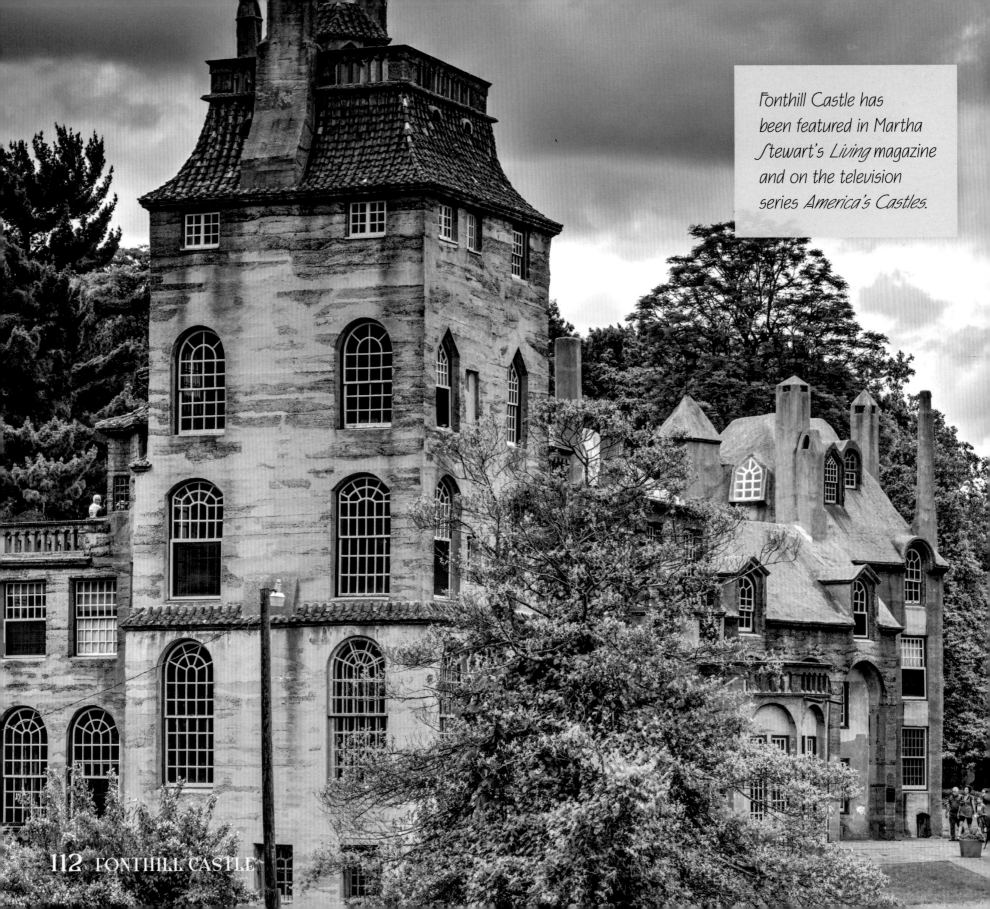

Fonthill Castle has been featured in Martha Stewart's *Living* magazine and on the television series *America's Castles*.

FONTHILL CASTLE
1908-1912

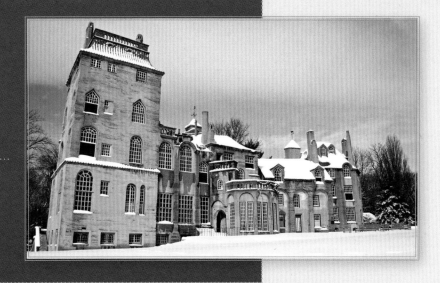

LOCATION: Doylestown, Pa
ARCHITECT: Henry C. Mercer
STYLE: Eclectic

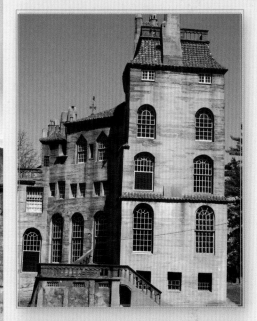

Henry C. Mercer's decorative ceramic tiles won a grand prize at the 1904 World's Fair, and many of his works of art can be seen at Pennsylvania's Fonthill Castle, the home he designed himself.

A well-traveled archeologist and Harvard graduate, Mercer designed a castle-like home and museum based on his love of the medieval style. He was a pioneer in using what was called poured-in-place concrete to build a residence. Early descriptions of the mansion—which contains 44 rooms, 200 windows, and 18 fireplaces—said it evoked various types of architecture, such as a Turkish mosque and an English medieval manor house.

Mercer designed the exterior to look like a Cothic castle, and his life's work—a series of tile designs—can be seen outside and inside the mansion. One room's ceiling, for example, is covered with Mercer's tiles, which he created to depict the life of Christopher Columbus.

Another room features tiles related to the travels of Cortez, and another, known as room of the winds, is designed with Mercer's artistic creations.

The castle features built-in furniture and contains some of Mercer's huge collection of artifacts, including European and American prints, tiles from around the world, and thousands of books.

The castle, along with the Mercer Museum and Moravian Pottery and Tile Works building—which he also designed and was where he created his tiles—are part of a National Historic Landmark District. The museum is about a mile away from the castle. Both are open for public tours and contain permanent and temporary exhibitions.

BELCOURT OF NEWPORT

1891–1894

LOCATION: Newport, RI

ARCHITECT: Richard Morris Hunt

STYLE: Beaux-Arts

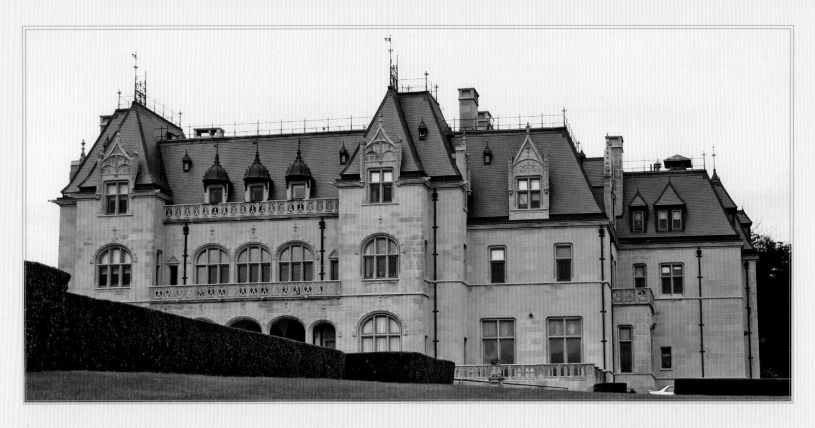

Richard Morris Hunt, designer of the Statue of Liberty pedestal and the Metropolitan Museum of Art, drew the plan for a private Rhode Island home that served as a summer cottage for bank heir Oliver Belmont.

Belmont had the 55,000-square-foot, 60-room home built for himself and his beloved horses. Hunt used the hunting lodge at Versailles in France for inspiration in designing the exterior. Inside, he created a carriage room for Belmont's horses.

Belmont later married Alva Vanderbilt, his neighbor. Vanderbilt insisted that the first floor designated for his horses be renovated for human use; she also demanded that the mansion become a place for entertaining. The carriage room became a banquet hall, for example, and various Renaissance features were added to the interior.

The mansion remained in the Belmont family until 1940; it ultimately passed through various hands who wanted to turn it into an antique automobile museum and a jazz festival venue. Over the years, the mansion fell into disrepair and lost its high society charm.

In 2012, Carolyn Rafaelian, the wealthy owner of a jewelry company, purchased the home and began restoring it to its original splendor. She also added environmentally friendly solar and geothermal systems. Rafaelian studied old photographs and spent millions of dollars on restorations.

ROSECLIFF
1898-1902

Stanford White

LOCATION: *Newport, RI*
ARCHITECT: *Stanford White*
STYLE: *French Baroque Revival*

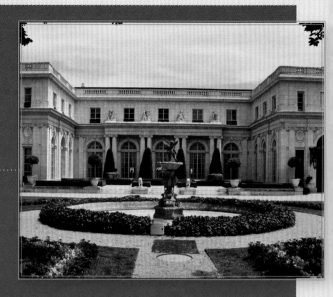

White was a partner in the Beaux-Arts architectural firm McKim, Mead & White. His commissions included Madison Square Garden II, the New York Herald Building, and the Washington Memorial Arch.

Theresa Fair Oelrichs wanted a summer mansion in Rhode Island rivaling all others. The result was Rosecliff, an epic home inspired by the Versailles baroque palace Grand Trianon.

Architect Stanford White designed the brick mansion in an H-shape, using decorative and functional columns, arched windows, and curved lines in a symmetrical format. For the interior, he included about 20 discreetly placed rooms for servants, along with hidden corridors. Other architectural designs included a grand staircase with a heart shape at the top.

The mansion's centerpiece is the ballroom, which is the largest in Newport and was decorated with Louis XIV furniture. Three episodes of the PBS series *Antiques Roadshow* were filmed inside the ballroom in 2017. The mansion also served as one of the main locations for the 1974 film *The Great Gatsby*.

Theresa Fair Oelrichs and her husband, Hermann, lived in the mansion. One of their biggest parties celebrated the Astor Cup Races, a nationally known auto racing event. The interior was decorated completely in white and silver for the event.

Rosecliff was later owned by Edgar and Louise Monroe, who also loved throwing parties like costume balls. The Monroes donated their estate to the Preservation Society of Newport County.

Rosecliff is open for tours and public exhibitions, as well as special programs for adults and children. The mansion is listed on the National Register of Historic Places.

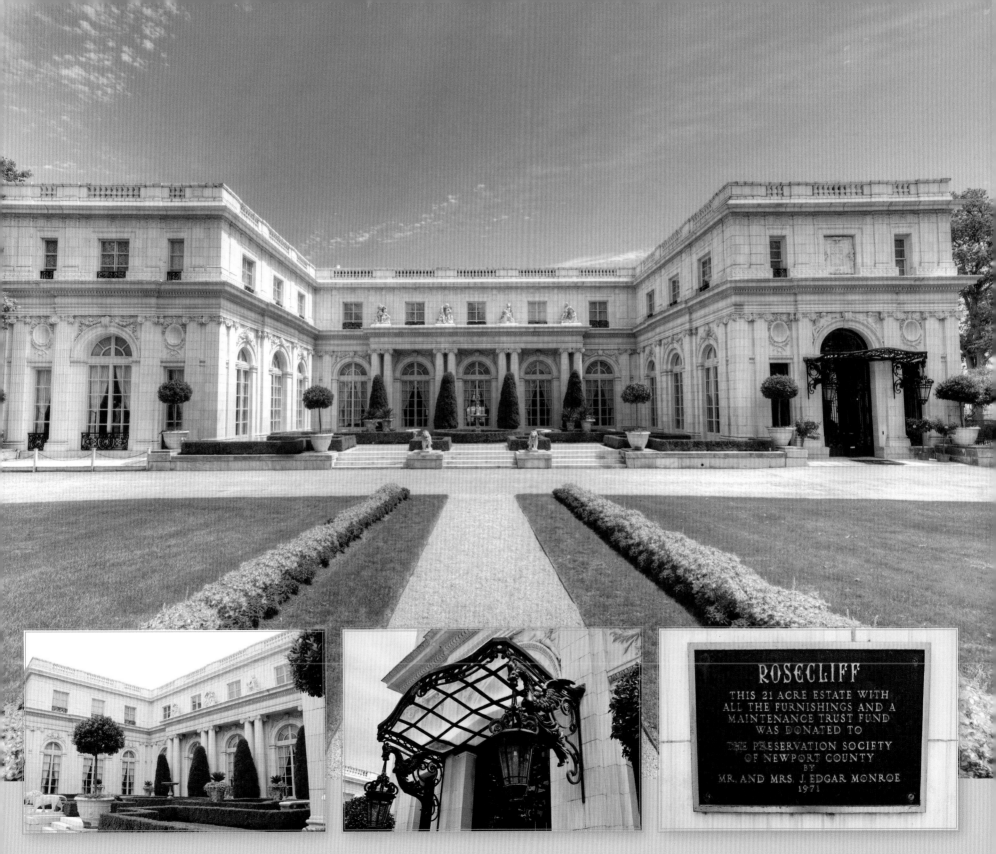

ROSECLIFF

THIS 21 ACRE ESTATE WITH
ALL THE FURNISHINGS AND A
MAINTENANCE TRUST FUND
WAS DONATED TO

THE PRESERVATION SOCIETY
OF NEWPORT COUNTY
BY
MR. AND MRS. J. EDGAR MONROE
1971

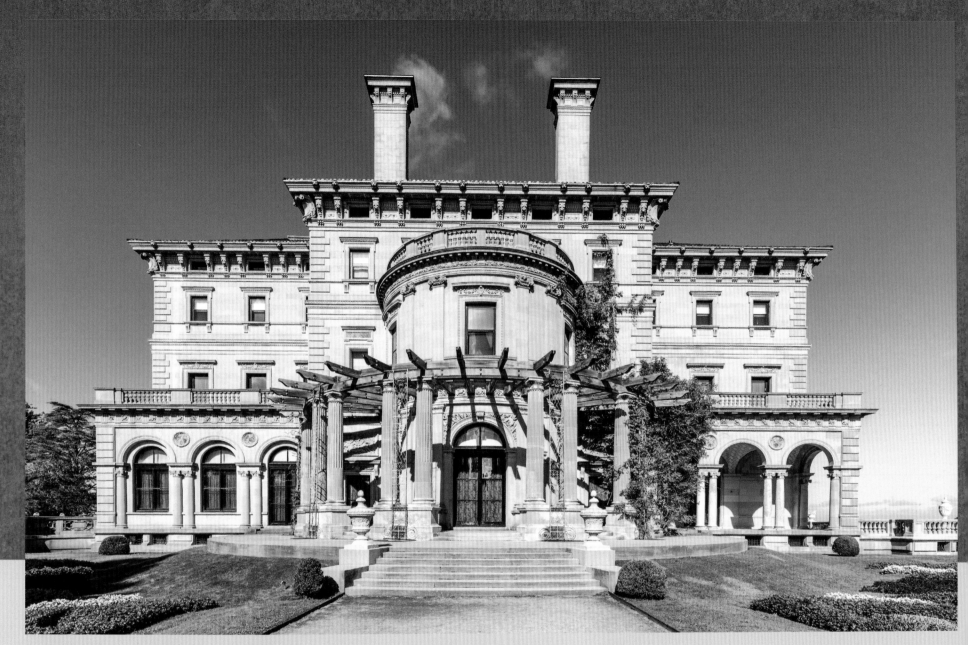

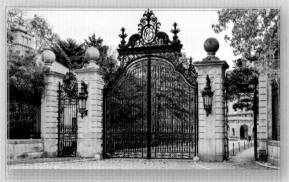
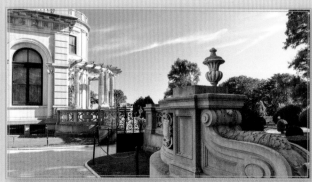
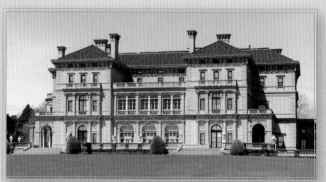

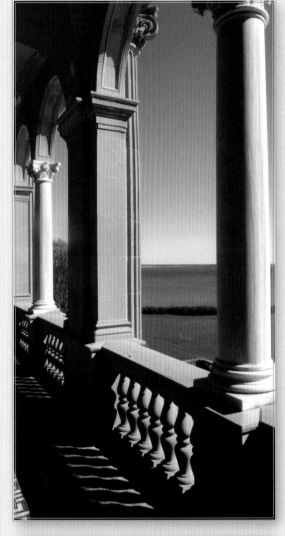

THE BREAKERS
1893-1895

LOCATION: Newport, RI
ARCHITECT: Richard Morris Hunt
STYLE: Italian Renaissance Revival

Richard Morris Hunt

Overlooking the Atlantic Ocean, The Breakers mansion served as the summer home for Cornelius Vanderbilt II. Considered among the finest homes in the area, the mansion has 70 rooms with more than 62,000 square feet of living space on a 14-acre estate.

In 1885, when Vanderbilt was named chairman and president of the New York Central Railroad system, he bought a wooden house known as The Breakers. In 1893, he commissioned an architect to rebuild the house, which was destroyed in a fire in 1892.

The new structure consisted of steel to make it as fireproof as possible. The foundation was made of brick, concrete, and limestone with a red terra cotta tiled roof. A 12-foot tall limestone and iron fence surrounds the estate, except for the side facing the ocean. The interior includes imported marble and artifacts obtained from a French chateau. Limestone figures of Galileo, Dante, and other well-known scientists and artists are featured atop six doors at the entrance of the Great Hall. A dining room has 12 Corinthian-style columns, and the ceiling features images of a Greek goddess and her chariots.

Like Rosecliff, The Breakers is owned and managed by the Preservation Society of Newport County. The Society owns 11 historic properties and landscapes from the colonial days through the Gilded Age, which includes several decades following the Civil War. The Breakers is a National Historic Landmark, and it is considered one of the most visited attractions in Rhode Island.

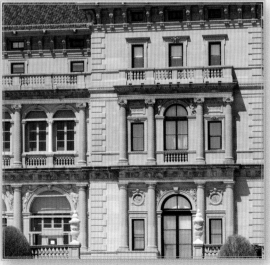

DRAYTON HALL
Ca. 1740S

LOCATION: Charleston, SC
ARCHITECT: Unknown
STYLE: Palladian

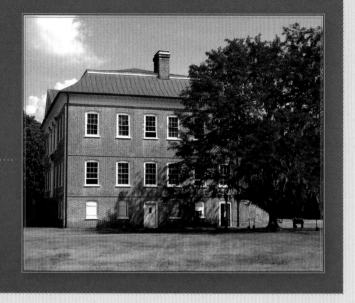

Drayton Hall, a National Historic Landmark, is considered one of the most famous plantation homes in North America, having survived both the Revolutionary and Civil Wars as well as hurricanes and earthquakes. Preserved, but not restored, it sits along the Ashley River in nearly its original condition, with no electricity or indoor plumbing.

John Drayton Sr. had the mansion built in the 1740s on land where rice was grown and dozens of slaves worked and lived. Historical accounts suggest that slaves helped build the house—and family members are buried in a nearby cemetery. Seven generations of Draytons lived in the home.

The two-story brick house's design was said to be inspired by English-Georgian architecture as well as Renaissance architect Andrea Palladio. In keeping with the Palladian style, two identical outbuildings were constructed on either side of the main house, which contained two separate porches and stairways leading to the entrance. The interior features a divided staircase (a Palladian trait) and detailed plasterwork on the main floor.

In 1974, the National Trust for Historic Preservation acquired it to preserve, opening it in 1977 for public tours.

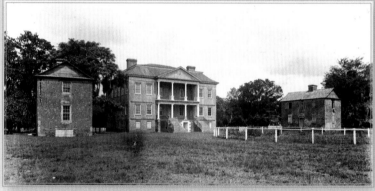

The public can walk the estate to see a nineteenth century caretaker's house (now repurposed as an interpretive center regarding life after the Civil War), an exhibit gallery, and a courtyard garden featuring plants that the Drayton families grew during the eighteenth and nineteenth centuries.

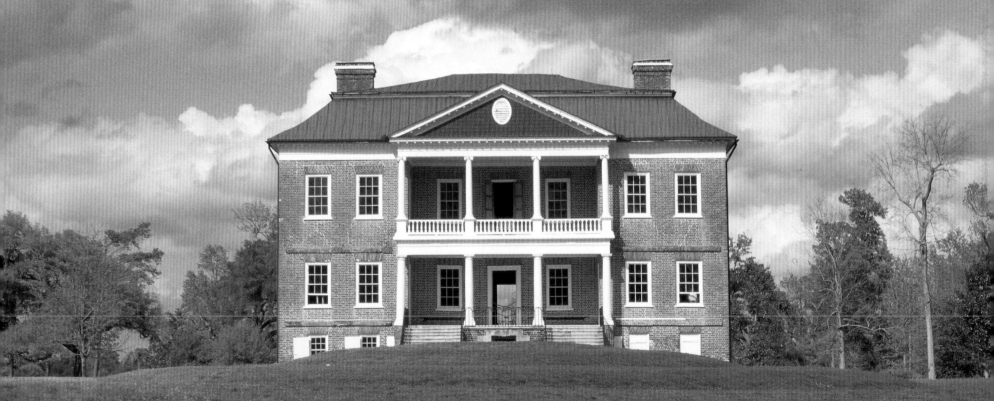

The main house is unfurnished, giving visitors the chance to see the interior's original architectural details.

GRACELAND
1939-1941

LOCATION: *Memphis, TN*

ARCHITECT: *Furbringer and Ehrman*

STYLE: *Colonial Revival*

Most folks know Graceland as the place where Elvis Presley lived and died. But he didn't build it. The 10,000-square-foot mansion was built in 1939 by orchestral harpist Ruth Moore and her husband Thomas.

Presley bought the mansion and grounds in 1957, and it soon became his private retreat. When Presley was on tour, he instructed hotel officials to remodel his quarters to make it feel as if he were back at Graceland.

Graceland Estate was built among oak trees at the top of a hill and surrounded by pastures. The 17,500-square-foot, 23-room, two-story home features a limestone façade, two chimneys, tall white columns, a gabled roof, and other colonial style architectural designs. Over the years, Presley added on to the house, building the Jungle Room, which became his recording studio, and a wrought iron front gate shaped like sheet music that depicted the musician's silhouette. He later added a meditation garden, where his tombstone and a monument dedicated to his twin brother are located.

Presley's daughter, Lisa Marie Presley, inherited his estate, and she still owns the mansion now listed on the National Register of Historic Places.

Only the White House in Washington D.C., gets more visitors annually than Graceland. More than 20 million people, including musicians Paul Simon and

Paul McCartney, have visited Graceland ("Graceland," written by Paul Simon, won a Grammy in 1987). The home is open to the public for tours of the mansion, gardens, and exhibits.

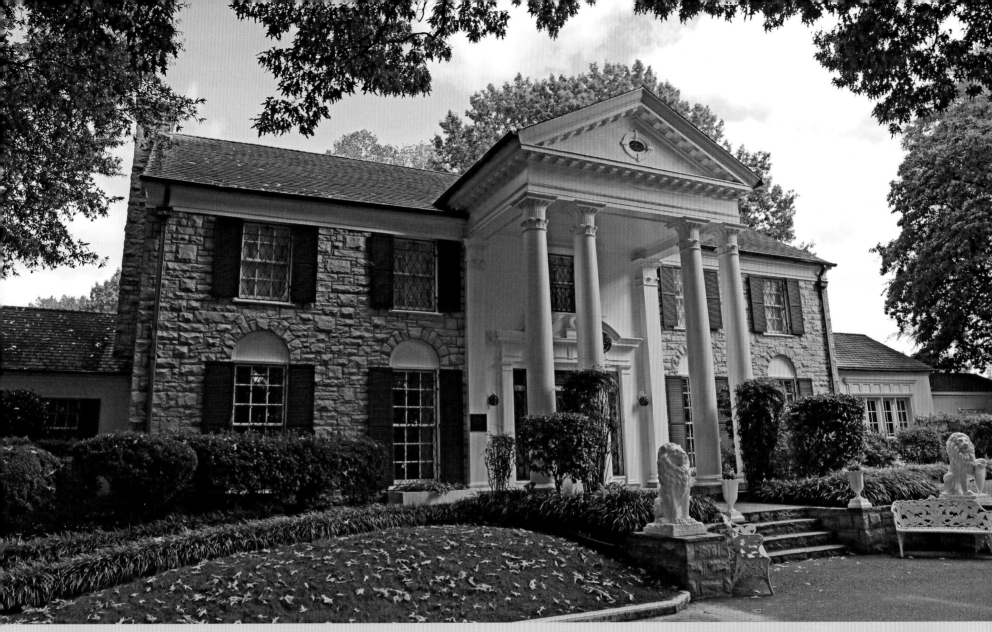

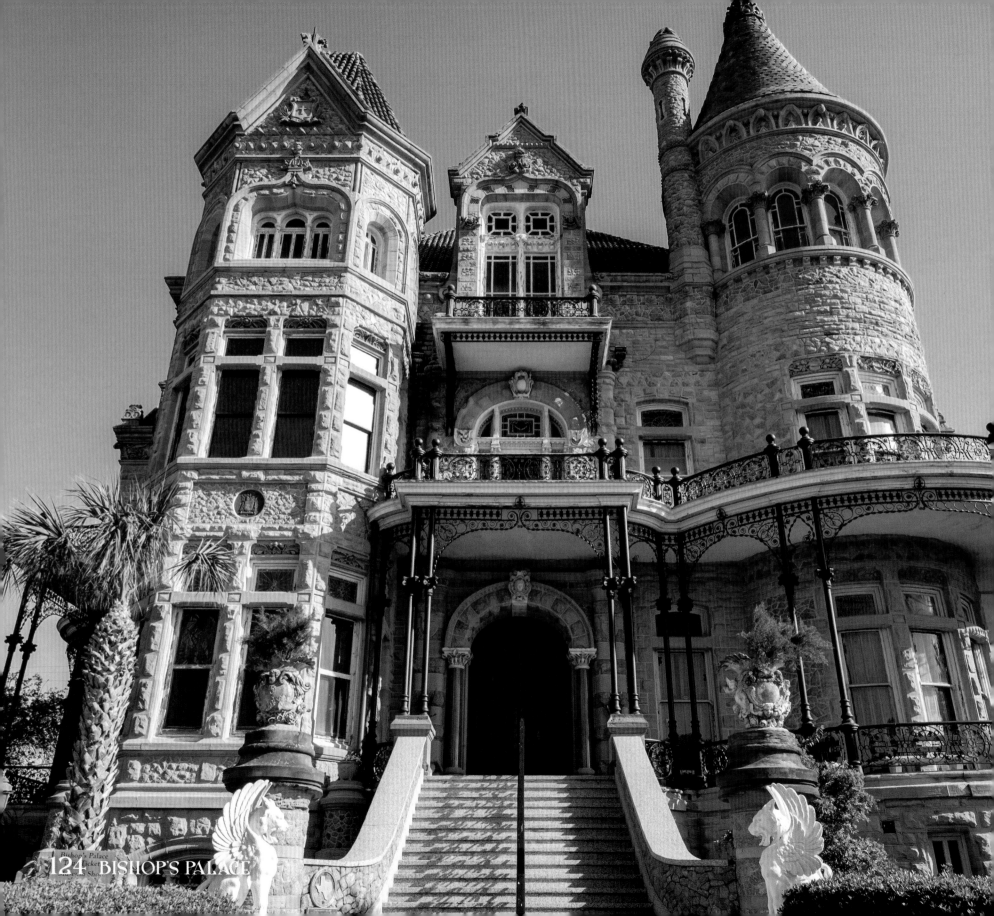

BISHOP'S PALACE
1887-1892

LOCATION: *Galveston, TX*

ARCHITECT: *Nicholas J. Clayton*

STYLE: *Victorian*

Attorney and politician Walter Gresham had a Victorian style home built for himself, his wife Josephine, and his nine children in Texas in the late 1880s. Constructed completely of steel and stone, the home survived a major hurricane that swept through the area in 1900.

Encompassing 19,000 square feet, the Gresham house, known as Gresham's Castle or Bishop's Palace, is listed on the National Register of Historic Places. Historians consider it one of the best examples of Victorian architecture in the country, although some say it also features French chateau revival styles.

Standing three stories tall, the mansion features carved Tudor arches and multiple roofs; it exudes a type of drama in the sky. The interior features towering marble columns in the entrance hall and a 40-foot-tall mahogany staircase decorated with stained glass windows. The dining room ceiling depicting cherubs was painted by Josephine Gresham.

The Roman Catholic Diocese of Galveston acquired the house in 1923; the house was to become the home for a bishop and serve as its headquarters. One of the bedrooms was converted into a chapel. When the diocese offices were moved to Houston, the mansion was opened to the public for tours.

Today, Bishop's Palace is owned by the Galveston Historical Foundation, which offers tours and works to preserve and restore the home.

Rumors suggest the home is haunted by Walter Gresham, who has been said to appear just outside the entrance of the home.

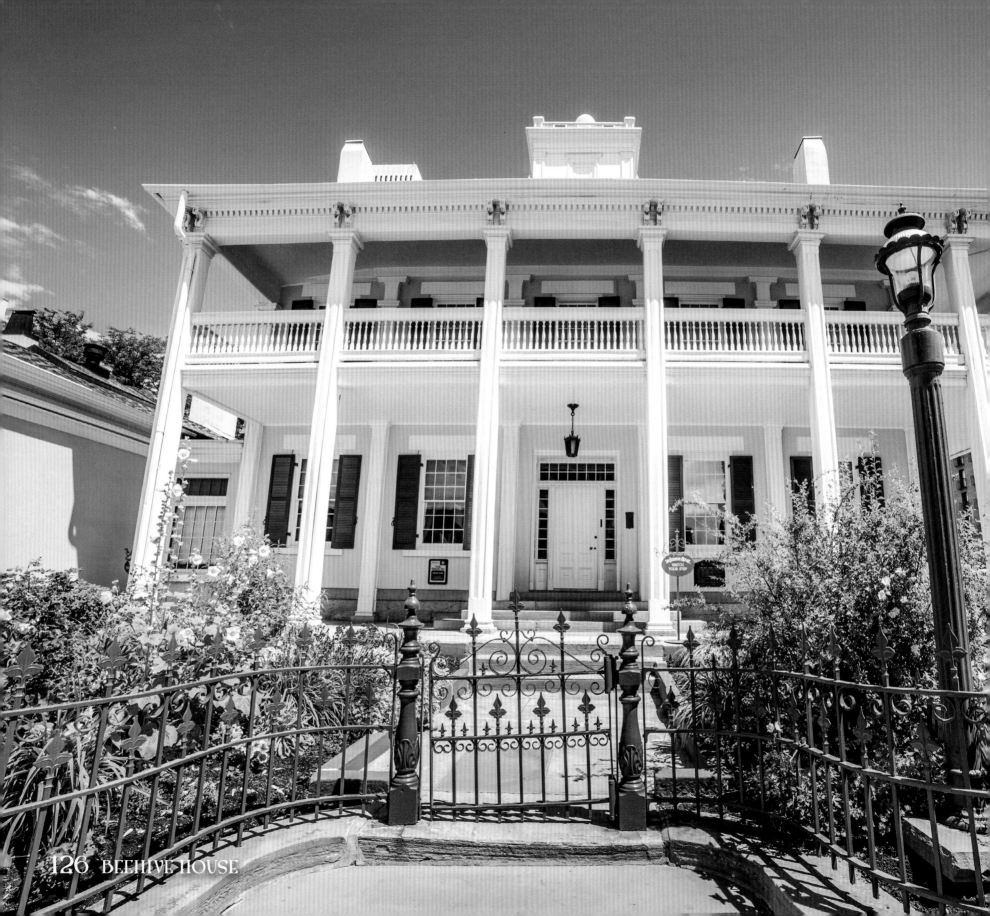

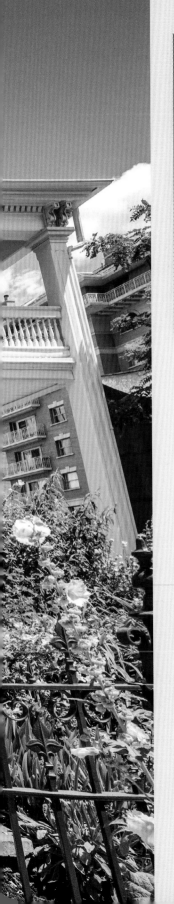

BEEHIVE HOUSE

1853-1855

LOCATION: Salt Lake City, UT

ARCHITECT: Truman O. Angell

STYLE: Greek Revival

Truman O. Angell

Built in the middle 1800s of adobe and sandstone, the Beehive House served as one of the residences of Brigham Young, second president of the Church of Jesus Christ Latter-day Saints. Young was also Utah's first governor. The mansion, with its tall columns and second story veranda, gets its name from a huge beehive sculpture placed atop the cupola. The beehive was said to symbolize community and hard work.

Young had at least 24 wives and more than 50 children, some of whom lived in the Beehive House and others who lived in the Lion House, which was built next door in 1856. The Beehive House and Lion House were both designed by Truman O. Angell, Young's brother-in-law.

Young entertained guests in the Beehive House; in 1888, one of his sons had a Victorian style addition added to the back of the home. At one time, the Beehive House served as a young women's boarding home. In the late 1950s, the Beehive House was restored. Today, it's on the National Register of Historic Places and serves as a museum, featuring some of Brigham Young's original furniture. The Lion House is also on the National Register of Historic Places, but it has been converted to a restaurant.

The Beehive House is owned by the church, and members give free daily tours of the home. Visitors can also roam the nearby Brigham Young Historic Park and view native landscaping, sculptures, and a wooden waterwheel.

The Beehive House is located in Temple Square in Salt Lake City, where many other historical church buildings can be seen, including the Salt Lake Temple.

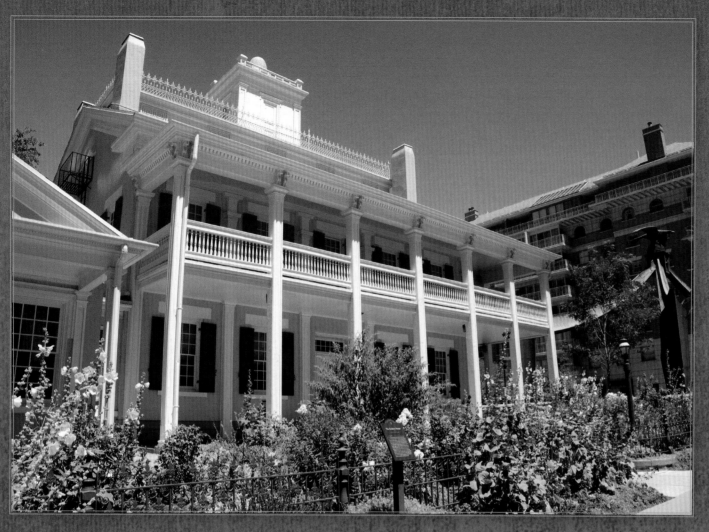

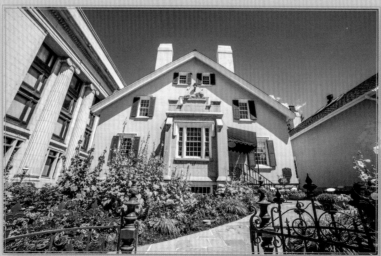

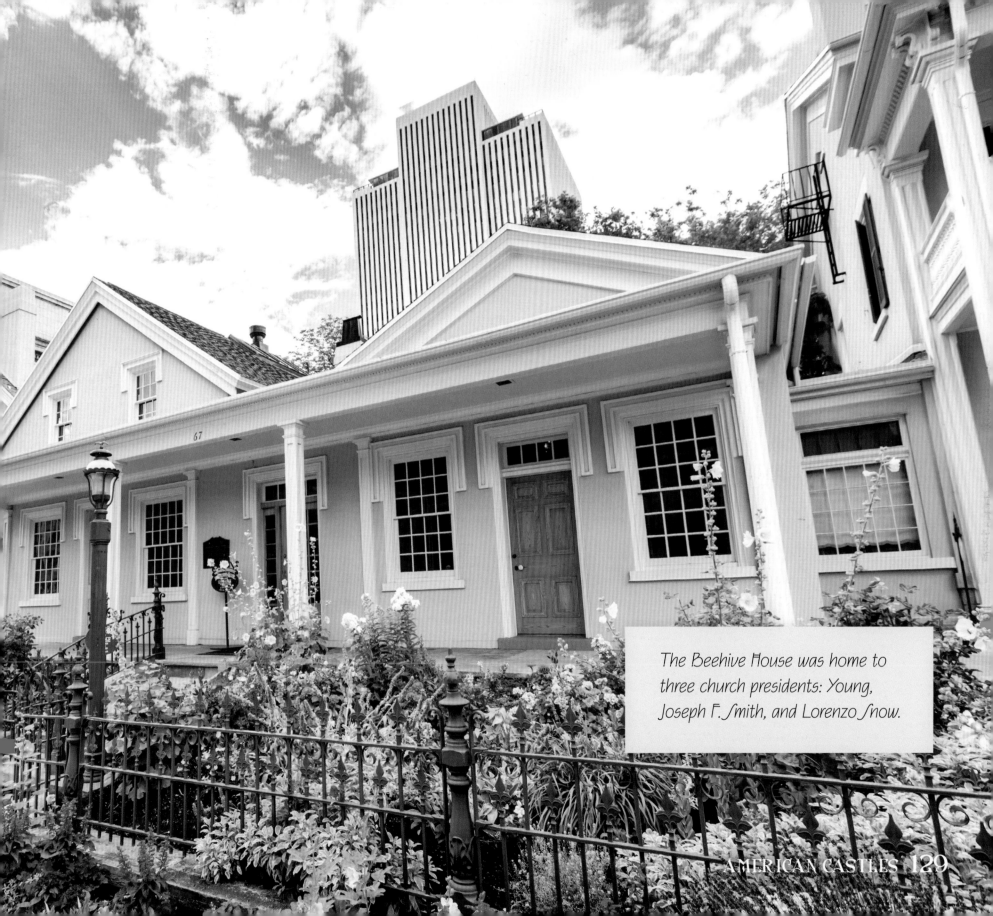

The Beehive House was home to three church presidents: Young, Joseph F. Smith, and Lorenzo Snow.

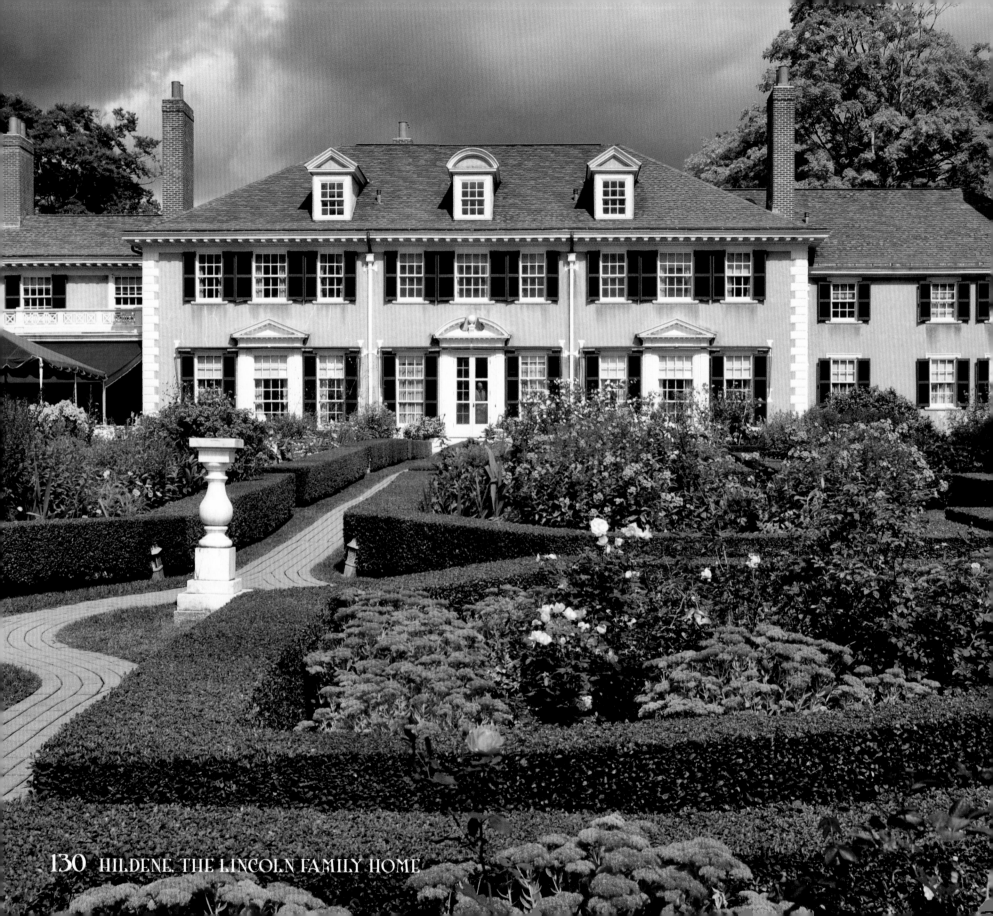

HILDENE, THE LINCOLN FAMILY HOME

1905

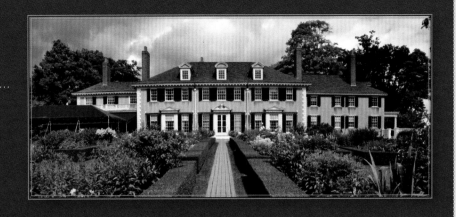

LOCATION: Manchester, VT

ARCHITECT: Shepley, Rutan and Coolidge

STYLE: Georgian Revival

Long after one of America's most famous presidents died, his descendants lived in a turn-of-the-century, 24-room summer home on some 400 mountainous acres in Vermont.

Abraham Lincoln's son, Robert Todd Lincoln, built the Georgian Revival home called Hildene in 1905. He was the only one of Abraham Lincoln's four children who survived until adulthood.

Hildene overlooks a valley, and the property contains meadows and wetlands, with a garden hosting more than 1,000 heirloom peony plants.

Robert Todd Lincoln served as president of the Pullman Company, and he was able to afford a fine home with eight fireplaces and a 1,000-pipe organ he gave to his wife, Mary. The organ is thought to be the oldest working residential pipe organ.

The 8,000-square-foot home with an open-air porch where Lincoln descendants lived until 1976, however, was not considered ostentatious. Robert Todd Lincoln apparently inherited his father's frugality by using mahogany-looking poplar tree wood for the interior walls.

The home was almost sold to developers, but the nonprofit Friends of Hildene made sure it was saved. Many of the Lincoln family's original furnishings and artifacts can be seen inside the home. These include one of three remaining stovepipe hats worn by Abraham Lincoln and a mirror from a dressing room the president used while in the White House.

Today, visitors can explore trails, an observatory, a welcome center, gardens, and the home's interior.

MONTICELLO
1769-1809

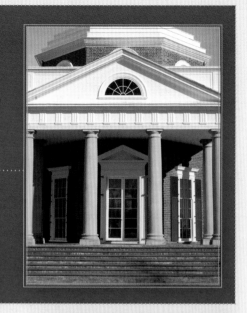

LOCATION: Charlottesville, VA

ARCHITECT: Thomas Jefferson

STYLE: Neoclassical

At age 26, America's third president began building and designing the home he would call Monticello at his Virginia plantation. Thomas Jefferson spent four decades creating the structure, which today encompasses 43 rooms and 11,000 square feet. It is listed as a National Historic Landmark and is designated as a UNESCO World Heritage Site. Jefferson also served as an architect for the University of Virginia.

Monticello started as a small brick building where first Jefferson lived alone and later with his wife, Martha Wayles Skelton. After Jefferson served as a minister of the United States to France, he returned with inspirations from the classical buildings he saw. He replaced a second-story porch with an eight-sided dome and experimented with plants in his garden, some of which are grown there today.

Approximately 80 slaves worked for Jefferson on his plantation. They lived in cabins on the grounds away from the mansion.

After Jefferson's death, Monticello passed through several owners until the Thomas Jefferson Foundation was formed in 1923 to preserve and restore the mansion and grounds. More than half of the furnishings in Monticello likely belonged to Jefferson.

In 2017, historians discovered a room next to Jefferson's bedroom where one of his slaves, Sally Hemings, with whom he had several children, lived. The foundation recently opened a new exhibit depicting the life of Sally Hemings; a new project will tell new stories about the slaves that lived at Monticello.

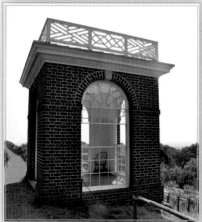

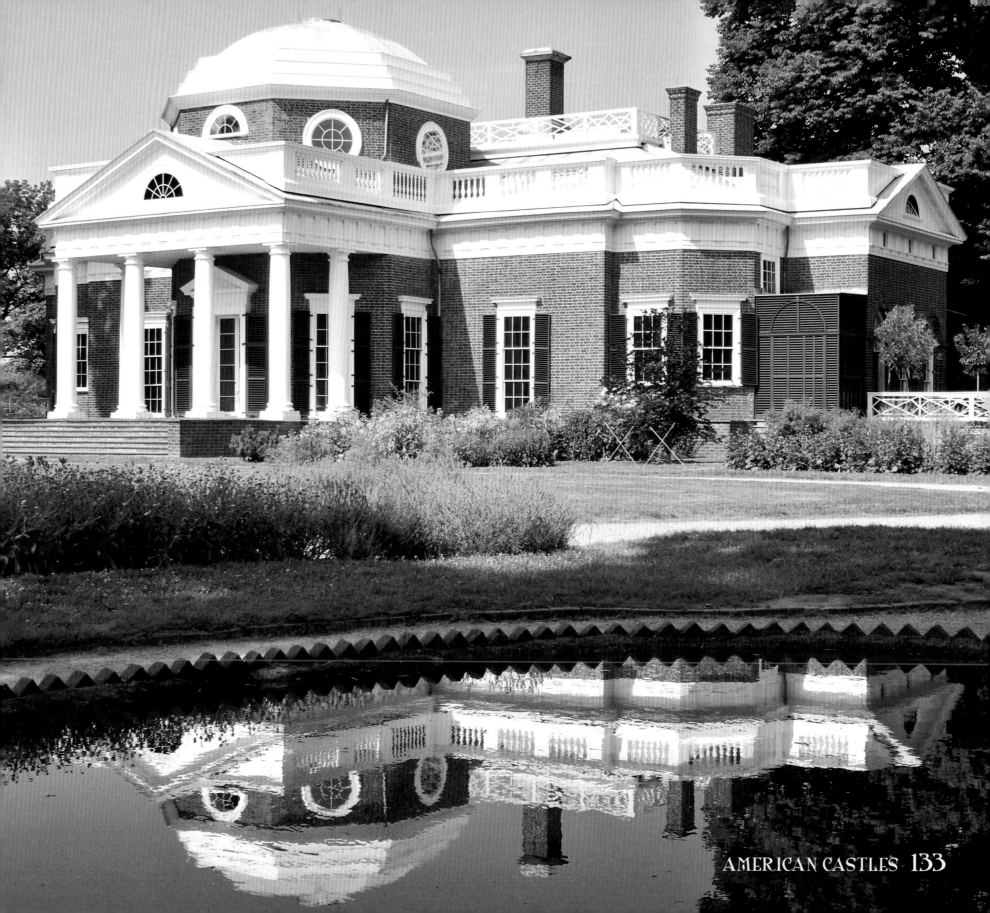

MOUNT VERNON
1734–1778

LOCATION: *Alexandria, VA*

ARCHITECT: *Unknown*

STYLE: *Palladian*

In 1734, Augustine Washington built a one-story wooden home near the Potomac River that later would be owned by his son, George Washington. Today it's known as Mount Vernon, and visitors can learn of its history and view the mansion as it looked when George Washington and his wife, Martha, lived there. The home—built by slaves—served as the family plantation, and included 30 outbuildings on 8,000 acres.

Over the years, George Washington added and improved upon the original building until it became an 11,000-square-foot mansion.

In the 1750s, he added two single-story wings on both sides of the main home, a Palladian style feature. Also added onto the main home were two chimneys flanking a cupola atop which stands a peace dove weather vane. He also employed a technique called rustication to make the wooden exterior look like stone.

In his will, George Washington, who questioned the morality of keeping slaves, asked for them to be freed. His slaves were set free in about 1802.

In 1858, the Mount Vernon Ladies' Association purchased Washington's mansion and began restoring it as a museum. The group, which still owns and manages the property today, also installed an education center on the grounds.

More than one million visitors annually tour the mansion and grounds, including a reconstructed distillery and gardens. Restoration continues today.

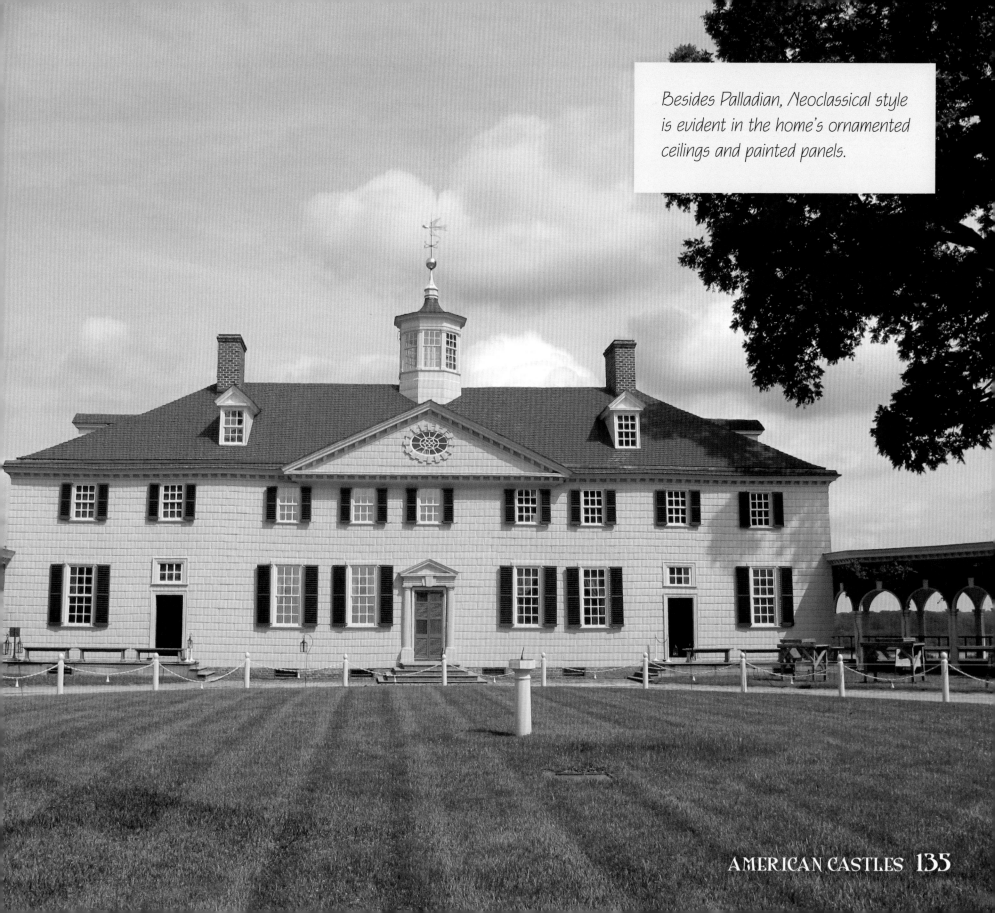

Besides Palladian, Neoclassical style is evident in the home's ornamented ceilings and painted panels.

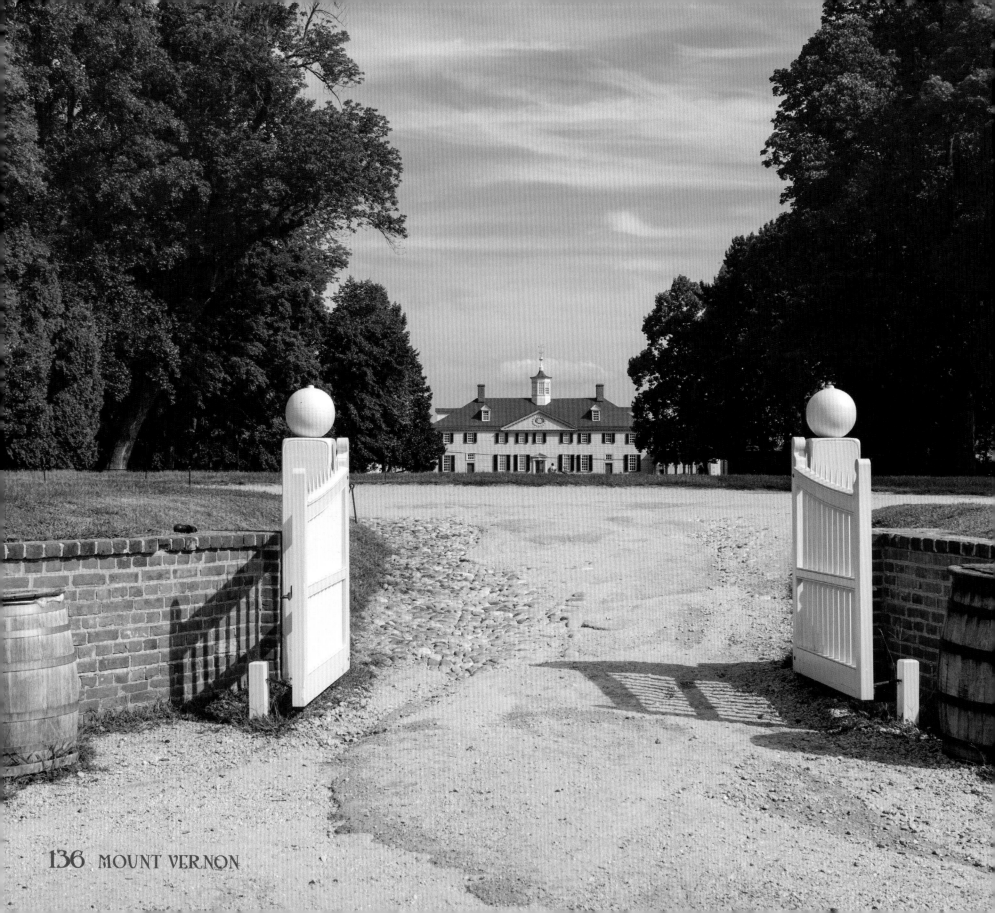

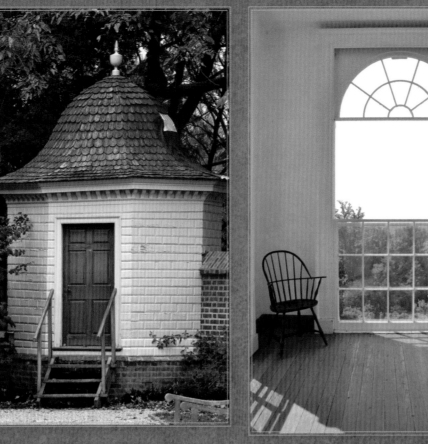

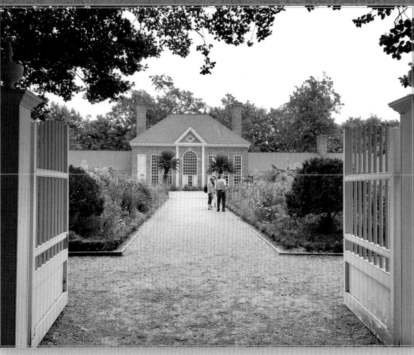

THE WHITE HOUSE

1792

LOCATION: Washington, D.C.
ARCHITECT: James Hoban
STYLE: Palladian

In 1791, George Washington chose the place where the nation's White House would be built with light gray sandstone—but it took eight years to be completed and the nation's first president never lived in it.

President John Adams and his wife were the first to live in what would become the president's home even before it was finished. But in 1814, the British would set fire to the home during the War of 1812. The original architect, James Hoban, was commissioned to rebuild it, and that's when the sandstone walls were painted white.

Historians think Hoban designed the presidential home based on his admiration of the Leinster House in Dublin, which was built around 1750 for a duke, and eventually became the meeting place for the Irish parliament. In his

drawings, Hoban included features that resembled the Leinster House; these features included two chimneys (one on each side of the building) and a triangular section in front of the home held up by four round columns.

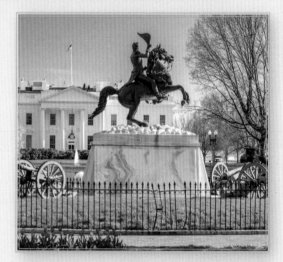

In 1824, Hoban, based on another architect's plans, added a neoclassical porch that resembles an 1817 chateau in France. The White House seen today reflects most of the renovations completed between 1948 and 1952 during Harry S. Truman's presidency. Though some architectural historians were aghast, Truman added a balcony to the second floor so he could see outdoors.

Today, the White House, which can be toured by making a request with a U.S. congressperson, has 132 rooms, 35 bathrooms, 28 fireplaces, and seven staircases.

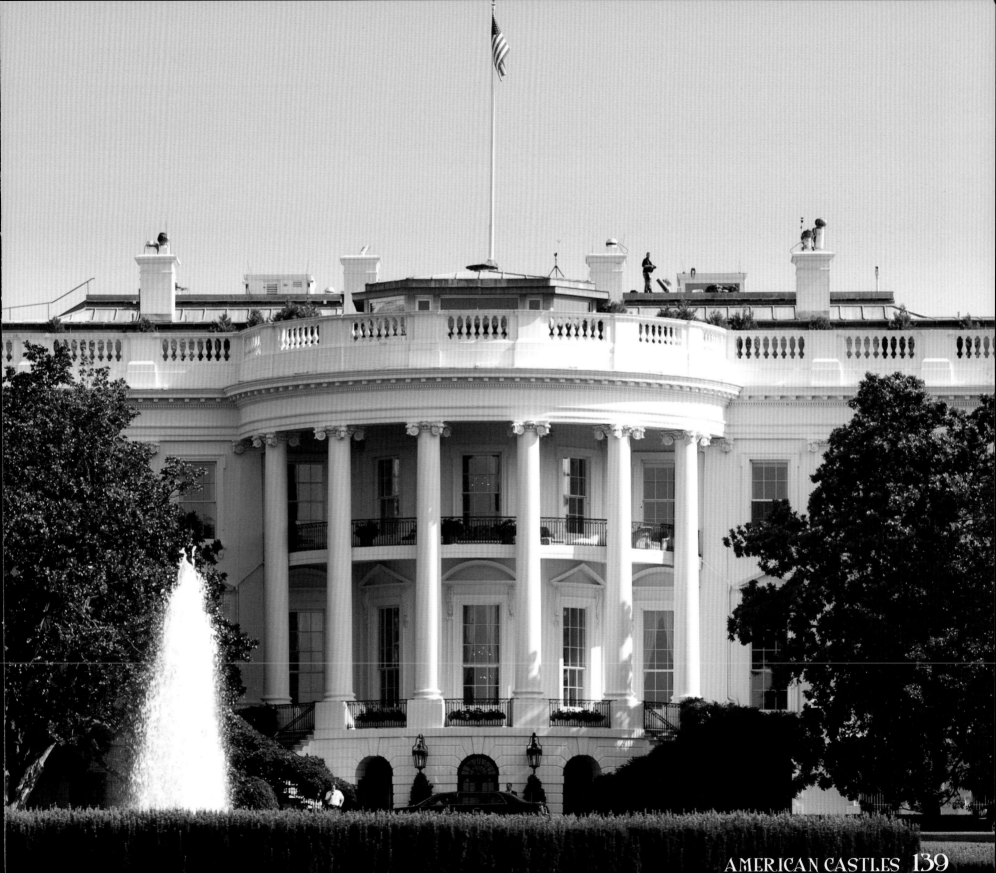

THE PABST MANSION
1890–1892

CAPTAIN FREDERICK PABST
MANSION
c.1892
HAS BEEN PLACED ON THE
NATIONAL REGISTER
OF HISTORIC PLACES
BY THE UNITED STATES
DEPARTMENT OF THE INTERIOR

LOCATION: Milwaukee, WI
ARCHITECT: Alfred Charles Clas, George Bowman Ferry
STYLE: Varied, including Flemish Renaissance Revival and Rococo Revival

Captain Frederick Pabst may be known for his role in producing one of America's most famous beers, but he was also a real estate developer who built a renowned Gilded Age home.

Pabst—who was a steamship pilot prior to his beer brewing career—built his 20,000-square-foot mansion for about $254,000 in the late nineteenth century (about $7 million in today's dollars). The home features a mix of architectural styles, including Flemish Renaissance Revival and Rococo Revival. The front hall, for example, has a seventeenth century German Renaissance style with an elk antler chandelier.

The home features an electric call bell system, smoking room, music room, wine cellar, grand staircase, conservatory, and parlor. The mansion's interior and exterior walls were built of masonry, some of which are about 20 inches thick. Radiators heated the home through a central system, and the mansion was cooled by way of gravity.

Sadly, the Pabsts were not able to enjoy the home for much time. The captain died in the beginning of 1904, and his wife, Maria, died in 1906.

After the Pabst family sold the house in 1908, the mansion became the headquarters of the Roman Archdiocese of Milwaukee for nearly 70 years. The home was almost destroyed to make way for a parking lot; fortunately, that did not transpire, and the house earned its place on the National Register of Historic Places in April 1975. In May 1978, the mansion was opened to the public, thanks to about two dozen loans and a state grant. Today, visitors can tour the mansion almost any day of the year.

The Pabst Mansion contains 37 rooms, 12 bathrooms, and 14 fireplaces.

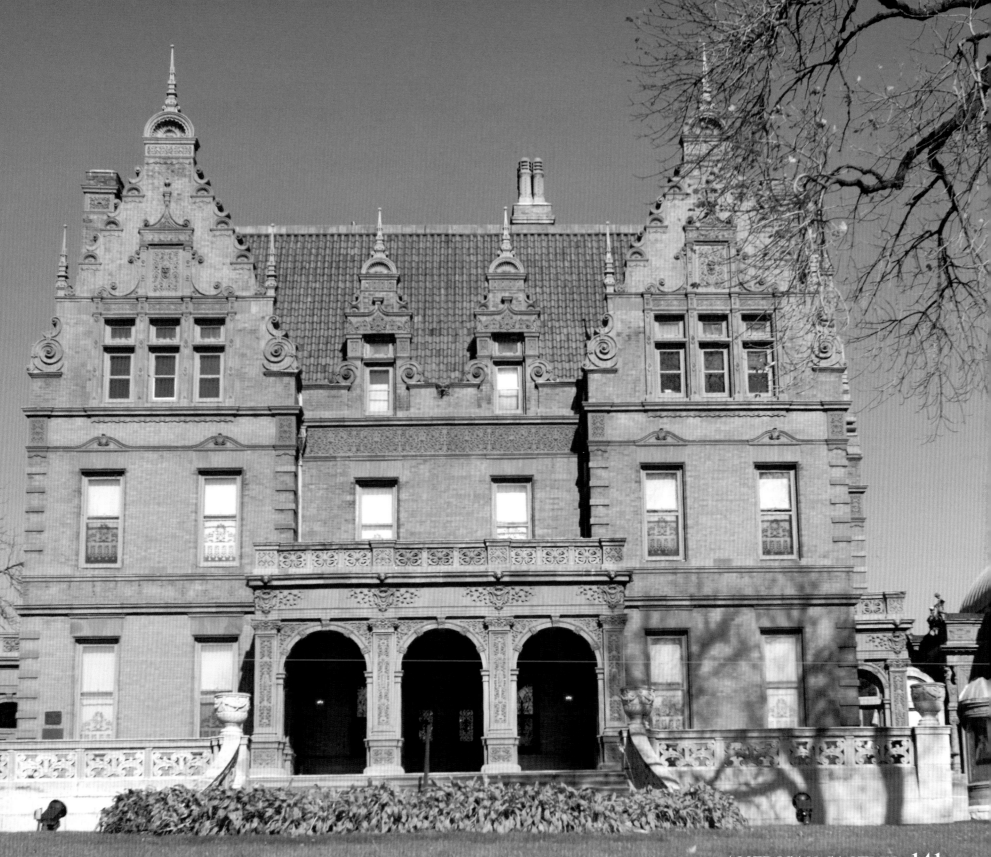

WINGSPREAD

1938-39

LOCATION: Racine, WI
ARCHITECT: Frank Lloyd Wright
STYLE: Prairie Style

An old story surrounds a Wisconsin home that Frank Lloyd Wright designed for Herbert Fisk Johnson. Johnson is said to have called the architect to complain that the house's roof was leaking right on top of his head. Wright reportedly responded by telling the owner to move his chair.

Whether legend or truth, the story refers to a 14,000-square-foot mansion called Wingspread. The mansion is considered the largest and last of Wright's Prairie style homes; in 1989, it was designated as a National Historical Landmark.

Viewed from afar, the home looks like a four-sided pinwheel, each of the four wings stretching outwards. The pinwheel-shaped home is found on 30 acres dotted with ponds, lagoons, and a ravine.

In his plans, Wright included a 30-foot-tall brick chimney, copious windows, and five fireplaces; he also included a Great Hall for large gatherings and smaller, more intimate rooms. The Johnson family lived there for about 20 years, and the children spent time in a glass-enclosed lookout waiting and watching for their father to return from work.

The Johnson Foundation now runs Wingspread as an education and conference center for leaders and thinkers worldwide. Wright's wife, Olgivanna Lloyd Wright, attended and spoke at the conference center's dedication ceremony in 1961. Today, private tours are available by appointment.

Groups often convene by one of the fireplaces in the living room, which is said to glow like a lantern at night. Organizations that grew out of conferences held at Wingspread include the National Endowment for the Arts and National Public Radio.

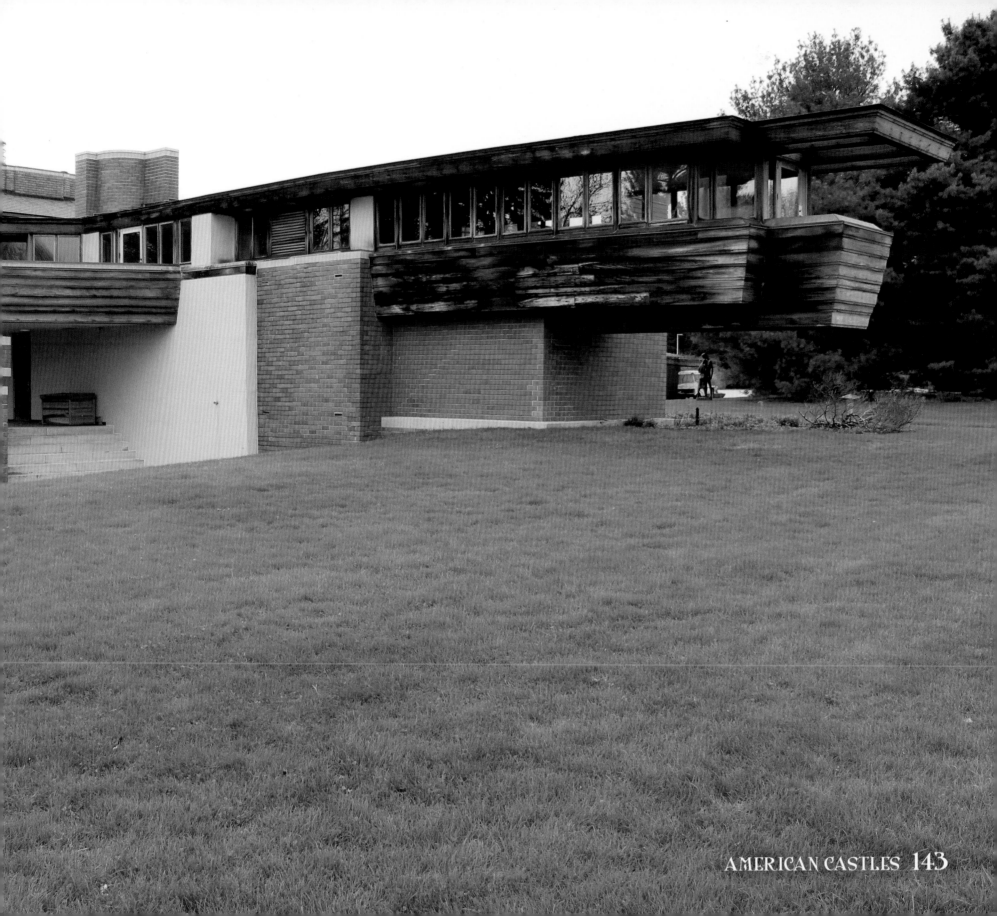

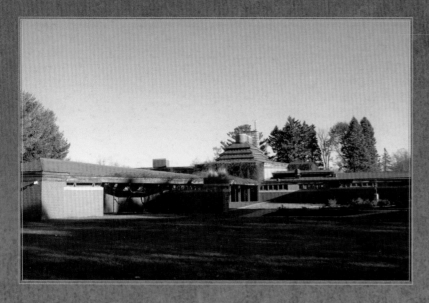

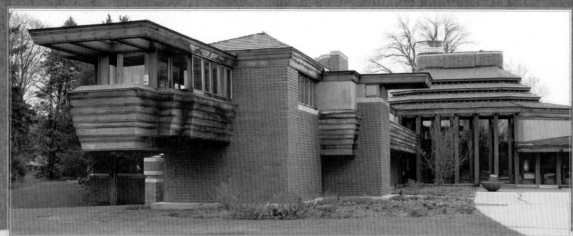

Wright designed
the home to
be built with
limestone, brick,
stucco, and
unfinished wood.